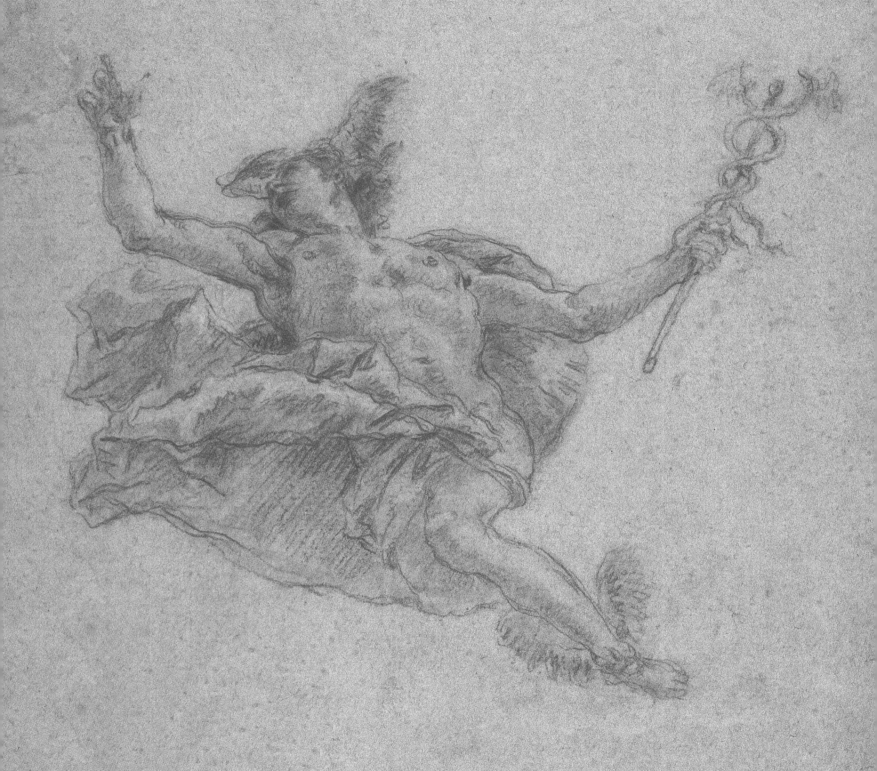

Heaven on Earth

TIEPOLO

Masterpieces
of the
Würzburg Years

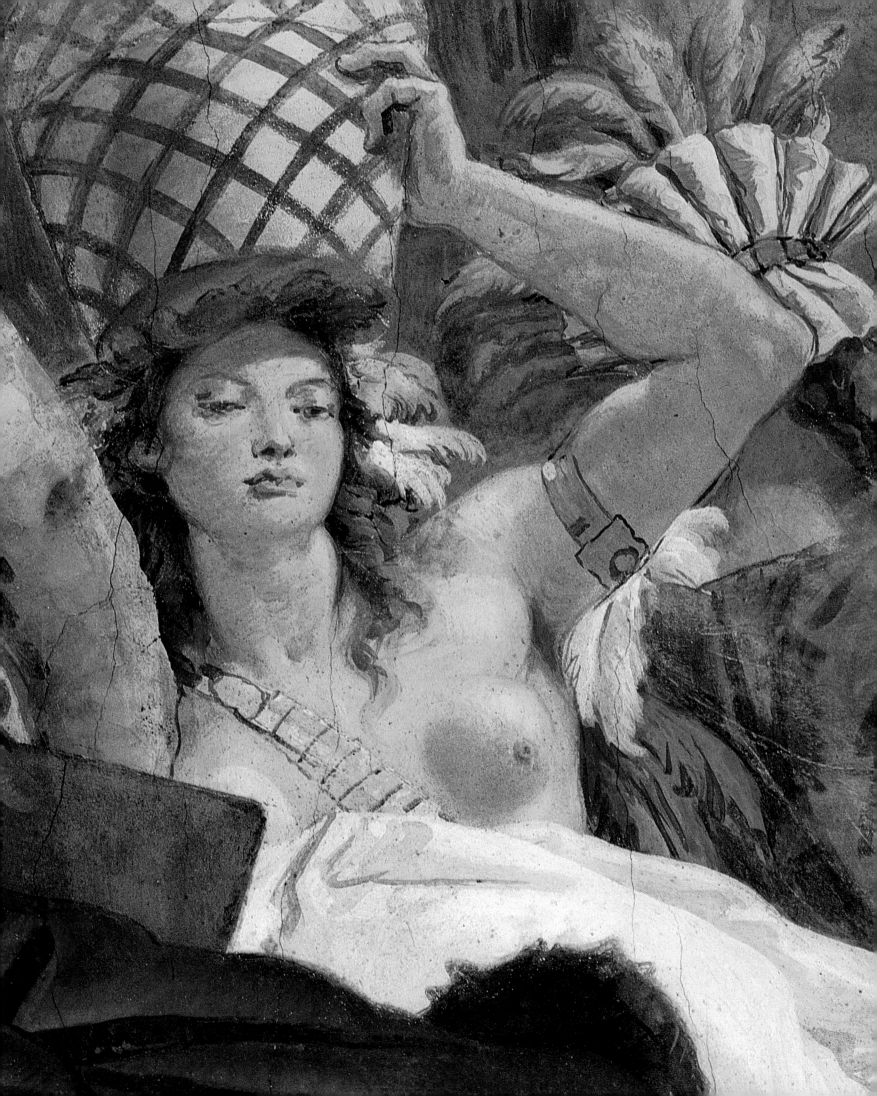

Heaven on Earth

TIEPOLO

Masterpieces
of the
Würzburg Years

by
Peter O. Krückmann

Prestel

Munich · New York

For Gerhard Hojer

Translated from the German by John Ormrod

Front cover: Giambattista Tiepolo,
figure of Apollo from the ceiling fresco in the
Kaisersaal of the Residenz, Würzburg (cf. plate 1)

Back cover: Giambattista Tiepolo, figure of a
page from the Investiture fresco in the Kaiser-
saal of the Residenz, Würzburg (cf. fig. 48)

Spine and frontispiece: Giambattista Tiepolo,
detail of the America fresco on the staircase
ceiling of the Residenz, Würzburg (cf. fig. 33)

Endpapers: (front) Giandomenico Tiepolo,
Mercury; red and white chalk on blue paper;
Würzburg, Martin von Wagner-Museum der
Universität Würzburg (cf. fig. 38);
(back) Giandomenico Tiepolo, *Horae*;
red and white chalk on blue paper; Stuttgart,
Staatsgalerie, Graphische Sammlung (cf. plate 1)

Page 1: Giambattista Tiepolo, *putto* from the
staircase fresco in the Residenz, Würzburg
(cf. plate 1)

Prestel books are available worldwide.
Please contact your nearest bookseller or write to
either of the following addresses for information
concerning your local distributor:
Prestel-Verlag, Mandlstrasse 26,
D-80802 Munich, Germany
Tel. (+49-89) 381 7090, Fax (+49-89) 381 709 35
and 16 West 22nd Street,
New York, NY 10010, USA
Tel. (212) 627-8199, Fax (212) 627-9866

Typeset in Janson-Text by
Max Vornehm GmbH, Munich
Lithography by eurocrom 4,
Villorba (TV), Italy (colour), and
Karl Dörfel GmbH, Munich (black and white)
Printed and bound by
Passavia Druckerei GmbH, Passau

Printed in Germany

ISBN 3-7913-1728-8

Printed on acid-free paper

Contents

Preface

Few periods in European history are as varied as the eighteenth century – an age of absolutism, but also an age of intellectual ferment and social upheaval, culminating in the French Revolution of 1789. In 1750, when the century stood at its zenith, Giambattista Tiepolo travelled with his two sons to Würzburg, where he had been commissioned by the Prince-Bishop, Carl Philipp von Greiffenclau, to decorate one of the state rooms, the Kaisersaal, and the ceremonial staircase of his recently completed palace, known as the Residenz. Together with the altarpieces and other oil paintings that he also produced during his time in Würzburg, Tiepolo's frescos in the Residenz are numbered among the most remarkable achievements of eighteenth-century art. They also form the apex of a long and venerable tradition of fresco decoration that began with Giotto and occupied a central position in the history of art over a period of some five centuries.

For the Bavarian State Administration of Palaces, Gardens and Lakes, it was both a duty and a pleasure to mark the 300th anniversary of Tiepolo's birth in 1996 by organizing a major exhibition devoted to the artist's years in Würzburg. This was the first show of its kind that set out to document the genesis of the frescos as a continuous process, from the preliminary sketches to the finished painting. The complex relationship between painting and architecture was a further theme addressed by the exhibition, whose exceptional – and not altogether predictable – success proved that the so-called Old Masters are more popular with the general public than ever before.

As the curator of the exhibition, I was particularly gratified by Prestel-Verlag's request to produce a short monograph dealing with Tiepolo's Würzburg years. The present study is not intended as an alternative to the exhibition catalogue, which contains essays by over twenty-five internationally esteemed authorities, together with descriptions of the individual works on show. Instead, it is designed as an invitation to the reader to take an imaginary stroll through the Würzburg Residenz, examining Tiepolo's frescos and the wealth of paintings and drawings that were assembled from all over the world to mark his anniversary.

This, I hope, will provide at least an initial insight into Tiepolo's artistic thinking and the workings of his extraordinarily fertile creative imagination. The reader will gain some idea of the lengths to which the artist went in designing and executing the frescos, and of the compositional skills that heighten the dramatic impact of his paintings. I have tried, furthermore, to convey something of the atmosphere of a provincial court in the final years of the *ancien régime*, a world that is so utterly remote from the reality of today.

To avoid overburdening the text with footnotes and references, I have opted to dispense with the customary discussion of the extensive literature on Tiepolo. Readers requiring further information should consult the bibliography appended to this book, and the essays in the exhibition catalogue. I am especially grateful to the contributors to the latter, whose new and pathbreaking investigations were crucial to my own work: this book could not have been written without them. I would also like to thank my colleagues in the Bavarian State Administration of Palaces, Gardens and Lakes for their unstinting support. Finally, my thanks are due to John Ormrod, for his excellent translation of the German manuscript, and to the energetic and committed staff of Prestel-Verlag, who have done so much to ensure the success of the project.

*Unless indicated otherwise in the captions,
all illustrated works are by Giambattista Tiepolo.*

PLATE 1
View of the staircase fresco in
the Residenz, Würzburg, with the depictions
of Apollo and (below) America

overleaf
PLATE 2
Detail of the staircase fresco,
with personification of America

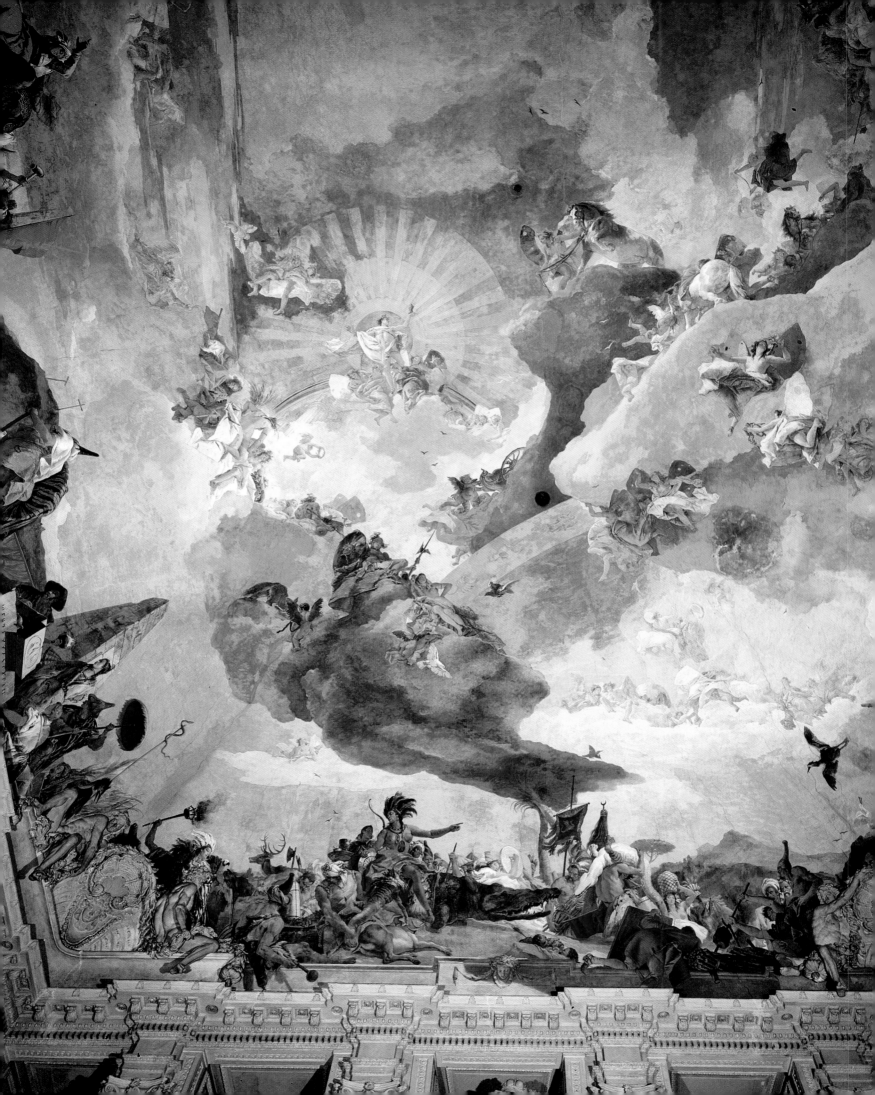

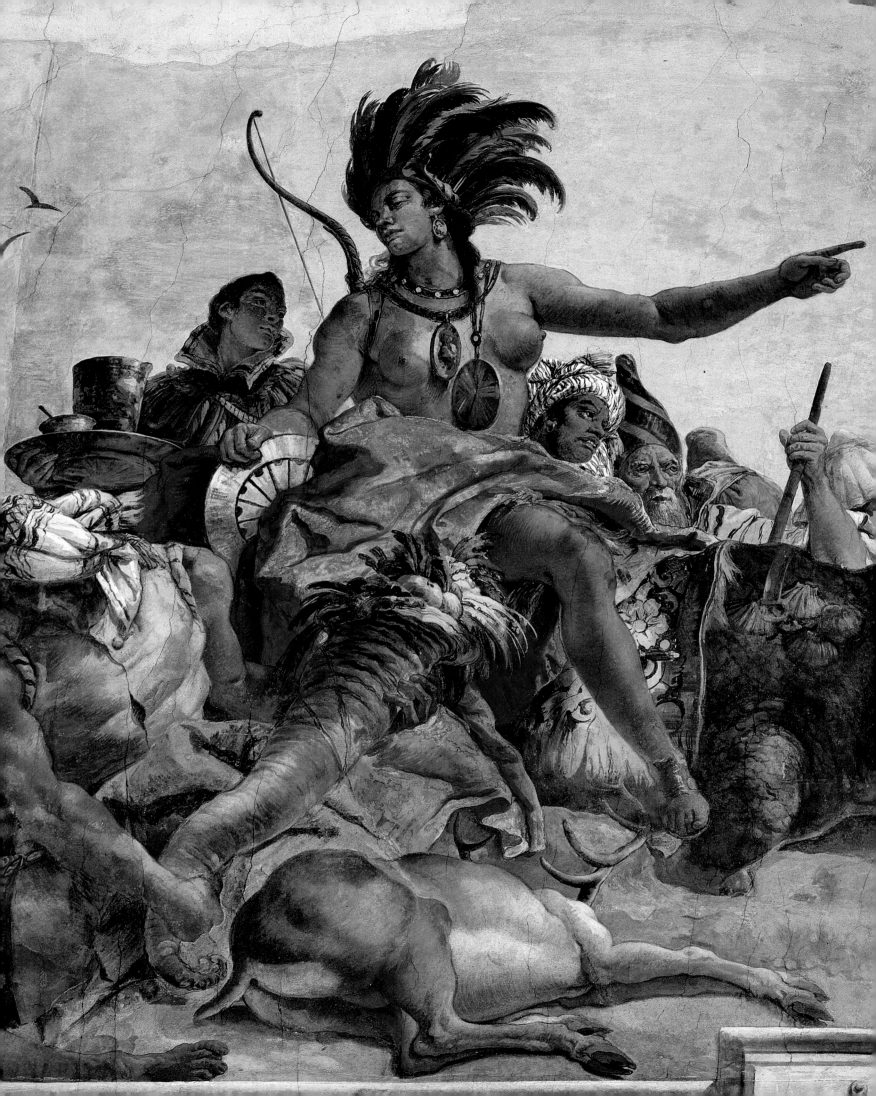

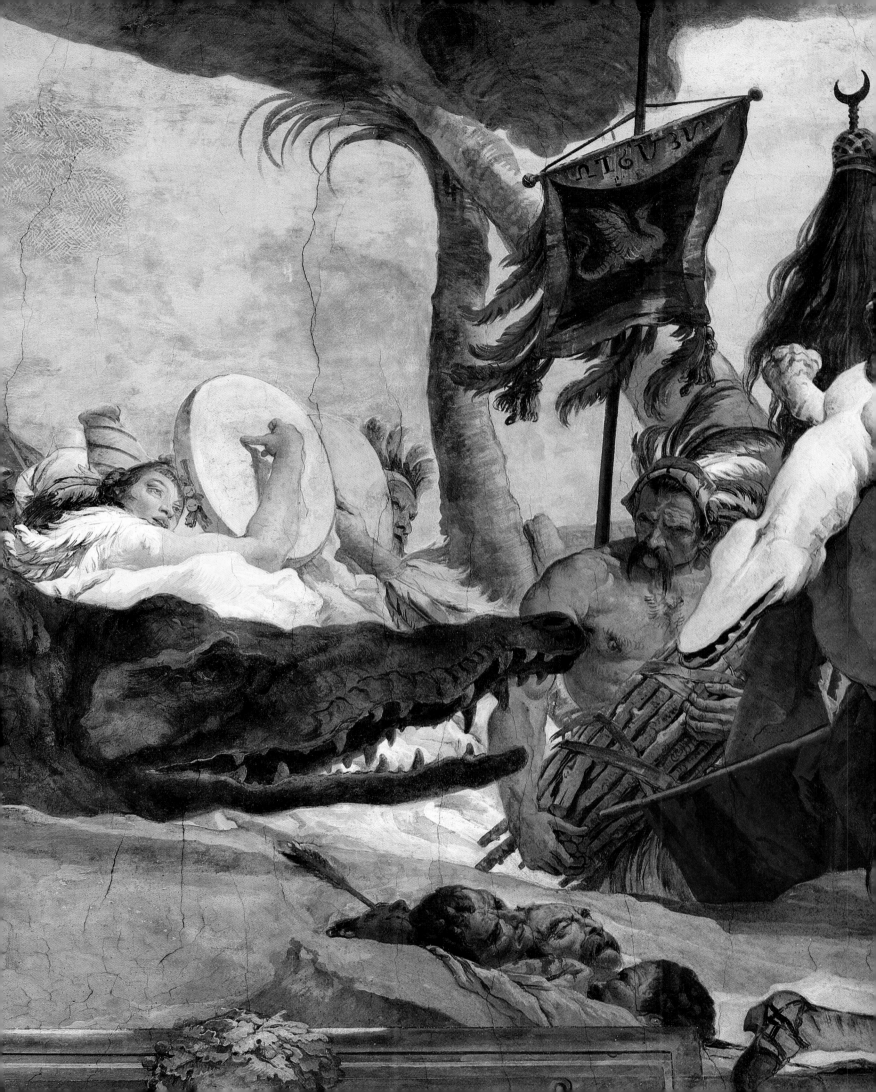

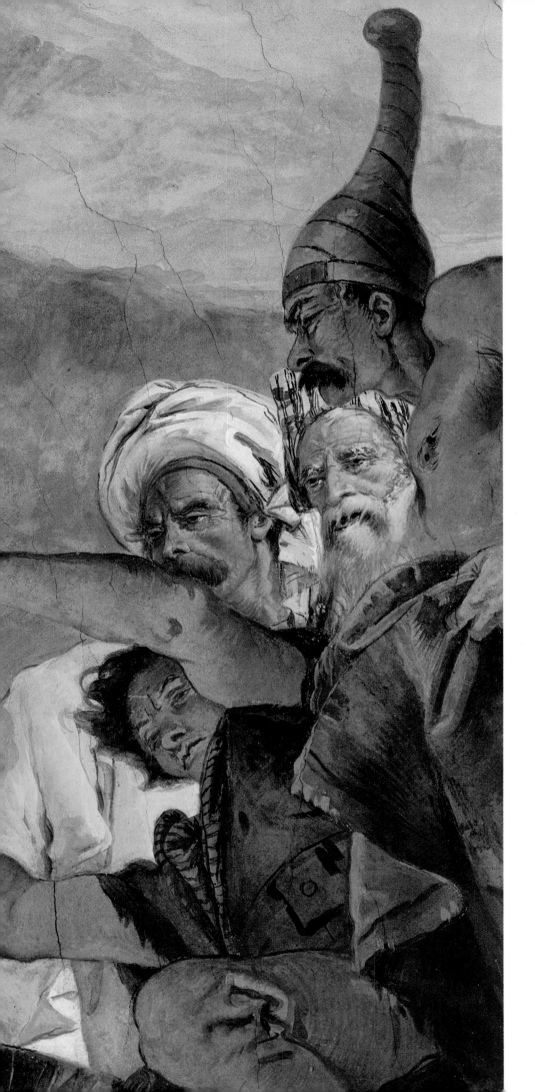

PLATE 3
Inhabitants of America;
detail of the staircase fresco
in the Würzburg Residenz

PLATE 4
Detail of the staircase fresco,
with personification of Africa

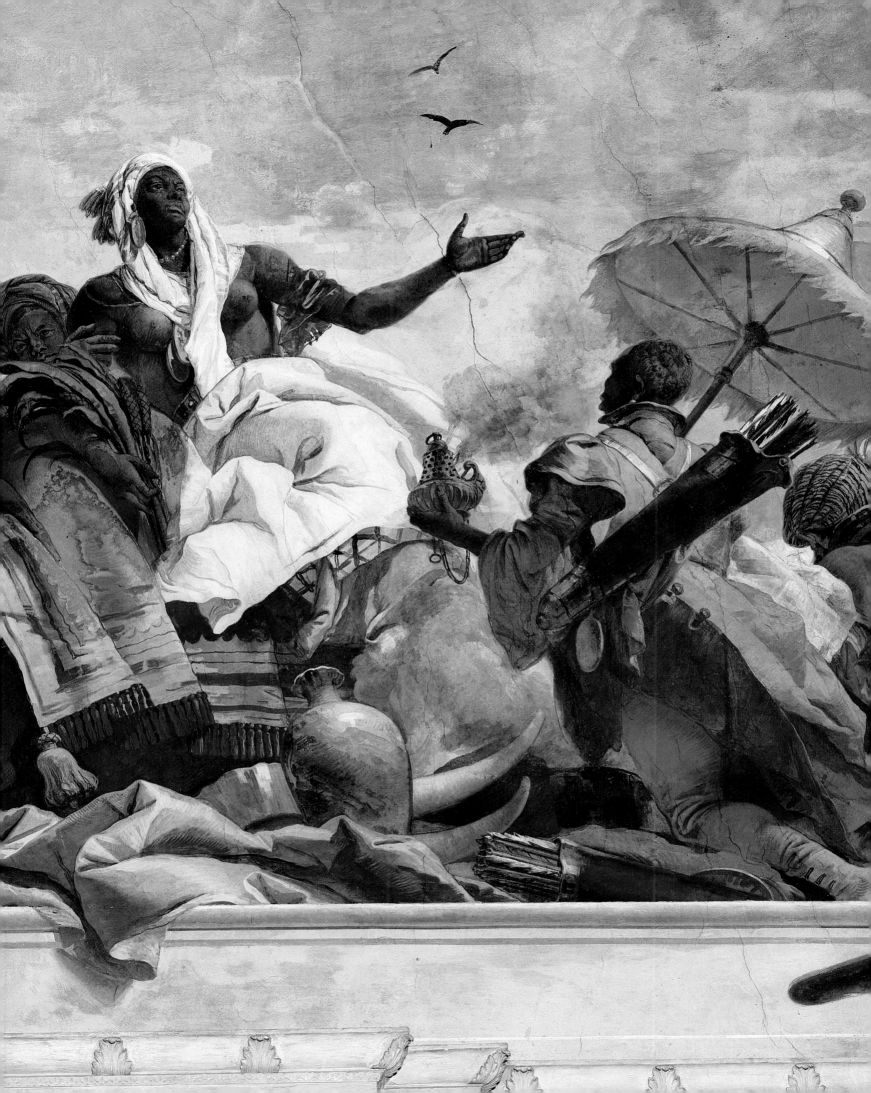

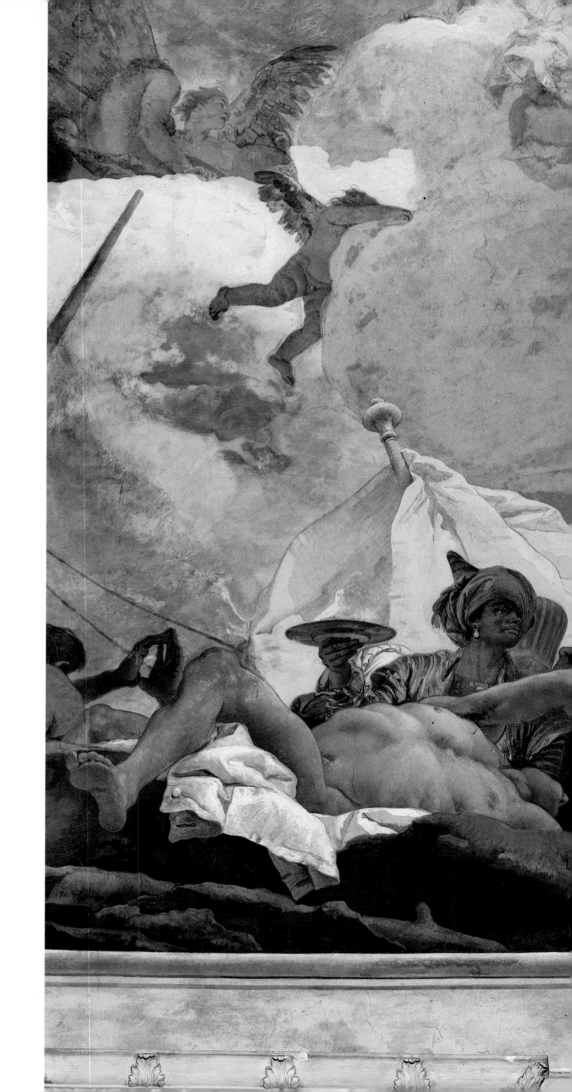

PLATE 5
Detail of the staircase fresco
in the Würzburg Residenz,
with personification of Asia

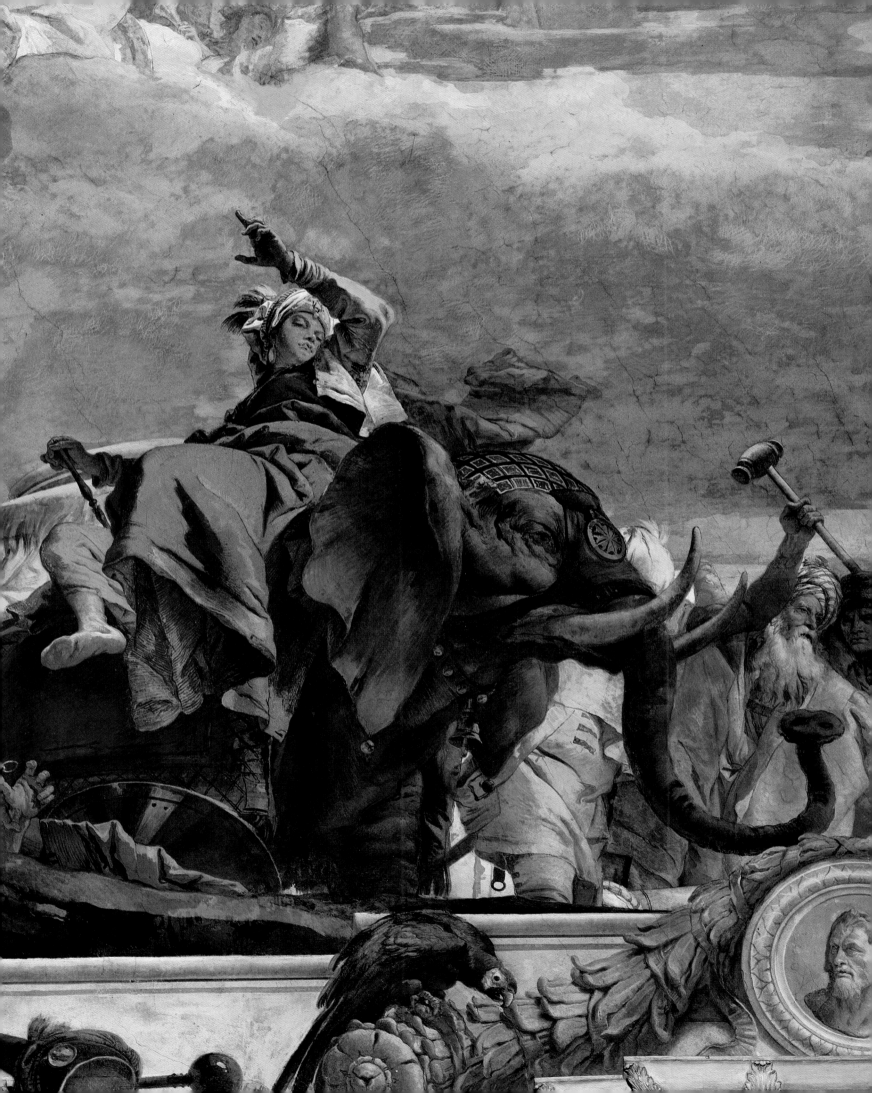

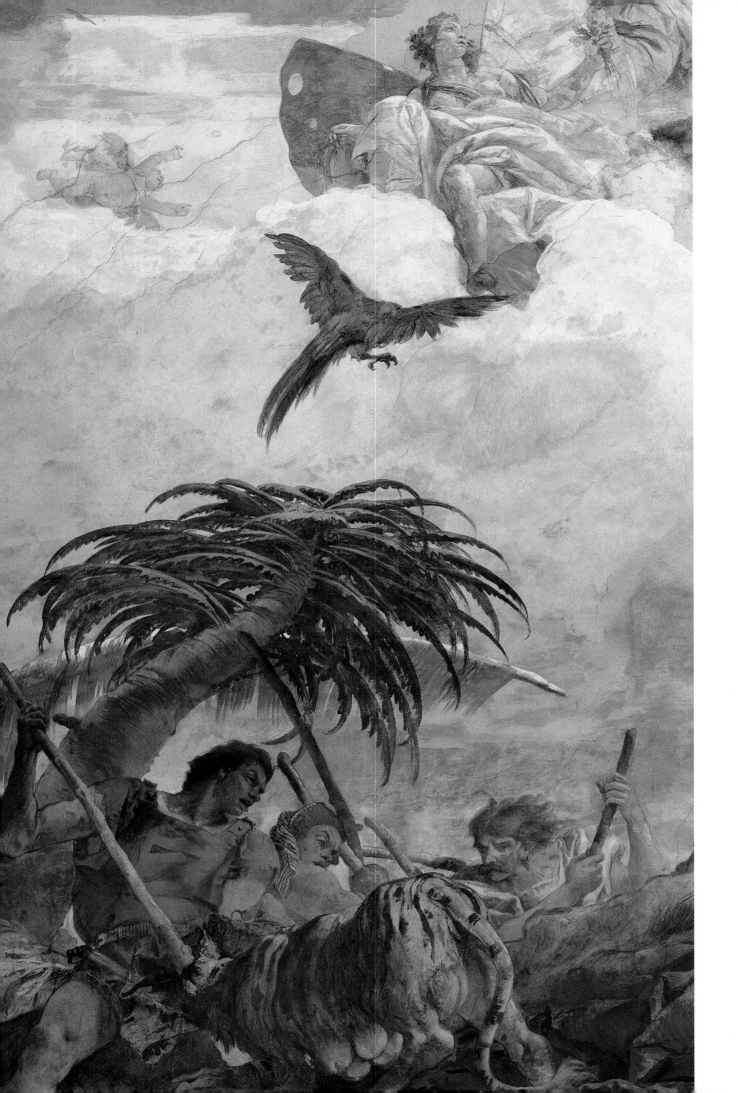

PLATE 6
Hunters
with tigress;
detail of *Asia*
from the
staircase fresco
in the Würzburg
Residenz

PLATE 7
Chronos;
detail of the
staircase fresco

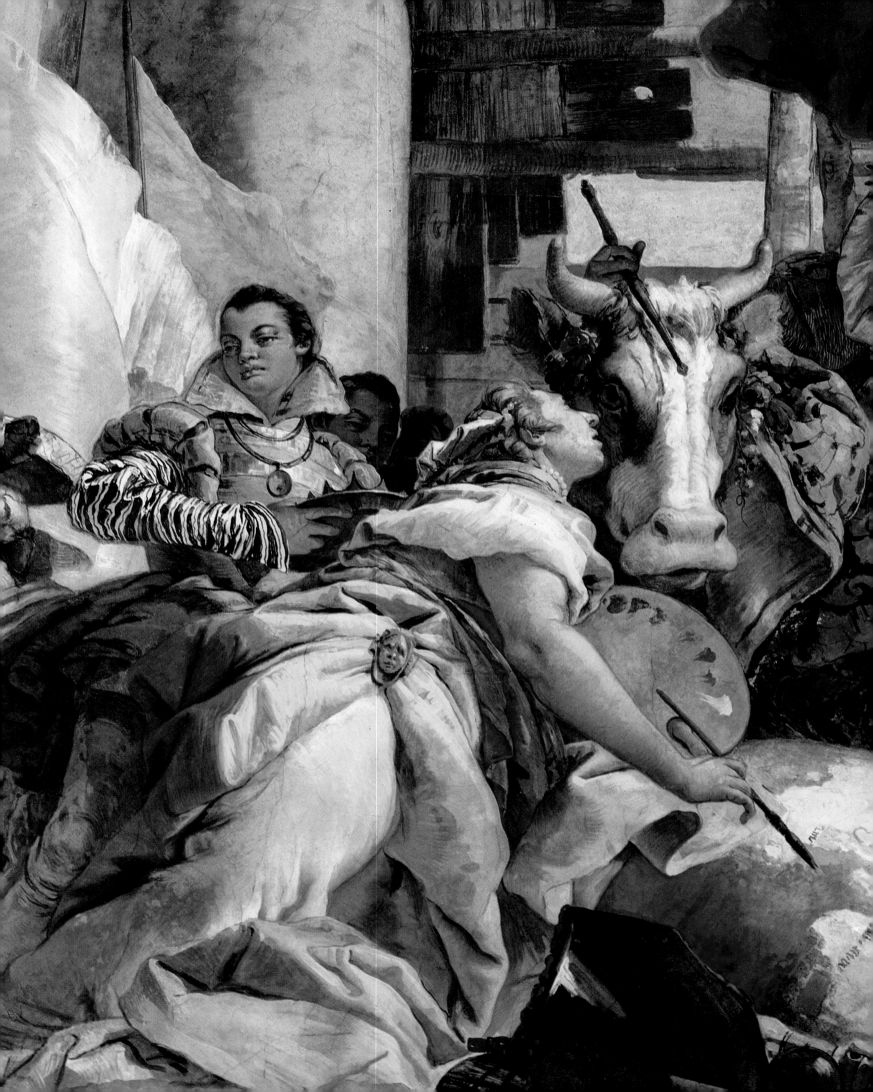

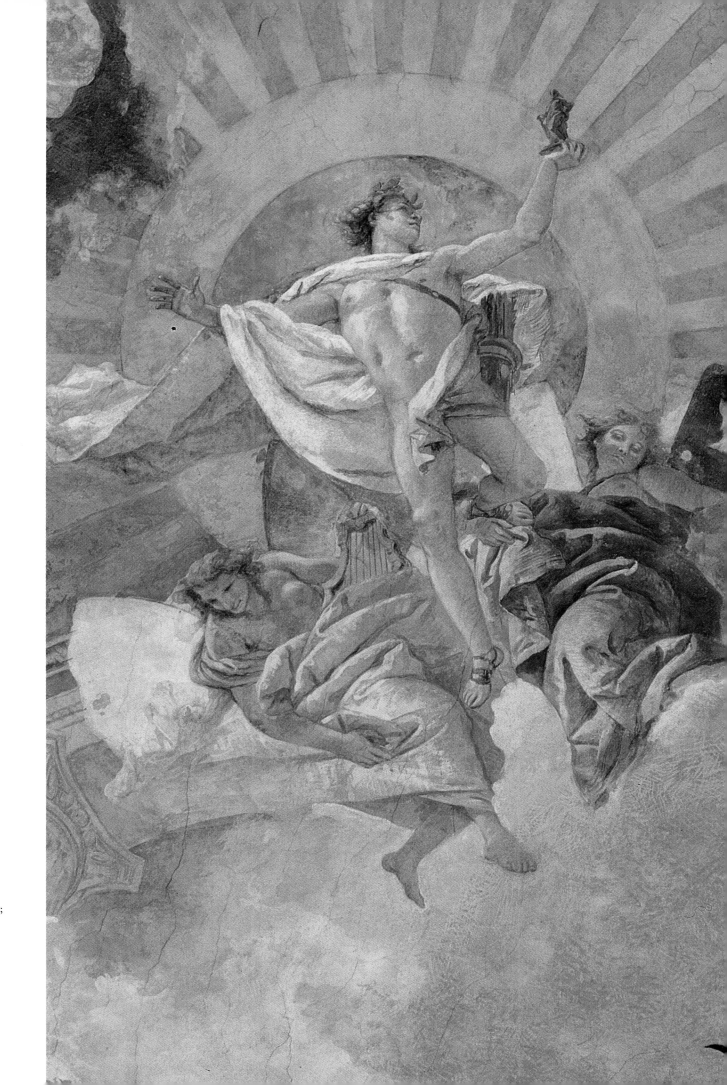

PLATE 8
Detail of *Europe*
from the
staircase fresco
in the
Würzburg Residenz,
with personification
of Painting

PLATE 9
Apollo;
detail of the
staircase fresco

overleaf
PLATE 10
Apollo with
Beatrice of Burgundy;
detail of the
ceiling fresco
in the Kaisersaal
of the Würzburg
Residenz

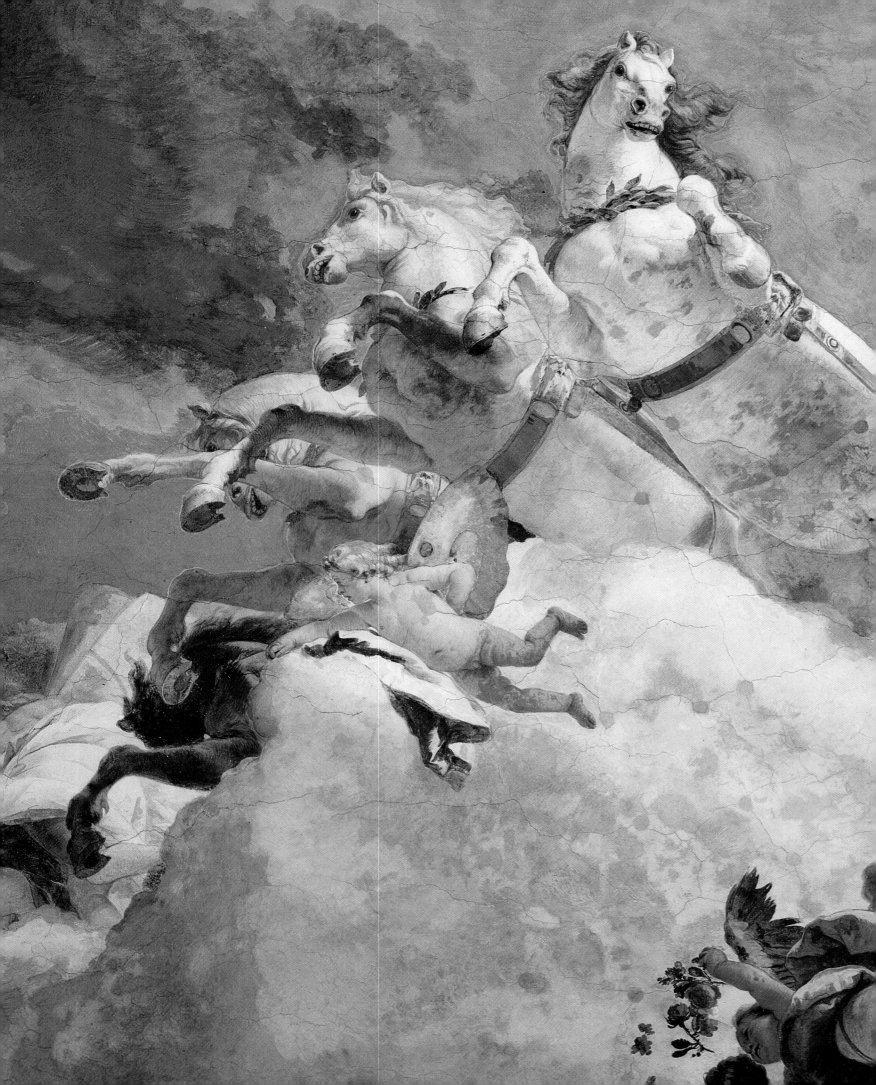

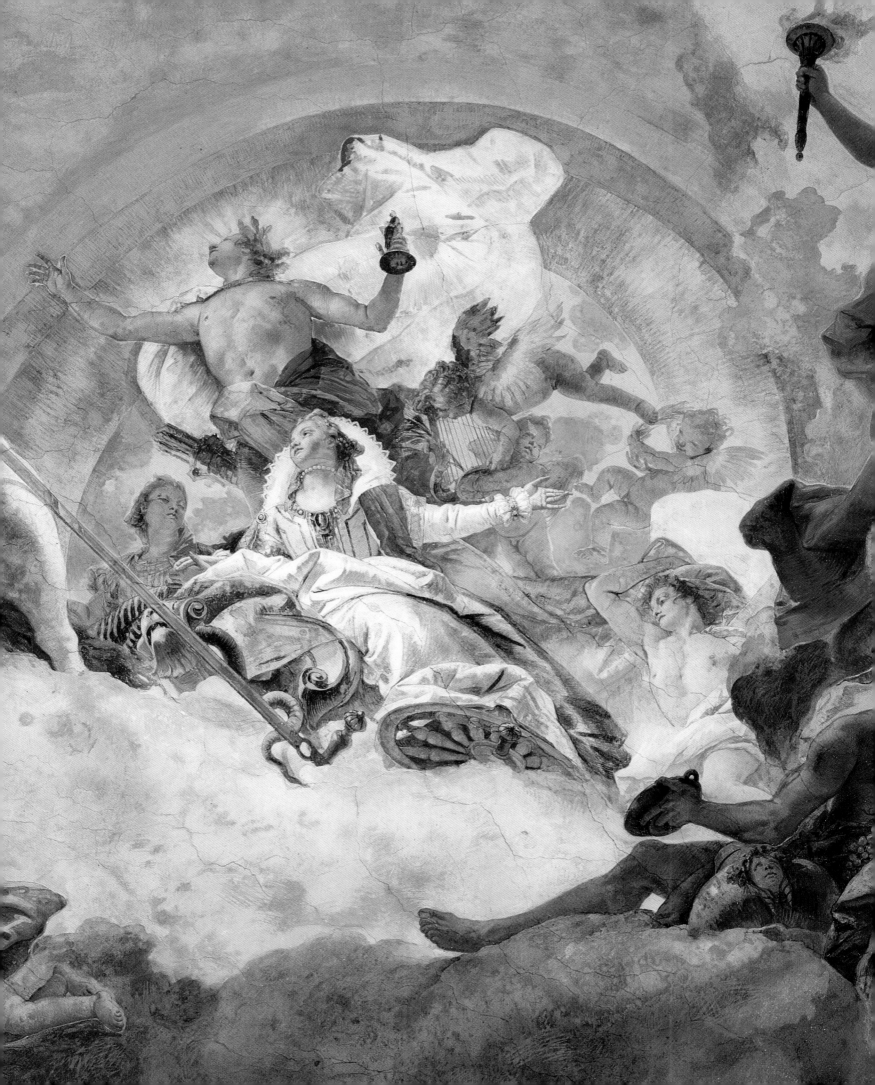

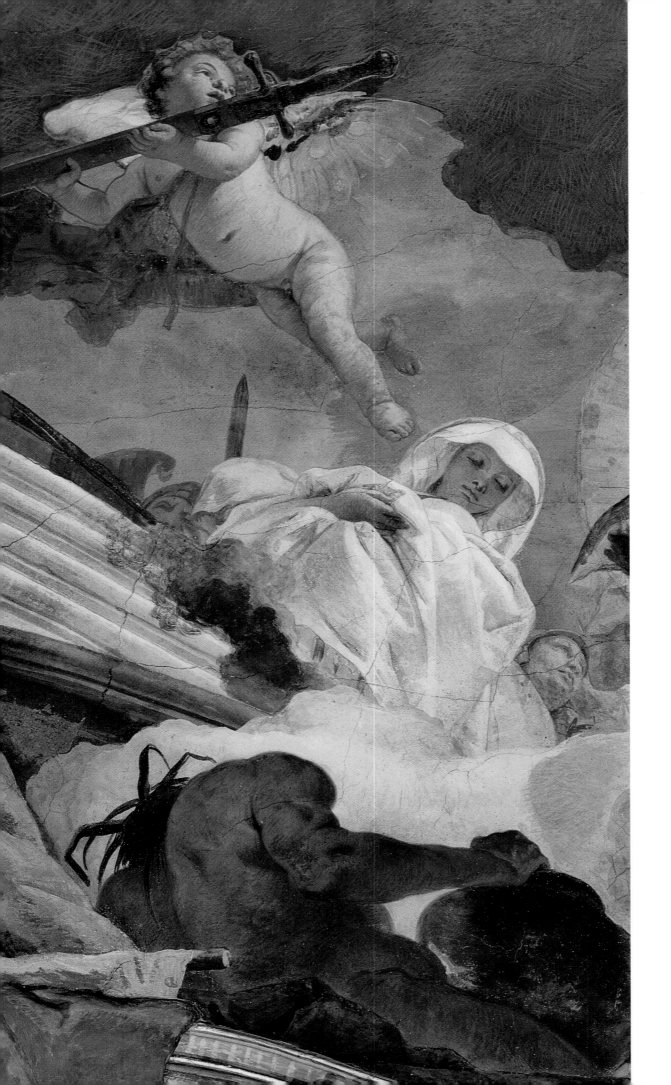

PLATE 11
Personification of Religion
and *putto* bearing
the sword of the Dukes
of Franconia;
detail of the
ceiling fresco
in the Kaisersaal
of the Würzburg Residenz

PLATE 12
Bacchus,
Venus and Cupid;
detail of the
ceiling fresco in
the Kaisersaal

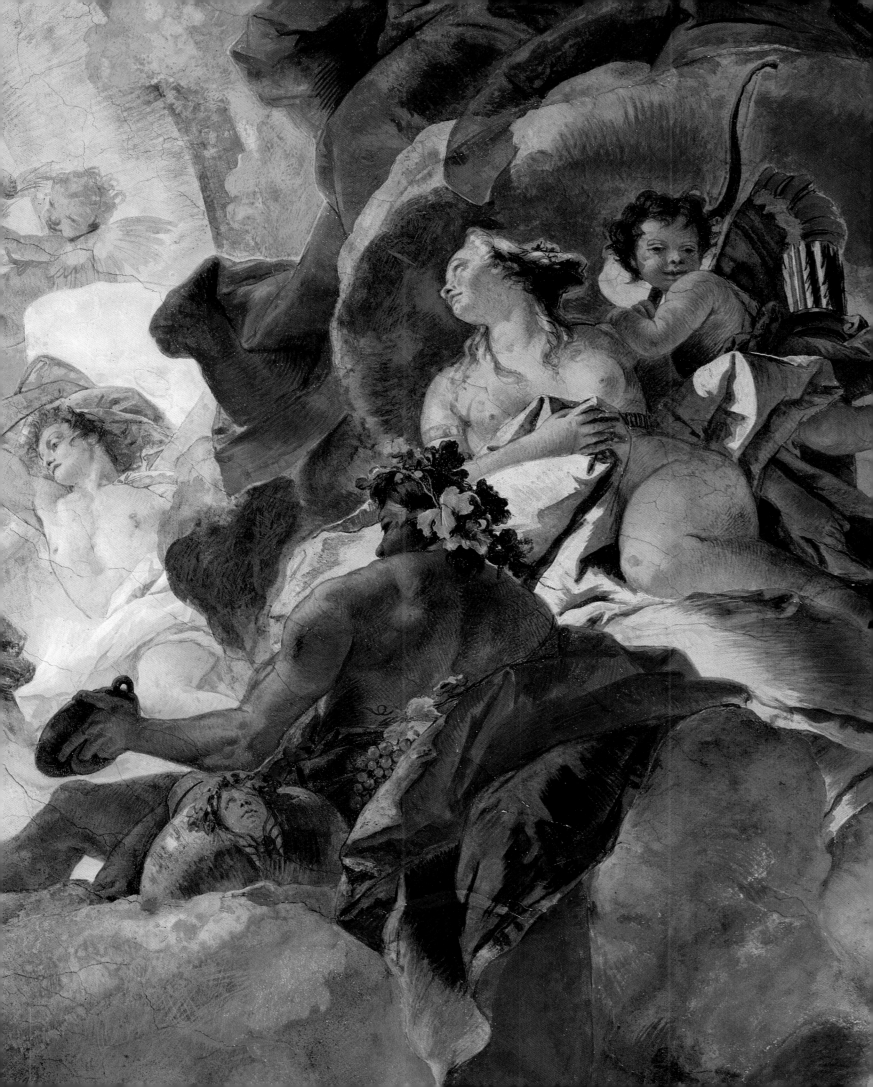

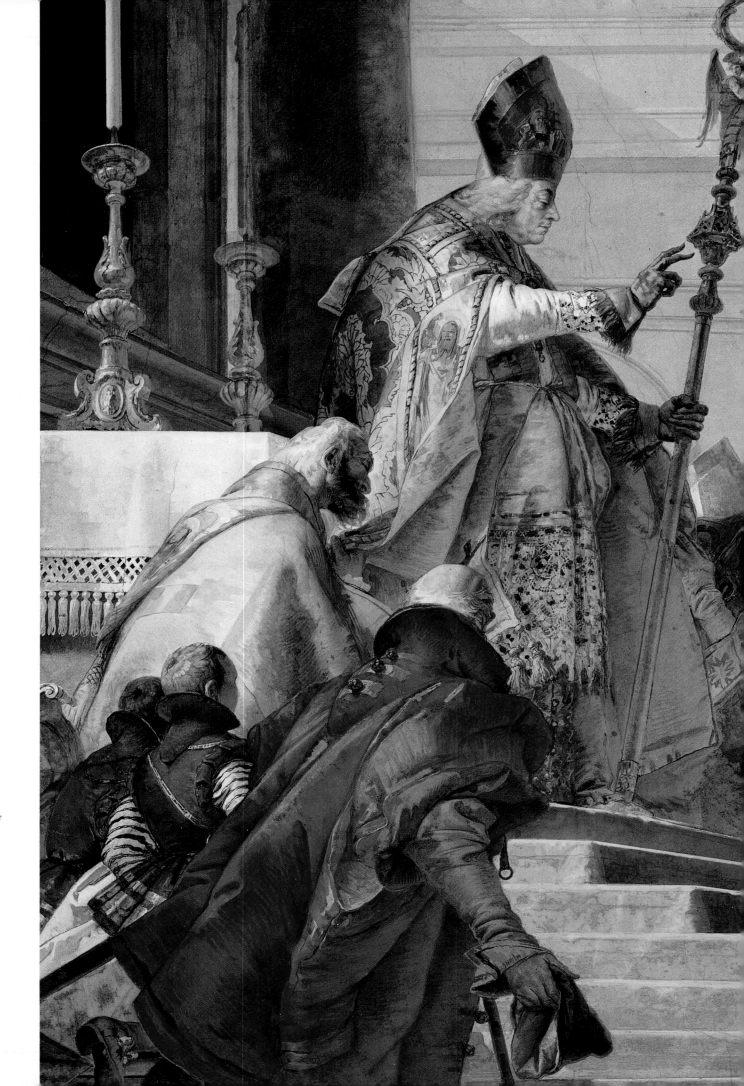

PLATE 13
Detail of
*The Marriage
of Frederick
Barbarossa
and Beatrice
of Burgundy*
on the
south wall
of the
Kaisersaal
in the
Würzburg
Residenz

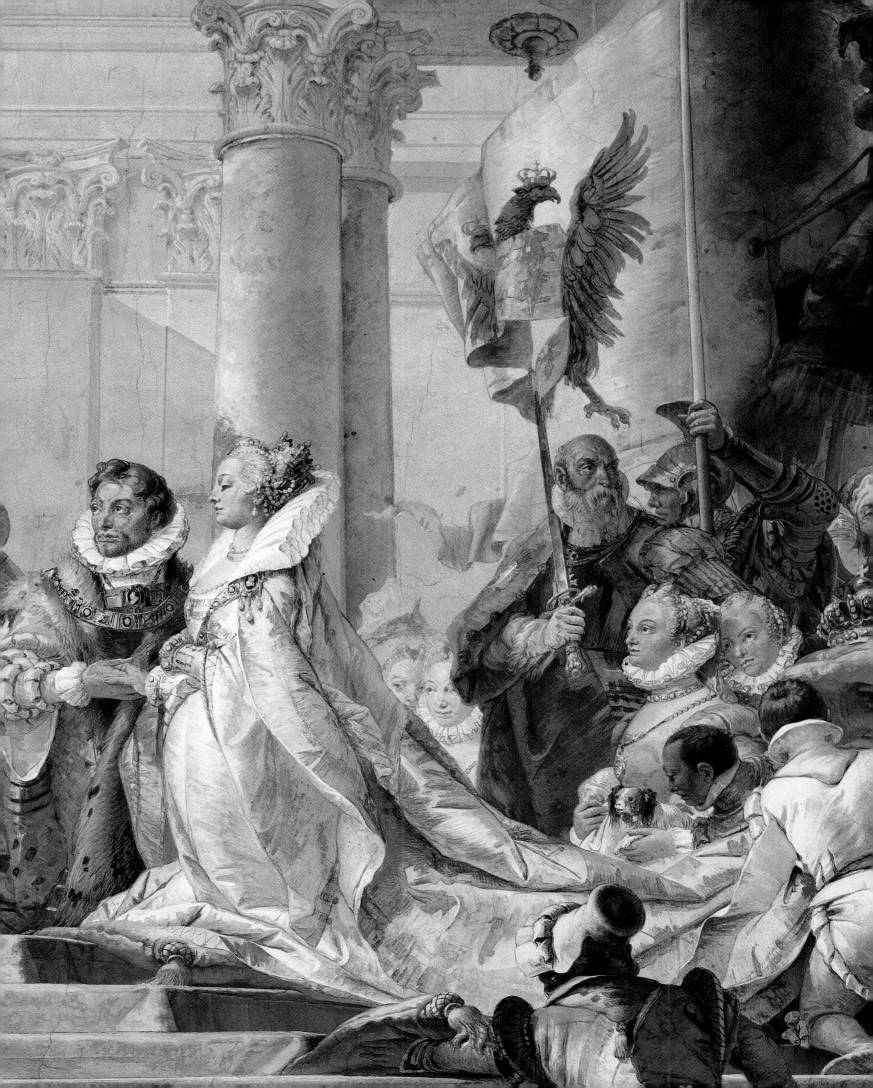

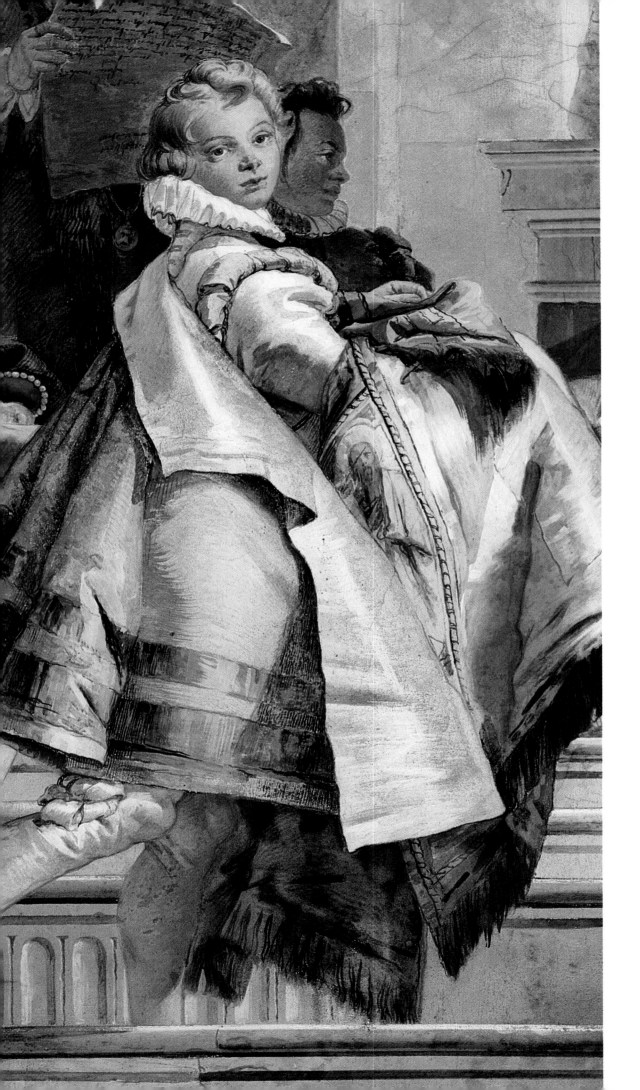

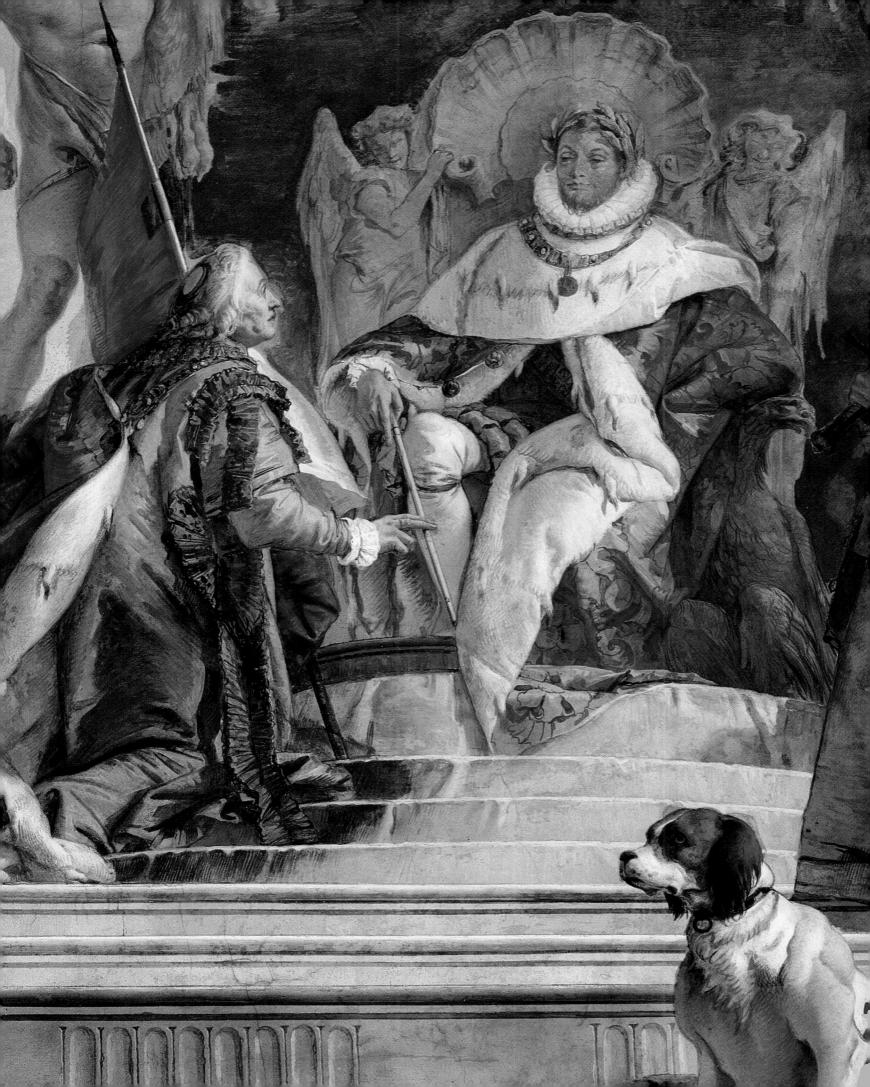

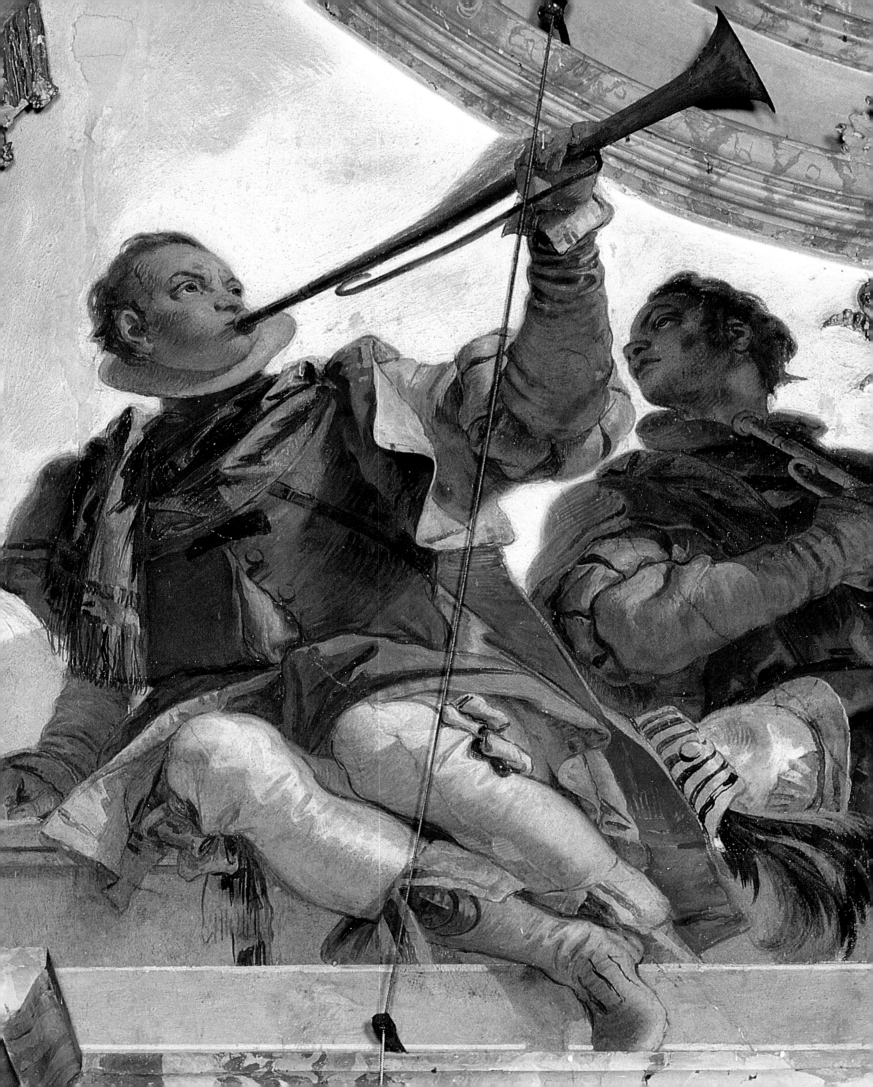

Introduction

The frescos of Giambattista Tiepolo in the Residenz at Würzburg are a truly epochal work of art. Their size and beauty are unrivalled, and the visitor seeing them for the first time cannot fail to be deeply impressed. Yet their significance cannot be fully appreciated without considering their position in the history of art.

Mural decorations, in the form of painted or incised pictures and patterns, have been with us since the beginning of the Stone Age. Our earliest ancestors realized that wall paintings have a particular capacity for visual impact, insofar as they redefine the wall in non-functional terms and invest the space bounded by it with a religious or mythical significance: thus the room (or in the case of Palaeolithic art, the cave) becomes a special area removed from the realm of everyday life.

This phenomenon has remained essentially unchanged through the ages, although the original cultic significance of mural art has long become dissipated into other forms. Up to and even beyond the triumph of a secular view of the world towards the end of the eighteenth century, the fresco decoration of such major buildings as churches and palaces was one of the central tasks of Western art.

The story of modern fresco painting begins in the first decade of the fourteenth century, when Giotto painted the interior of the Arena Chapel in Padua and initiated the transformation that formed the basis for the subsequent development of art, from the Renaissance until well after the eighteenth century. Giotto liberated art from the constraints of the flat surface by placing his boldly modelled, draped figures in a setting that embodies a sense of spatial depth and by using an animated vocabulary of gesture and facial expression. He thus established a whole new set of techniques for the depiction of concrete events and objects via a medium that in itself is two-dimensional.

Since Giotto's day, every era has brought forth one or two cycles of frescos that seem to encapsulate the entire range of possibilities open to the artists of the period. The list of these art-historical landmarks extends, initially, from Masaccio's pictures in the Brancacci Chapel in S. Maria del Carmine, Florence (1425–8), to those highlights of Roman painting in the sixteenth century – Michelan-gelo's Sistine Chapel (1508–12, 1535–41) and the Vatican rooms decorated by Raphael (1509–19) – that are often seen as epitomizing the spirit of Italian art. A century later, the sequence is resumed with Annibale Carraci's decoration of the Gallery in the Palazzo Farnese, also in Rome (1597–1604). The eighteenth century, too, is rich in frescos; however, the pre-eminent work of the period is to be found not in Italy but north of the Alps, in the palace of Prince-Bishop Carl Philipp von Greiffenclau at Würzburg. It was here, from 1750 to 1753, that Tiepolo created the frescos that constitute the keystone of his oeuvre.

The frescos in the grand staircase and the Kaisersaal are numbered among the great glories of eighteenth-century painting. Tiepolo drew on the entire repertoire of possibilities open to him and to his contemporaries, and in the process he brought the tradition of fresco painting initiated 450 years earlier by Giotto to a triumphal consummation from which there could be no further development. A new beginning – which was to be associated with the name Anton Raphael Mengs – became inevitable.

Tiepolo: The Man and the Artist

Who was this remarkable individual whose work was to be accorded such an elevated position in the history of art? There are very few surviving documents, such as letters, diaries or descriptions of personal encounters, that might provide a direct insight into Tiepolo's personality. The best way of exploring his life and opinions is to look at his paintings, especially at the products of his early years. Here, we already find clear evidence of the striving for innovation that characterizes his oeuvre as a whole. Right from the outset, Tiepolo continually sought to prove his own worth by challenging the ideas of his predecessors and looking for bold new pictorial solutions. To identify the strategies he adopted, it is instructive to compare one of his early paintings with a similar work by Giovanni Battista Piazzetta (1682–1754), his most important mentor and artistic model.

In 1722–3 Piazzetta painted *St James Led to Martyrdom* as part of a cycle of the twelve Apostles in the church of S. Stae in Venice (fig. 2). The picture owes its main impact to the use of light, which streams down from above and holds out such a glowing promise of heavenly glory that the martyr-to-be fails even to notice the executioner who is taking him captive. Thus the figure symbolizes the supreme power of faith to overcome all forms

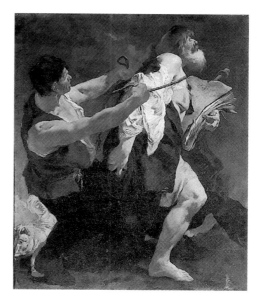

Fig. 2 Giovanni Battista Piazzetta,
St James Led to Martyrdom, 1722–3.
Oil on canvas, 165 x 138 cm.
Venice, S. Stae

facing page
Fig. 1 Two musicians; detail of the fresco beneath the window to the right of the Investiture fresco in the Kaisersaal of the Würzburg Residenz

of earthly suffering. The richly nuanced chiaroscuro modelling creates a sense of plasticity that makes the powerful body look like a real, tangible figure standing right in front of the viewer.

Tiepolo's early *Martyrdom of St Bartholomew* (fig. 3), commissioned as part of the same series, also makes heavy use of chiaroscuro. But at the age of 26, Tiepolo appears a great deal more adventurous than Piazzetta. The play of light and shade is far more dramatic, and the martyr's pose is deliberately exaggerated and distorted to convey a sense of ecstasy. Much use is made of contrast and opposition: thus, for example, the executioner's knife is about to be applied to the lightest and tenderest part of the saint's skin, and the three main figures all appear to be moving in conflicting directions. Everything in the picture – right down to the detail of the gestures and even the anatomy of the feet – is raised to the highest pitch of expressive force.

The purpose of such devices is to induce a state of emotional excitement in the viewer. Tiepolo was extremely successful in achieving this aim – more so than any of the other Venetian masters who contributed to the cycle of Apostles in S. Stae. He wanted the public to see the full extent of his virtuosity and acknowledge that his work was at least equal to that of Piazzetta. However, he realized that the attempt to surpass the latter also involved certain risks: extreme stylization might be visually exciting, but it was also likely to detract from the sense of naturalness that Piazzetta sought to convey. Tiepolo's approach here undoubtedly betrays the influence of Federico Bencovich (1677–1753), who had introduced

Fig. 3 *The Martyrdom of St Bartholomew*, 1722–3. Oil on canvas, 167 x 139 cm. Venice, S. Stae

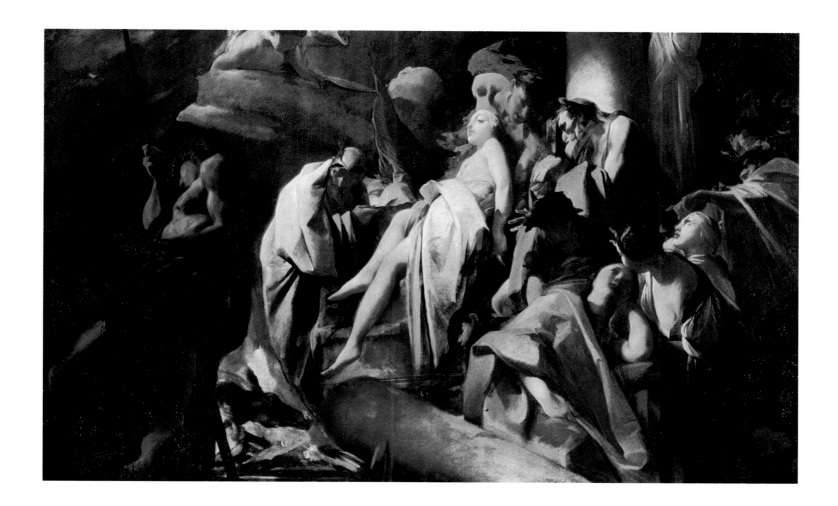

to Venetian art certain elements derived from Bolognese painting, notably from the highly contrived style of Guido Reni (see fig. 4).

A few years later, Tiepolo produced another characteristic picture, titled *Apelles Painting the Portrait of Campaspe* (fig. 5), which offers a number of further clues to his temperament and outlook. The reference to Apelles, the most renowned painter of classical antiquity, is intended as a gesture of self-homage. According to the story on which the picture is based, Alexander the Great commissioned Apelles to paint a portrait of his mistress but then allowed him to keep her for himself on realizing that the artist had fallen in love with the model. The anecdote is traditionally cited as proof that painting is looked on with particular favour by the powerful.

Instead of following the approach of other artists and investing the image with weighty significance, Tiepolo gives it an ironic, humorous interpretation. The self-allegorizing intention normally associated with the motif is offset by the fact that the main focus of interest lies, not on the painter Apelles, but on the physical charms of Campaspe, whose

features are those of Tiepolo's wife, Cecilia Guardi. Apelles/Tiepolo is clearly bewitched by her beauty, and his attention is entirely taken up with the attempt to model her bared bosom. Her face is that of a plain country girl rather than a noble lady, but this does not prevent Alexander from admiring the portrait with the gaze of an infatuated lover. Meanwhile, the members of his personal guard – the captain as well as the ordinary soldiers – have seized the opportunity to feast their eyes on the body of the real Campaspe. In the form of a sculpture, Hercules, the virtuous hero who nobly resists the temptations of the flesh, muses on their lustful eagerness with suitable detachment. In the background, two large-format history paintings stand propped against the rear wall of the studio. Whereas the picture on the left features the biblical image of Moses with the brazen serpent, the motif of its right-hand partner seems to be taken from classical mythology. The scene from the Old Testament vaguely recalls the depiction of St Bartholomew. Compared with the lustful vitality of the events taking place in the foreground, these two secondary pictures

Fig. 4 Federico Bencovich, *The Sacrifice of Iphigenia*, before 1719. Oil on canvas, 182 x 287.5 cm. Pommersfelden, Collection of Count Schönborn-Wiesentheid, Schloss Weissenstein

appear less than vivid, even stiff. The work as a whole, a minor masterpiece, can be seen as a form of ironic commentary on Tiepolo's conception of art.

Classical mythology, the ancient world of gods and heroes, has evidently lost at least a part of its former authority. It has become little more than a source of literary narratives, albeit of a kind ideally suited to the requirements of painting. In this respect, Tiepolo's thinking shows an important shift of emphasis that typifies the intellectual outlook of the eighteenth century, the age of Enlightenment. At this crucial turning-point, painters suddenly found themselves confronted with a whole new range of hitherto unsuspected possibilities. Where time-hallowed thematic conventions cease to be binding, a space is cleared in which new ideas can take root and

flourish. The traditional view of the artist's subject-matter, as a repertory of 'objective', ontologically founded meanings that were independent of the individual, gradually gave way to a quite different conception whose proponents emphasized the value of personal, subjective experience. As Tiepolo's painting indicates, this new attitude to the world is secular and firmly empirical. This does not mean that the artist has to hold the traditional stories up to ridicule or to abandon them altogether. Instead, the break with tradition, already anticipated in the seventeenth century with the rise of the genre known as the *capriccio*, allows him to take a fresh look at the stories, seeing and reworking them from the viewpoint of his own imagination rather than applying the perspective of a scholar. This, in turn, gave him greater freedom to display his

Fig. 5 *Apelles Painting the Portrait of Campaspe,* *c.* 1725 – 6. Oil on canvas, 57.4 x 73.7 cm. Montreal, Museum of Fine Arts, Adaline Van Horne Bequest

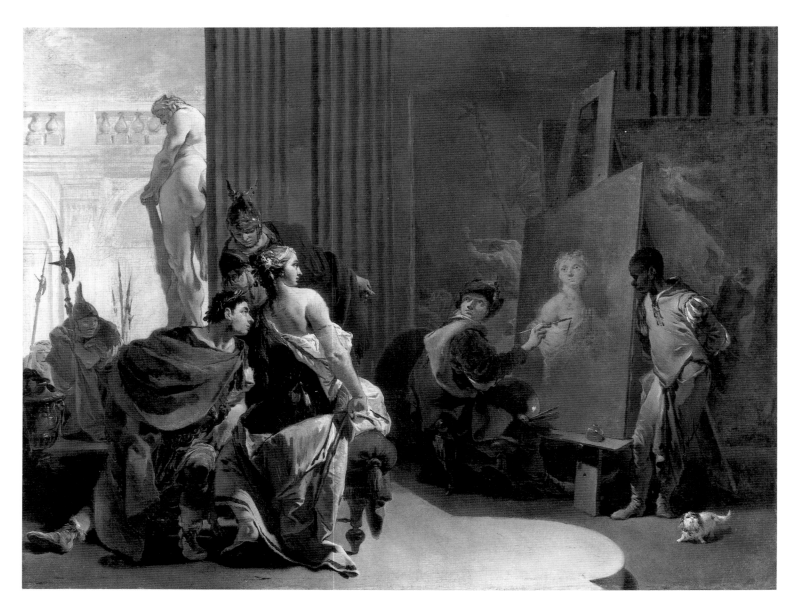

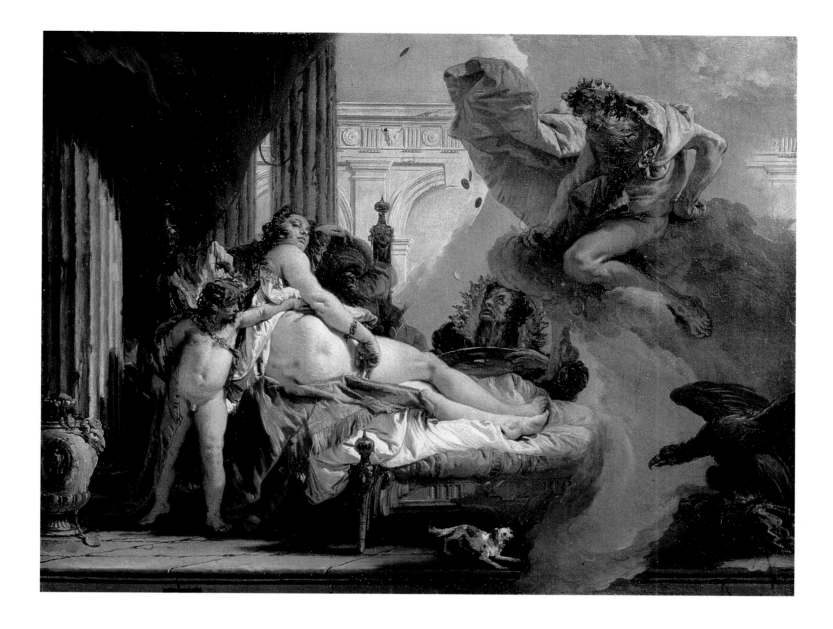

technical virtuosity, as well as interpreting mythological or biblical themes in his own individual terms. Defying convention, Tiepolo frames the world in two ways: first, through irony, and second, by emphasizing human emotion. His gods are very much flesh-and-blood creatures.

Tiepolo exploited these new possibilities to the hilt, and his striving for virtuosity is apparent in every picture he painted. This characteristic distinguishes him from Piazzetta and allies him, instead, with Giacomo Casanova, whose life can only be understood as a continual attempt to display virtuosity in every sphere, be it the erotic, the intellectual or the social. For this kind of eighteenth-century figure, content is a secondary consideration; the main thing is the quality of

performance, intelligence and wit being displayed for one's own enjoyment as much as for that of the viewer or reader.

Thus when Tiepolo compares himself with Apelles, he is proudly claiming to have found a valid artistic idiom for his own age, just as Apelles supplied the model for classical antiquity – a truly bold gesture, given that Tiepolo was only about thirty years old at the time of making the picture.

Ten years later, in 1736, the Swedish ambassador Count Carl Gustav Tessin came to Venice with the aim of recruiting a painter to decorate the Royal Palace in Stockholm. His favoured candidate for the task was Tiepolo. However, the negotiations failed, because the painter demanded a far higher fee than the King of Sweden was prepared to pay.

Fig. 6 *Jupiter Appearing to Danaë*, 1736. Oil on canvas, 41 x 53 cm. Stockholm, Universitet Konsthistoriska Institutionen

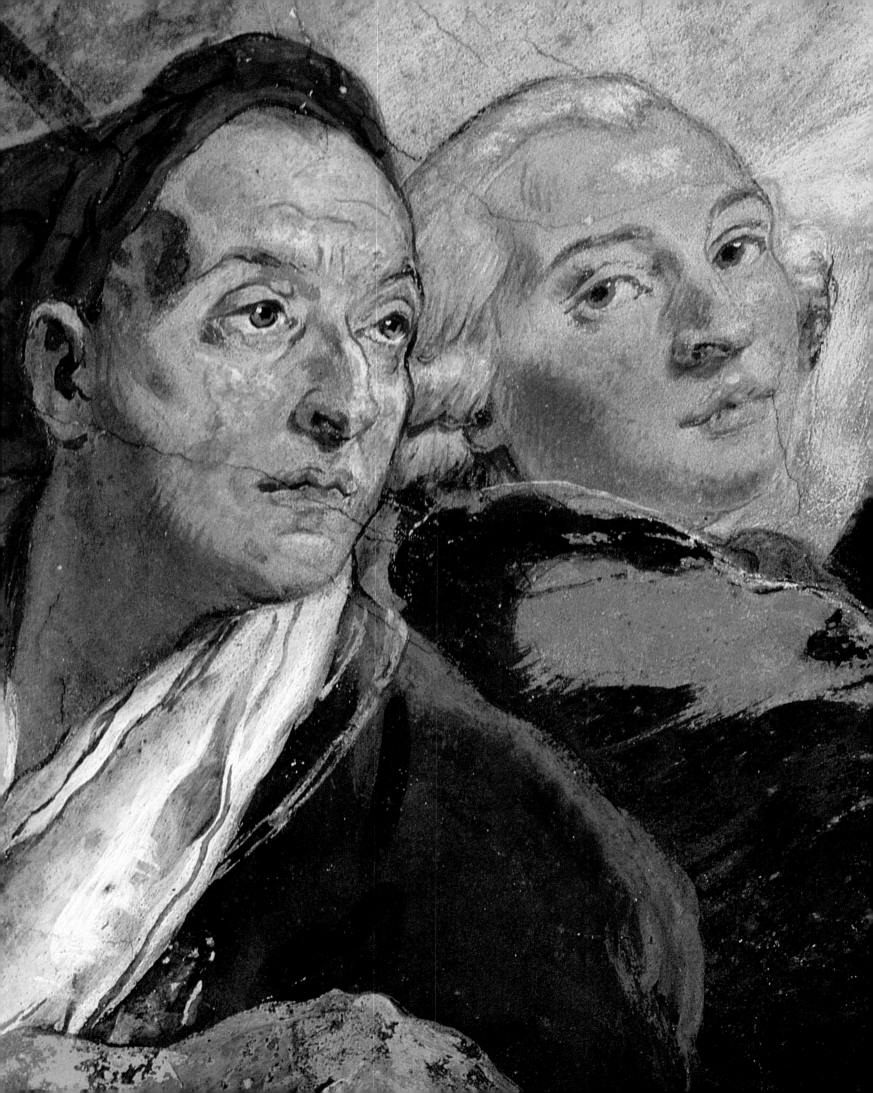

Tiepolo was already a prominent figure, known throughout Europe, who could well afford to turn down even such a prestigious commission.

Tessin did buy two smaller paintings for himself. One of these works, *Jupiter Appearing to Danaë* (fig. 6), was evidently made specially for the Swedish ambassador, who may even have been present while Tiepolo was working on it. Tessin, who was enough of a connoisseur to appreciate the exceptional quality of Tiepolo's technique, enumerated the picture's various merits in a letter and mentioned that it had been painted at great speed.

The painting is indeed one of Tiepolo's most perfectly executed works. For example, the technical quality of the paint surface is so good that the picture shows virtually none of the signs of ageing, such as *craquelure*, that many painters seem to build into their work almost as a form of planned obsolescence. A rare brilliance and verve are to be seen in the handling of the paint, the suggestively sensual modelling of the body of Danaë and the subtle treatment of the drapery. The witty interpretation of the subject-matter conforms to the same high standard.

A humorous intention is apparent in all the motifs, including the vignette in the lower right-hand section showing the lapdog, which should really be a fierce watchdog, performing his duty as Danaë's guardian by barking furiously at Jupiter's eagle, which clutches a bundle of thunderbolts in its talons. Meanwhile, Danaë herself, the King's daughter, has become a languid courtesan, whose lack of interest in Jupiter is all too understandable, because the Olympian tyrant has turned into a sordid and near-decrepit old rake. The shower of gold in which he descends to take possession of Danaë is also less impressive than it might be: as befits the humorous reinterpretation of Danaë, the shower has become a sparse trickle of gold coins. Jupiter therefore has to enlist the help of Cupid to lift up Danaë's shift and manoeuvre her into the required position.

As in the painting of Apelles and Campaspe, Tiepolo sees the world of classical mythology from the human viewpoint of an inveterate ironist. And here, too, he includes a self-portrait, this time in the guise of Danaë, who is clearly unimpressed by the meagre offerings of Jupiter, just as Tiepolo had found the proposals of the King of Sweden unacceptable. Perhaps the recasting of Danaë as a courtesan can be seen as an allusion to the readiness of some painters to prostitute their talents. At all events, it would be hard to think of a more spirited riposte to the unsuccessful advances of the Swedish negotiator.

What did Tiepolo himself look like? His best-known self-portrait is the painting made at the age of 54 for the staircase fresco in the Residenz at Würzburg, showing himself as an artist with a simple cap and scarf (fig. 7). The attentive gaze and the striking cast of the features speak for themselves. Perhaps the most impressive aspect of the portrait, apart from its clarity and air of determination, is the sense of confident serenity in the expression. This is the face of a man who knows that he is on the verge of completing one of the most significant works in the entire history of painting.

In the etching made by his son Giandomenico after a painting from the 1760s, Tiepolo looks quite different (fig. 8). As in the Würzburg fresco, the eyes, fixed on the viewer, are the central feature, and the attentiveness of the gaze is accentuated by the thick eyebrows. But instead of appearing in the pose of an artist, Tiepolo is portrayed as an elegantly turned-out courtier with a powdered wig. Whereas the fresco portrait shows him as the creator of a hugely significant artistic oeuvre, the engraving seeks to emphasize his social status.

facing page
Fig. 7 Self-portrait by Giambattista Tiepolo (left) with his son Giandomenico; detail from the depiction of Europe in the staircase fresco of the Residenz, Würzburg

this page
Fig. 8 Giandomenico Tiepolo, *Portrait of Giambattista Tiepolo,* c. 1775. Etching, 11.9 x 9.4 cm

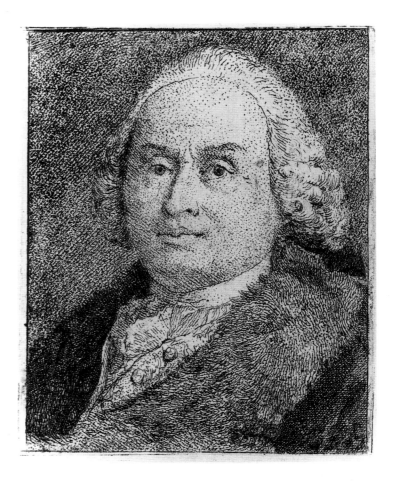

The Patron and the Commission

Looking at the history of the Würzburg Residenz, it seems something of a miracle that this remarkable building was ever completed, and that the structure has survived, despite damage incurred in the Second World War (fig. 9), to the present day. By a series of fortunate coincidences, all those involved in its construction – the patrons, the architect and the painter – were in the right place at the right time and were willing to do everything in their power to ensure the success of the undertaking.

The Residenz was built over a period of almost thirty years, which saw the election of no less than five Prince-Bishops. Only three of these made any positive contribution to the project. Two of the enthusiasts were members of the Schönborn dynasty, while the third was a nephew of the same family. Both the Schönborn bishops were succeeded by regents who, partly for reasons of economy and partly out of sheer indifference, took few steps to complete the building. But the regencies were brief, and the inactivity of the two temporary incumbents delayed the work for only a short time, with the effect that the task of decorating the main rooms fell due after the election of Carl Philipp von Greiffenclau, the last of the five Prince-Bishops involved in the palace's construction.

Greiffenclau's accession to the episcopal throne on 14 April 1749 met with an exceptionally enthusiastic reception from the people of Würzburg. A contemporary chronicler wrote: 'Never before has such a public display of rejoicing been seen and heard in Würzburg. The jubilant cries and shouts of "Long may he reign!" did not only persist for this one day but could be heard for several weeks afterwards.' After the oppressive regency of the ailing and eccentric Anselm Franz von Ingelheim (1746–9), who had spent much of his time dabbling in alchemy, the new Prince-Bishop's subjects hoped for a return to the golden days of his uncle, Johann Philipp von Greiffenclau (1699–1717), and the two popular Schönborn rulers, Johann Philipp Franz (1719–24) and Friedrich Carl (1729–46).

Carl Philipp von Greiffenclau was born on 1 December 1690 at his family's ancestral home, Schloss Vollrads in the Rheingau region. Singled out for the Church in early childhood, he received the tonsure at the age of eleven and entered the Würzburg cathedral seminary only four years later. He became a member of the cathedral chapter in 1728. Carl Philipp was a man of cosmopolitan outlook and manner. He spoke five languages and had enlarged his cultural horizons by undertaking the Grand Tour, which in his case included a stay of several years in Italy, mainly in Rome. Apart from his other interests, he had a particular love of learning: throughout his life he continued to study law, the subject in which he took a doctorate in 1710, and to occupy himself with the classics and other branches of the humanities. His knowledge in these latter areas had a considerable impact on the iconographic ideas that guided Tiepolo in designing the Würzburg frescos. In 1738 he was appointed Rector of the University of Mainz, and by virtue of his election as Prince-Bishop he inherited the same office at the University of Würzburg.

After his election Greiffenclau placed the task of decorating the Residenz at the top of his list of priorities. The palace was completed but still undecorated, because the vari-

Fig. 9
The Würzburg
Residenz, 1947

Fig. 10 Portrait medallion of Carl Philipp von Greiffenclau, with personifications of Fame and Virtue; detail of *Europe* from the staircase fresco in the Würzburg Residenz

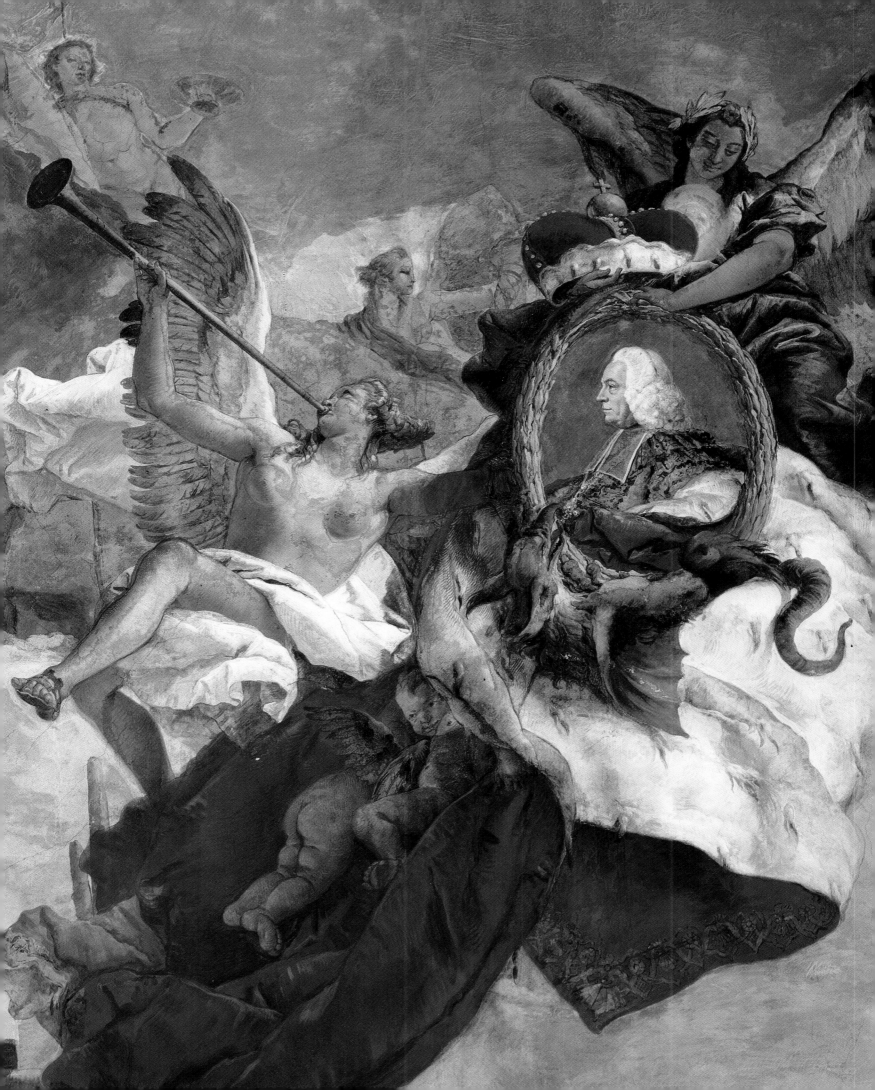

ous painters who had been considered had either failed to meet the patron's expectations or had died before work could begin. As well as being fond of pomp and splendour, the Prince-Bishop had a trained eye for artistic quality, and he was fully prepared to pay the price his tastes demanded. Tiepolo, for his part, had time to spare and was evidently very interested in the commission. His readiness to accept it was no doubt bolstered by the prospect of being permanently associated with the work of Balthasar Neumann, arguably the most important architect of his day. Moreover, the 54-year-old painter was at the very peak of his powers. All these factors – the grandiose ambitions of the patron, and the exceptional genius of the architect and of the painter – came together in a perfect conjunction that caused the names Greiffenclau, Neumann and Tiepolo to go down in history as the creators of one of the great architectural and artistic glories of the eighteenth century.

The Prelude to the Award of the Commission

Ascending the grand staircase of the Residenz and entering the Kaisersaal, the visitor of today sees this sequence of rooms as a coherent whole, a uniquely successful ensemble, as if all those involved had sat down around a table to design the building and its remarkable interior in a process of close consultation and co-operation. But history shows that this was not the case. Neumann's intention was to create an *architettura assoluta*, which did not necessarily include any form of mural painting. One of his later design sketches, dating from about 1742, still envisaged a stucco decoration on the lines of the Weisser Saal (fig. 11). However, the Prince-Bishop was keen to have the staircase painted, as well as the Kaisersaal. The problem was to find a suitable artist.

Three names suggested themselves: Anton Clemens Lünenschloss, Nikolaus Stuber and Federico Bencovich, who were employed by the Prince-Bishop as court painters or were working for other patrons in the Würzburg area. But the idea of entrusting such an exacting task to any of these artists seems to have been ruled out immediately. In 1737 the ruling Prince-Bishop, Friedrich Carl von Schönborn, commissioned Johann Rudolf Bys to design a mural for the staircase and the Kaisersaal, but the painter's proposals evidently failed to pass muster. The first artist to receive serious consideration, towards the end of the 1730s, was Johann Evangelist Holzer, who had recently begun to decorate the monastery church at Schwarzach (now Münsterschwarzach), not far from Würzburg. Born in Tyrol in 1709, Holzer was still relatively young, but his talents were considered so outstanding that he was asked in 1739 to make an

Fig. 11 Balthasar Neumann, Design for the *corps de logis* of the Würzburg Residenz, *c.* 1742. Staatliche Museen zu Berlin – Preussischer Kulturbesitz, Kunstbibliothek

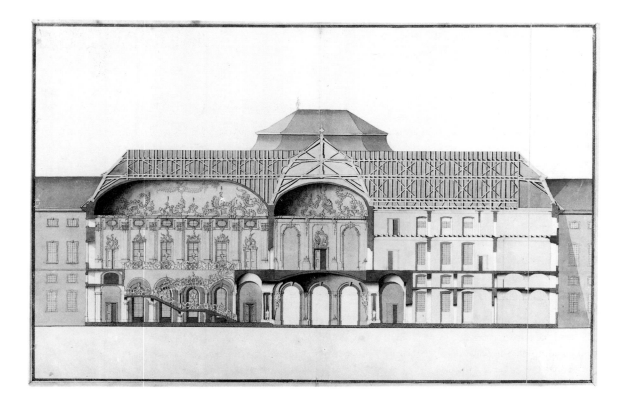

oil sketch for the Gallery. Since the building was still under construction, he was unable to begin work immediately, so to bridge the interval he went to Münster with the intention of decorating Schloss Clemenswerth, the seat of Clemens August, the Elector of Cologne and a member of the Wittelsbach dynasty which ruled Bavaria. Unfortunately, however, Holzer died shortly after arriving in the town. A surviving oil sketch shows that his plans for an illusionistic painted architecture, strongly reminiscent of Andrea Pozzo, were indeed extremely interesting; had they been put into effect, they would have made the Gallery one of the most spectacular rooms of its time in southern Germany (fig. 12). Holzer had set a standard of artistic quality that no other German artist could match. Moreover, the War of the Austrian Succession was still in progress in 1742, at the point when the vault was completed and the work of frescoing or stuccoing it could have begun.

After the death of Friedrich Carl von Schönborn in 1746 three years elapsed until Carl Philipp von Greiffenclau took over the reins of power and set about completing the Residenz. One of the main tasks immediately facing him was that of finding a painter to fresco the staircase and the Kaisersaal. A few months later, Neumann suggested a new candidate: Johann Zick. But Zick's test piece, the decoration of the Gartensaal, failed to secure the Prince-Bishop's approval (fig. 13). In view of the heaviness and clumsiness of the figures and the academic narrowness of the overall artistic approach, one is inclined to agree with Greiffenclau's judgement.

At this point an unknown artist called Giuseppe Visconti presented himself at the court. He produced a glowing testimonial, which was probably forged, and an impressive preliminary sketch, painted in oils, which was probably the work of another artist. Greiffenclau fell for the bait and decided to award him the commission. His fee was to be 4,000 florins, including an immediate down-payment of 1,000 florins to cover his initial expenses. When he started work, he tried to conceal the first fresco from view, but the court's suspicions were soon aroused, and the painter was forced to reveal the full extent of his incompetence. Unmasked as an impostor, he was dismissed and expelled from the court.

This unfortunate episode throws an interesting light on the Prince-Bishop. His lack of caution in employing Visconti was entirely the result of impatience: he simply could not wait to complete the palace and surround himself with the pomp and splendour befitting his newly acquired status.

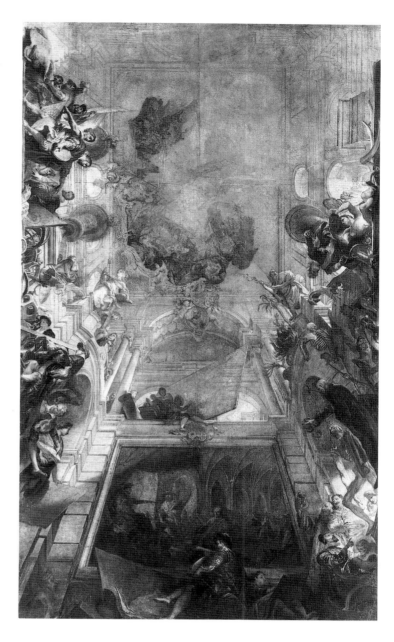

Fig. 12 Johann Evangelist Holzer, Sketch for the decoration of the Gallery of the Würzburg Residenz, 1739. Oil on canvas, 88.8 x 51.7 cm. Nuremberg, Germanisches Nationalmuseum

The Commission is Awarded to Tiepolo

Following the disappointment with Zick and the débâcle with Visconti, the Prince-Bishop evidently felt that the time had come to stop looking for compromise solutions. There was only one painter equal to the task: Giambattista Tiepolo from Venice. Things began to move very quickly. On 29 May 1750, less than three months after the end of the Visconti episode, the court treasurer reported that the negotiations with Tiepolo were nearing conclusion. No records exist of the unofficial preliminary conversations, conducted in Venice by the banker Lorenz Jakob Mehling, who lived in the city. The treasurer writes: 'For the sake of art in Germany, and in order to immortalize his own name, the famous fresco painter Sig. Tiepolo has agreed to come to

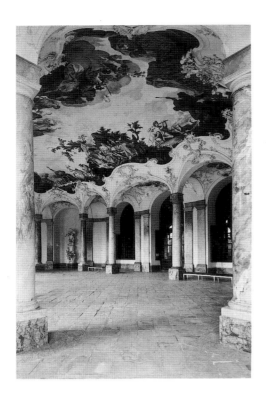

tunity to persuade ourselves at first hand of his fine qualities and abilities, and for this reason, we consider his honesty to be above reproach.'

The fee for carrying out the work in the Kaisersaal was set at 10,000 florins. It had already been decided that Tiepolo should paint the staircase as well, but the matter had not yet been discussed with the painter himself, as the court wanted to make sure that the actual quality of his work was commensurate with his exalted reputation.

In view of the long and involved sequence of previous events, the alacrity with which the commission was awarded to Tiepolo may seem surprising. The painter never sent preliminary sketches to Würzburg or presented any other kind of formal proposal for the decoration of the rooms. Nor did he and his patron meet before the contract was signed. What, then, were the reasons for deciding that Tiepolo had to be recruited at all costs, and that no other painter would do?

The urgency with which Tiepolo was invited to Würzburg, the willingness to pay him almost any fee he named, the relief at his acceptance of the offer, the fact that he was seen as a risk-free candidate for the job – all these points indicate that the court knew exactly who Tiepolo was and what he was capable of.

The decision to employ a Venetian painter is in itself unsurprising. Following the revival of its former glory in the early part of the eighteenth century, Venetian painting had

Würzburg. His Grace is much gratified by this news, and the painter's arrival is awaited with eager anticipation. The sooner he gets here, the happier we shall be, and the greater our sense of relief.... We therefore hope that Sig. Tiepolo, accompanied by his son and his assistants, will depart for Würzburg with all due speed. Our confidence in this agreement has been greatly strengthened by the oppor-

above
Fig. 13 The Gartensaal of the Würzburg Residenz, showing the ceiling fresco of 1750 by Johann Zick

below
Fig. 14 Giovanni Antonio Pellegrini, *Susannah and the Elders*, before 1737. Oil on canvas, 105 x 155 cm. Würzburg, Residenz

achieved great popularity in southern Germany, as elsewhere. This in turn was connected with the political changes occurring at the time. The age of the great wars, from the Thirty Years' War to the War of the Spanish Succession, was now over, and the incursions of the Ottoman Empire into central Europe had finally been halted. As a result, Venice found itself plunged into a political and economic crisis, but the small and medium-sized German states were in a relatively favourable position. After decades of conflict, their standing *vis-à-vis* the Holy Roman Emperor had improved dramatically; they had backed the various war efforts by supplying large contingents of competently officered troops. Their growing power and self-confidence were reflected in the rush to adopt the rituals and trappings of the courts of Vienna and Versailles. This led to an unprecedented boom in the building of castles and palaces.

Castles and palaces had to be decorated, a task for which Venetian artists were particularly suited, since they were experts in fresco and in the production of large-format oil paintings. Venetian art was generally held in high esteem: its inventions were to acquire an exemplary significance for the eighteenth century as a whole, outstripping the impact of any other European artistic centre apart from Paris. Furthermore, the overabundance of painters in the city made it imperative that they look for patrons elsewhere. Federico Bencovich, for example, was apprehensive about his future economic prospects and therefore sought the position of *pittore di corte e famigliare* to Friedrich Carl von Schönborn, who at that time held the office of Vice-Chancellor of the Holy Roman Empire. Bencovich entered the Prince-Bishop's service in 1734 and retained his post for about twenty years, during which time he made a large number of paintings for the various Schönborn palaces in Vienna and Franconia. Significantly, very few of these works were easel paintings: most of them were either pieces of counterfeit tapestry or decorative elements integrated into the wall panelling. Bencovich's altar paintings for the Court Chapel in Würzburg were replaced barely twenty years later with works by Tiepolo (figs. 112, 113).

While Bencovich was sending paintings to Würzburg from Vienna, Giovanni Antonio Pellegrini was travelling to Dresden to paint a series of ceiling frescos (which no longer survive). His journey took him through Würzburg, where he made four paintings in the modern, airy style for which he is known. When the Residenz was completed, these works were hung over the doorway of two

of the rooms in the Imperial apartments (see fig. 14).

The Schönborn collection also contained several works by Piazzetta, all of which were subsequently lost. They probably included a picture of St Aloysius that was recently reacquired for the Residenz. Moreover, Venetian painting was well represented – with works by Liberi, Ricci, Pellegrini and others – in the art collections of three further Schönborn residences, at Werneck, Wiesentheid and Pommersfelden.

Venetian artists were not the only possible source of information about Tiepolo's qualities. The Franconian painter Georg Anton Urlaub lived and worked in Venice for a time at the end of the 1740s before returning, probably in 1751, to his native region. Whether he was actually employed in Tie-

Fig. 15 *The Adoration of the Trinity by Pope Clement,* c. 1737–8; detail of fig. 16

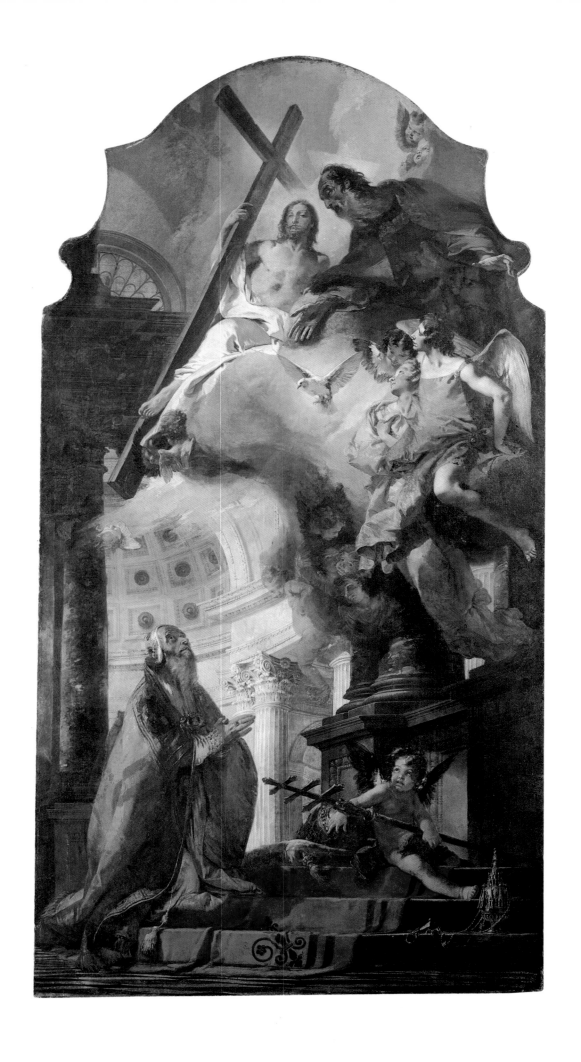

polo's studio is uncertain: this had been assumed in the past, but recent research has shown that the case cannot be proven one way or the other. The Martin von Wagner-Museum in Würzburg has an extensive collection of his drawings, which are done in the style of Tiepolo and show that he studied the latter's work very closely, as well as that of Piazzetta and Bencovich. It is quite likely that he reported back to Würzburg about Tiepolo.

Works by Tiepolo in Germany

Finally, a number of paintings by Tiepolo himself served as evidence of his exceptional gifts. Greiffenclau must have been aware that Tiepolo had been commissioned by Clemens August, Elector of Cologne, to make a painting for the main altar of the recently consecrated convent church in the north wing of Schloss Nymphenburg, just outside Munich. The theme is St Clement kneeling before a vision of the Trinity (fig. 16). During restoration work for the 1996 Tiepolo exhibition in Würzburg, numerous *pentimenti* (overpaintings) by the artist were discovered that tally with an oil sketch now in London (fig. 17). The latter must have been a preparatory exercise for the painting, although the motif is different: instead of the adoration of the Trinity, the picture shows the martyrdom of St Clement, who was supposedly killed by being bound to an anchor and cast into the sea. One can only assume that the subject was changed at the behest of Clemens August, who was probably displeased at the idea of seeing his namesake – and, by implication, himself – suffering a violent death. Up to now, a second oil sketch, also in London, has been regarded as the authentic model for the picture (fig. 18). But as this work shows the final version of the motif, minus the corrections, it can only be a later copy commissioned by a collector. This would explain the wider format, which gives it the proportions of a cabinet painting. It is conceivable that parts of the architecture were executed by assistants, although the figures are clearly by Tiepolo himself.

Clemens August, an enthusiastic patron of the arts, had visited Venice in 1734, and had commissioned Piazzetta to paint an altarpiece (now in the Louvre) for the Deutschordenskirche in Sachsenhausen (today part of Frankfurt am Main). This was probably when he met Tiepolo and discussed the altar painting for Schloss Nymphenburg.

The existence of close contacts between the courts in the Rhineland and Franconia is indicated by the involvement of Balthasar

facing page
Fig. 16 *The Adoration of the Trinity by Pope Clement*, *c.* 1737–8. Oil on canvas, 488 x 256 cm. Munich, Alte Pinakothek

below
Fig. 17 *The Martyrdom of St Clement, c.* 1735. Oil on canvas, 61.1 x 34.4 cm. London, Courtauld Institute Galleries, Princes Gate Collection

Neumann, from 1740 onwards, in the design of the ceremonial staircase at Schloss Brühl, near Cologne. It is possible, therefore, that the final impetus to recruit Tiepolo for the task of decorating the Residenz in Würzburg came from Clemens August.

In about 1738 Tiepolo received a further commission from southern Germany, when he was asked to make a painting for a side-chapel in the new church of the Augustinian canons at Diessen, some thirty-five miles south-west of Munich (fig. 20). The proposed subject was the martyrdom of St Sebastian. A preliminary drawing and an oil sketch still survive (figs. 19, 21). Whereas the latter is very similar to the finished work, the drawing is quite different. The switching of the figures on the left and right of the foreground makes the final composition more coherent and gives it a greater feeling of space. By moving the executioners into the background, the artist also reduces the emphasis on physical brutality and puts the main stress on the idea of salvation.

The court at Würzburg was also aware that Tiepolo was being systematically collected in Dresden, on the basis of connections forged by Francesco Algarotti, a personal friend of the painter. In sum, Tiepolo's name was well known north of the Alps, and his talents could be assessed at first hand by anyone who seriously wished to do so.

Court Ceremony

The image of Greiffenclau as a scholar and a responsible ruler may well appear to clash with his fondness for pomp and ostentation, which also seem inappropriate to a principality of Franconia's modest size. Yet although it was far smaller than such other German states as Prussia or Bavaria, the duchy of Franconia was still the third largest of the various provinces of the Holy Roman Empire that were under the rule of Church appointees. It had a total of about 200,000 inhabitants, less than a tenth of whom lived in Würzburg, but it was rich in natural resources and had a relatively developed economy with a flourishing export trade in wine and other agricultural commodities. Such prosperity was otherwise rare in eighteenth-century Germany.

Moreover, the Prince-Bishops of Franconia were by no means alone in their love of expensive display. In his *Einleitung zur Ceremoniel-Wissenschaft* (Introduction to the Science of Ceremony), which first appeared in 1729 and subsequently went through numerous editions, Julius B. von Rohr comments on 'the ever-increasing splendour and mag-

nificence of the courts, in Germany as elsewhere'. This trend occasioned a good deal of criticism, and Greiffenclau was one of the targets, since his court expenses swallowed up approximately half the state budget. On his election, for example, he had all his servants fitted out with new uniforms; hired extra soldiers for purely ceremonial purposes; ordered large quantities of silver and porcelain; and treated himself to a new set of vestments, embroidered with pearls, which cost a total of 10,000 florins – exactly the sum agreed upon as Tiepolo's fee for decorating the Kaisersaal.

On the other hand, however, the 'magnificence' spoken of by Rohr was seen as a positive virtue. Monarchs were expected to mount lavish displays of wealth and luxury in order to maintain their aura of grandeur. The ceremonies of the court played a crucial part in the pursuit of this aim. Rohr describes the purpose of such rituals as follows: 'If the subjects are to acknowledge the King's majesty, they must realize that he is the source of all power and authority; thus their actions must be directed in such a way as to make that power and authority clear. The common man, who is guided only by his senses and makes little use of his wits, cannot really grasp the idea of royal majesty, but the evidence of his own eyes, and his other senses, will enable him to achieve a full appreciation of it.'

The particular importance of ceremony in Würzburg, and the emphasis placed on creating the right framework for it, is also bound up with the issue of social precedence, to which the Church and its dignitaries paid minute attention. Some indication of the intricacy and continuing relevance of these matters is provided by the mention, in Rohr's book, of a weighty-sounding disquisition with the title *Of Judgment and Jurisdiction in Disputes Concerning Precedence Between the Spiritual and Temporal Sovereigns of the Holy Roman Empire of the German Nation*.

The forms of ceremony during state visits were carefully tailored to the status of the guest: 'On such occasions, the *gradus praerogativae* is carefully observed and every aspect of the ceremony is designed accordingly.' From the diary of the court harbinger, Johann Christoph Spielberger, we know how such matters of protocol were dealt with in Würzburg, where visitors were received in different parts of the palace, depending on their station. Rohr describes the same phenomenon: 'If the host has not driven or ridden to greet his guest outside the Residenz, then he will come down to welcome him at the door of his carriage, or on one of the staircases, or in a certain room, according to the difference in rank or the pre-

Fig. 18 *A Vision of the Trinity to Pope Clement*, c. 1738. Oil on canvas, 69.2 x 55.2 cm. London, National Gallery

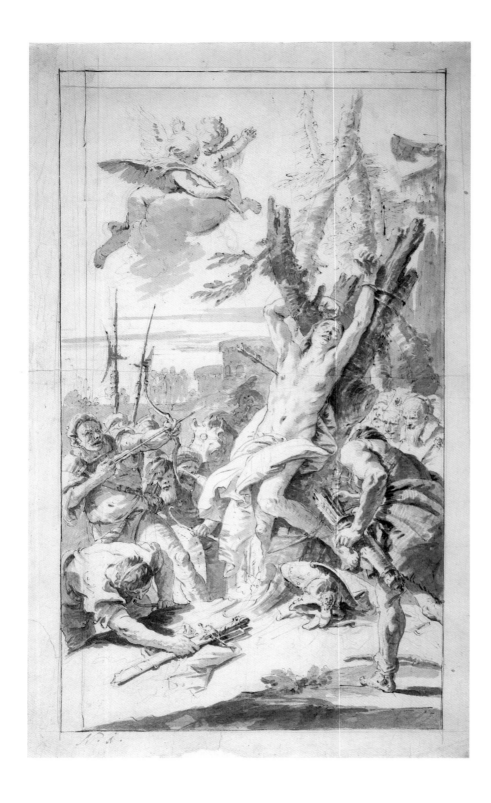

rogative of the one *vis-à-vis* the other. Often enough a distinction is even made between the number of steps taken by the rulers themselves, or by their princes and other relatives, or by their ministers, in greeting the strangers and conducting them to their quarters.'

It was counted a particular honour to be allowed to drive directly into the palace and to be welcomed at the foot of the stairs by the Prince-Bishop. This happened on the occasion of the visit by the Emperor's brother, Prince Carl of Lorraine, in 1751. After the initial greeting ceremony, Greiffenclau accompanied his guest all the way to the hall of mirrors before finally sitting down to converse. Arriving at the gate, ascending the staircase, walking through the adjoining rooms, and gradually approaching the innermost regions of the palace – these were all central aspects of court ritual, to which the architecture of the Residenz is specifically geared. Ceremony, one could say, is built into its very structure.

above
Fig. 19 *The Martyrdom of St Sebastian*, c. 1739.
Pen and ink and wash on paper, 55 x 33 cm.
Lwiw, Ukrainian National Museum

right
Fig. 20 *The Martyrdom of St Sebastian*, 1739.
Oil on canvas, 410 x 200 cm.
Diessen, monastery church

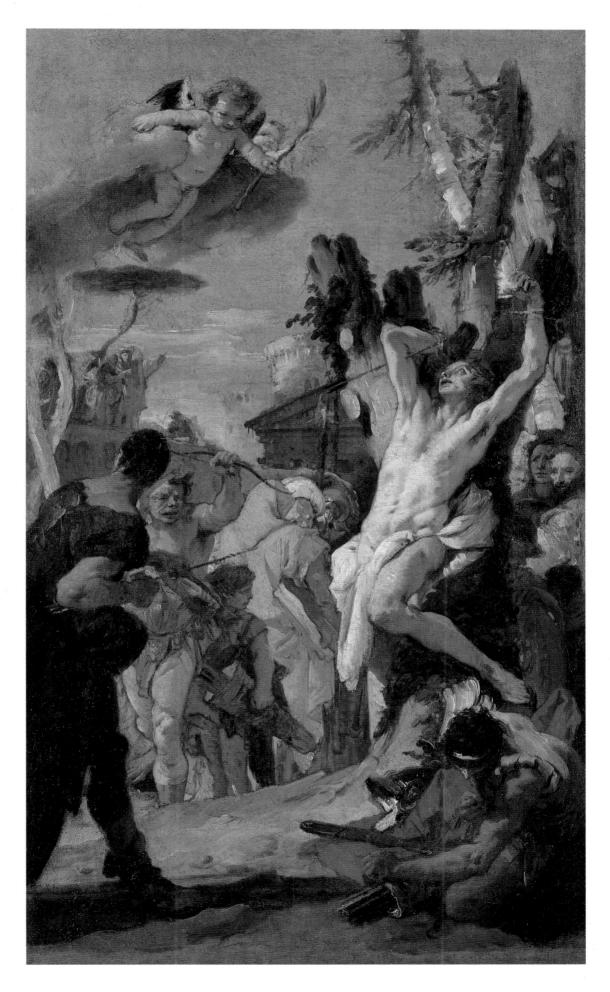

Fig. 21 *The Martyrdom of
St Sebastian*, 1739. Oil on canvas,
52.5 x 32.5 cm. Cleveland, Ohio,
The Cleveland Museum of Art

The History
and Architecture
of the Residenz

In many respects, the building history of the Würzburg Residenz mirrors the general development of palace architecture in eighteenth-century Germany. Between 1700 and 1705 a relatively small residence, generally referred to as *das Schlösslein* (the little château), was built by Prince-Bishop Johann Philipp von Greiffenclau (the uncle of Tiepolo's patron) in the centre of Würzburg, only a short distance from the site of the later Residenz. Although the Prince-Bishop continued to occupy the fortress of Marienberg, which dominates the town from the top of the hill on the opposite side of the River Main (see fig. 146), the *Schlösslein* exemplifies the contemporary trend among German rulers to abandon their forbidding medieval fortresses and move into more modern and comfortable quarters in the centre of town.

A precondition for this development was Germany's gradual recovery from the ravages of the Thirty Years' War, concluded in 1648 by the Treaty of Westphalia. The resolution of the subsequent conflicts within the Holy Roman Empire, during the course of which power passed from the centre to the provinces, was accompanied by a relaxation of the long-standing tension between the princes and their town-dwelling subjects, which had caused considerable unrest in Würzburg, as in many other parts of Germany.

On a more specific note, the virtual completion of Versailles in 1684 set a new standard in palace architecture, which other European rulers felt obliged to follow. The exemplary status of Versailles was based less on artistic considerations than on its embodiment of the idea of absolute monarchy, which found its perfect model in the reign of Louis XIV and increasingly dominated the attitudes and actions of Germany's provincial potentates.

These influences are clearly apparent in the evolution of the Residenz at Würzburg, whose dimensions were gradually expanded far beyond those of the original building. The decisive step was taken by Johann Philipp Franz von Schönborn, who ordered the demolition of the modest *Schlösslein* in 1719, shortly after his election. A new set of plans, drawn up by an unknown 32-year-old artillery officer named Balthasar Neumann, indicated the scope of the Prince-Bishop's ambitions. The availability of the necessary finance was due to the unexpected outcome of a fraud investigation against the court treasurer, which led to the recovery of the colossal sum of 600,000 florins.

facing page
Fig. 22 View south along the *cour d'honneur* façade of the Würzburg Residenz

right
Fig. 23 The Würzburg Residenz, *c.* 1805. Pen and ink and wash drawing by Sebastian Vierheilig showing the ironwork gates that were removed in 1821. Formerly Munich, Bayerisches Nationalmuseum

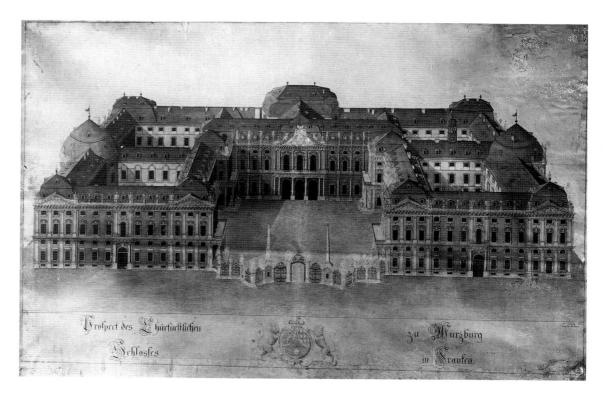

In eighteenth-century Germany the type of country house known as the *Lustschloss* generally comprised three wings, whereas town residences were constructed around a central courtyard with walls on all sides. These two patterns are combined in the distinctive layout of the palace at Würzburg (fig. 24). Following the approval of the plans so far, the foundation stone for the building was laid on 22 May 1720.

The reasons why the plans evolved in this way are obvious. Johann Philipp wanted to give his palace a broad façade, coupled with a blocklike appearance that would reinforce the building's overall visual impact. This made it essential to include a further courtyard. The plans indicate a fundamental change of approach: the tightly enclosed structure of the original *Schlösslein* has been expanded and opened up, and the architectural *mise-en-scène* guides the approaching visitor directly towards the main door.

A similar process of architectural dramatization has occurred inside the building. Neumann originally intended to construct two staircases of relatively simple and traditional design on either side of the entrance. This plan was dropped in 1723 after Neumann had been on a study trip to Paris, where he showed his drawings for the Residenz to Germain Boffrand and to Robert de Cotte, the director of works at the French court. De Cotte was the source of the suggestion that the two small stairways be replaced by a grand staircase with a gallery at the top – an idea evidently based on the Escalier des Ambassadeurs at Versailles, which occupied an important posi-

tion in the court rituals relating to the reception of guests.

This suggestion from the French court led Neumann to think very carefully about the potential of the staircase. Looking at the development of his plans, one senses his growing fascination with an architectural feature that not only fulfils the everyday function of connecting one floor with another but also has an important symbolic dimension, in embodying and dramatizing the idea of movement from a lower to a higher level.

The courtyard and staircase are among the most impressive features in the palace of Versailles, and the same is true of Würzburg. Here, a number of ideas from Europe's largest palace are incorporated into a building that became one of eighteenth-century Germany's chief architectural wonders.

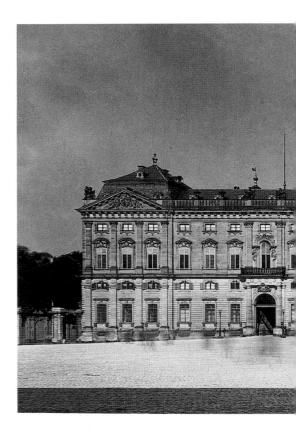

'Per aspera ad astra': Neumann's Spatial Conception

In his *Einleitung zur Ceremoniel-Wissenschaft* Julius von Rohr describes how the reception ceremony for guests of the court begins immediately after the traveller has crossed the state border. 'As a mark of exceptional respect for persons of higher rank, the ruler may either ride out to meet the noble visitors himself or send his princes or other blood-relatives to perform the task. The procession is led by a large detachment of postilions, accompanied by trumpeters and drummers. The master and servants of the ruler's hunt are in attendance, and the sound of their horns alternates with the blowing of posthorns. A

Fig. 24
Plan of the main storey
of the Würzburg Residenz

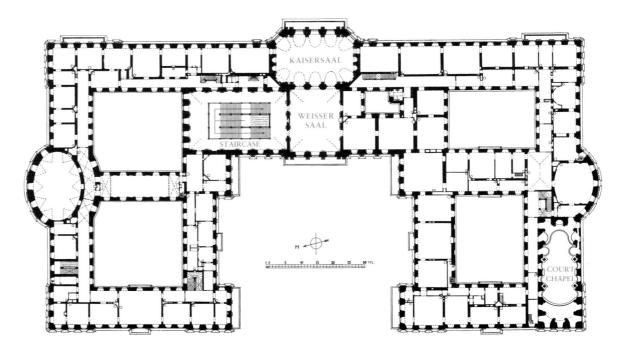

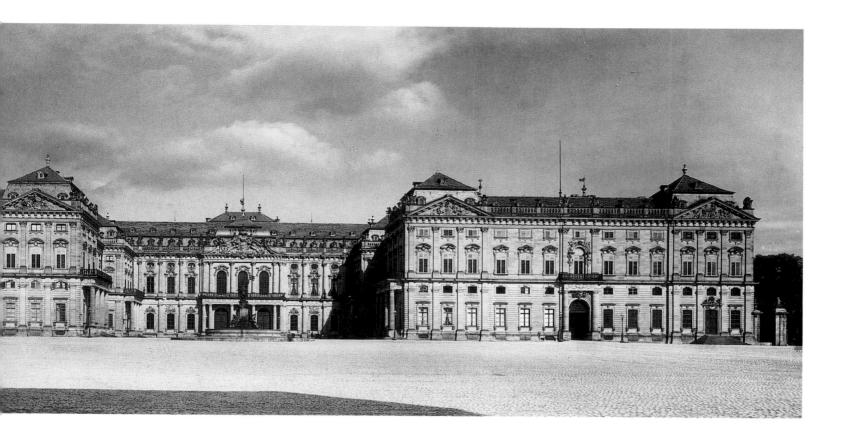

number of representatives may also be sent by the ambassadors. Cannons are fired in every fortress through which the party passes, and the garrison has to appear on parade. When the visitors approach the palace, a rocket goes up as a signal to release the salutes, three of which are fired at certain points along the way. The citizenry and soldiery are required to line the route … through the town.'

Then, as the guest approaches the palace, his or her progress reaches a crescendo at two successive points, in front of and inside the building. On emerging from the narrow streets of Würzburg, the visual impact of the Residenz is quite overwhelming, especially when the ensemble is seen from the cathedral end (fig. 25). One suddenly finds oneself in a vast, empty square, whose slightly raked surface reinforces the impression of monumentality and majesty conveyed by the façade. Although the two side-wings are powerful structures in their own right, they seem to recede into the background as one advances towards the door. Passing through the elaborate ironwork gates (later removed; see fig. 23), the guest finally entered the palace grounds. The *cour d'honneur* was constructed like a stage, which the guest had to cross in order to enter the palace, under the gaze of the spectators gathered on the balconies of the three wings that enfold the courtyard and make it into a kind of interior space.

As the guest passed through the main door, the expectations aroused by the imposing façade would then be confounded by the reality of what lay behind the outer wall: instead of immediately entering a sumptuous suite of state rooms, he found himself in a dimly lit vestibule, which, with its low vault and heavily burdened atlantes, has a slightly oppressive effect. But on the left, behind the columns and piers, one can already make out the filigree architecture of the grand staircase, the largest space in the building (fig. 26).

Advancing to the staircase, the visitor is confronted with a new spatial situation (fig. 27). From the relative gloom at the foot of the steps, the path leads up towards the light at the top, revealing ever more magnificent and brightly lit aspects (fig. 28). This sense of growing splendour and illumination becomes particularly marked when one reaches the second, half-way landing, where the staircase doubles back on itself (fig. 29). This is where the Prince-Bishop's private realm begins. The staircase, too, is like a stage, with spectators standing around the upper gallery observing the visitor's progress (fig. 30).

After this, the visitor entered the Weisser Saal (fig. 43), the anteroom where he encountered the Prince-Bishop's palace guard, whose members were clad in red uniforms. This extra colour accent doubtless enhanced the overall effect.

Fig. 25 The main façade of the Würzburg Residenz

Access to the Kaisersaal is gained by turning left, which, like the arrival at the half-way landing on the staircase, produces a further sudden increase in visual impact. The motif of the triple-span *arc de triomphe* is repeated here; the visitor walks under the central arch and finally enters the most sumptuous of all the rooms in the palace (fig. 44). Significantly, the entrance to the Kaisersaal is not at the end of the chamber, but in the centre; the guest therefore found himself confronting the room head-on, and the sense of continual perambulation was interrupted. From here, he would be guided into the Imperial apartments, where the reception ceremony reached its conclusion.

In some respects, this sequence of rooms recalls the dramatic structure of a stage play. The approach to the Residenz is like a prologue, preceding the real action, which begins on a note of uncertainty when the visitor enters the vestibule. From this point onwards, the plot rapidly thickens as the visitor ascends the grand staircase. The mounting tension is broken by the Weisser Saal, which provides a temporary lull before the drama proceeds to its furious climax in the Kaisersaal, followed by the tranquil epilogue of the Imperial apartments.

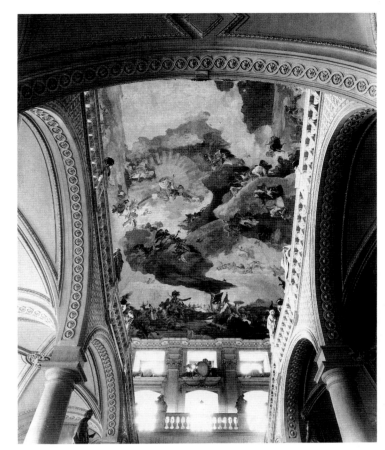

28

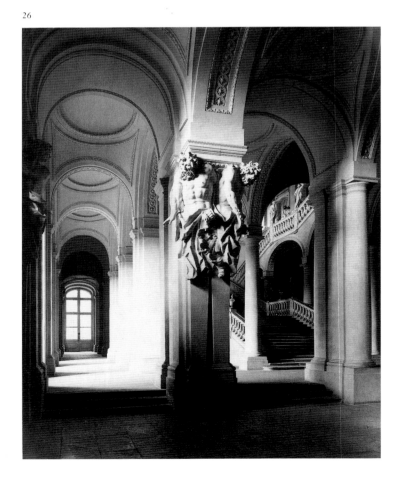

26

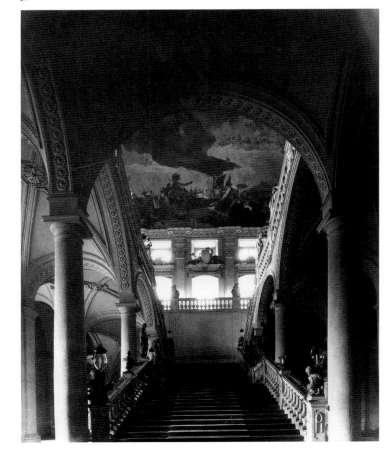

27

Neumann's interior architecture derives a large part of its impact from the play of contrasts between interior and exterior, top and bottom, massiveness and transparency, narrow and broad, light and dark. These oppositions are emphasized by a series of turning-points. Instead of conceiving the ceremonial itinerary as a simple enfilade, leading to the Kaisersaal in a single straight line, Neumann designed the interior so as to include three complete changes of direction, each of which presents the visitor with a new and surprising spatial situation. The left turn in the vestibule leads him out of the darkness and into the light; the turning-point on the half-way land-

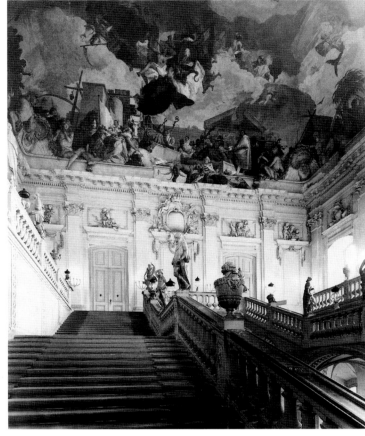

30

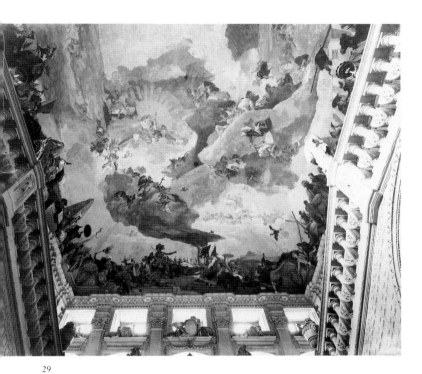

29

ing reveals, for the first time, the full dimensions of the staircase, pointing upwards towards the realm of the Prince-Bishop. Finally, the left turn in the Weisser Saal indicates that the path is about to reach its terminus in the Kaisersaal.

The success of Neumann's architectural *mise-en-scène* depends, too, on the expansion and contraction of space. As one ascends the staircase, it proves to be far larger and wider than the almost tunnel-like bottom section might have led one to believe. The transition from the one spatial effect to the other is initiated by the wide landing mid-way between the lower and upper floors. When one enters the Kaisersaal, the space is opened up again, in a somewhat different manner, by the surprising lateral extension immediately inside

the door. This raises a further point: the varying dynamic structures of Neumann's rooms. The staircase extends lengthways, as well as vertically, with the former effect emphasized by the reversal of direction. Here, the aim is to slow the visitor's pace, obliging him to move through the space in a gradual, stately progression. By contrast, the cubical shape of the Weisser Saal has a relatively neutral effect, but the Kaisersaal is different again: the sense of movement is arrested by the fact that the visitor enters it frontally and finds himself directly facing the wall on the opposite side. There is only one possible viewing point: the spot where he automatically pauses on walking into the room. Here, in contrast to the situation on the staircase, time contracts to the space of a single moment.

Fig. 26 View from the vestibule to the foot of the staircase
Fig. 27 View of the staircase from the vestibule, with *America*
Fig. 28 View from the first step of the staircase, with Apollo above *America*
Fig. 29 View from the half-way landing, with the Apollo fresco, *America* (below), *Asia* (left) and *Africa* (right)
Fig. 30 View from the half-way landing, with *Europe*

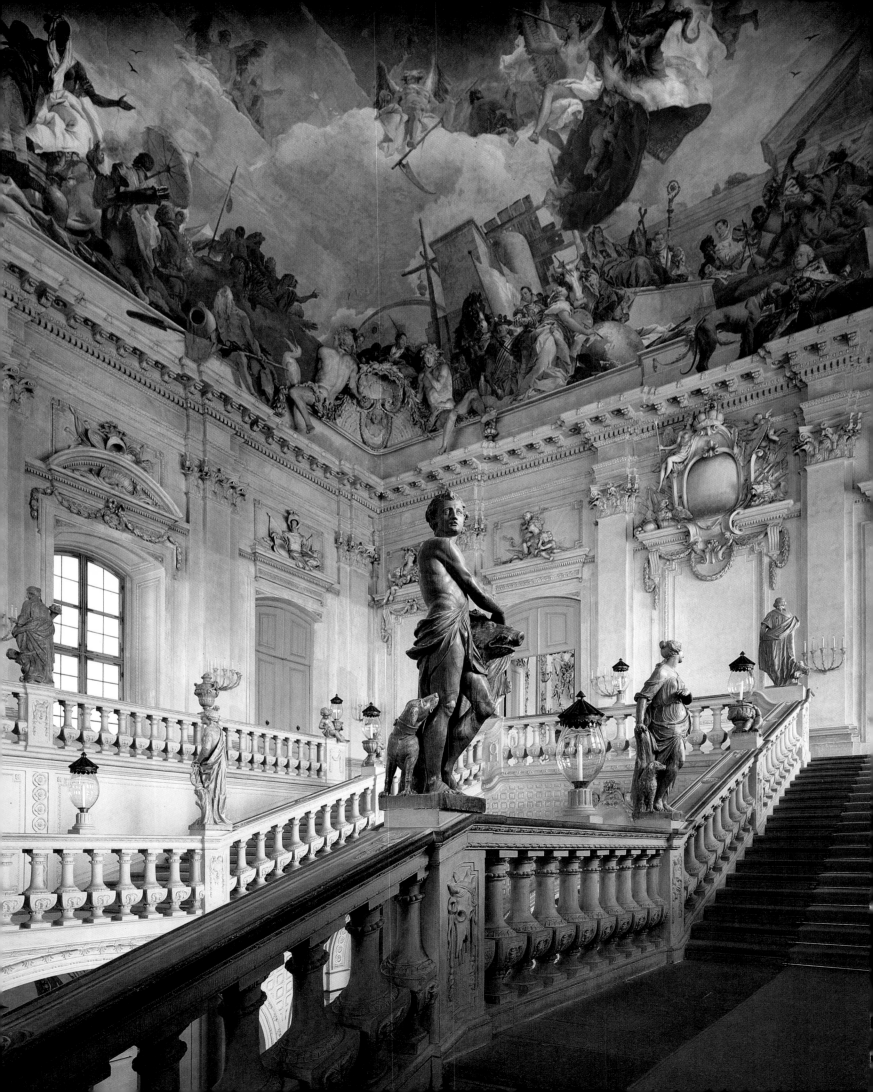

The Staircase Fresco

As mentioned above, Neumann devised his brilliant spatial conception without considering the issue of painted decoration (see fig. 11). As far as the staircase was concerned, he probably felt that any such decoration was impossible, because – and this was the problem that Tiepolo saw as a particular challenge – the ceiling cannot be viewed at a single glance. Of course, the visitor of today can admire the fresco from the landing or the upper gallery, but for the guests of the Prince-Bishop this would have been out of the question: it would have meant craning one's neck or straying from the prescribed path, either of which actions would have been regarded as highly improper. A guided tour of the Residenz and its environs might eventually have been laid on, but only after the official welcoming ceremony was over.

Since the end of the eighteenth century, when absolutist ceremony lost its importance and meaning, the staircase fresco has been approached largely in modern terms, as a purely aesthetic creation or a tourist attraction. Instead of viewing it sequentially, people stand on the landing or the gallery and try to see it as a single, coherent image. This way of looking at the work greatly diminishes its excitement and tends to obscure its true complexity. Such prominent art historians as Hetzer, or Alpers and Baxandall, have begun to explore its mysteries, but even their investigations have failed to disengage the full range of meanings contained in what is surely one of the greatest works in the history of Western art.

The Marriage of Painting and Architecture

Looking at the staircase fresco, it is evident that Tiepolo studied the architectural structure of the space very carefully. He analysed the component elements and realized that he could solve the problems of decorating such a vast surface only by working with the architecture rather than against it. The answer lay in tailoring the composition of the fresco to the continual changes of viewing angle as the visitor ascended the stairs, so that the painting can – and indeed must – be seen as a sequence of discrete images, instead of as a single picture. Tiepolo identified a number of positions

from which the individual parts of the work were to be viewed. These vantage points are shrewdly sited at the landings and the start of each flight of steps, where the visitor slows his pace and has an opportunity to look at the ceiling above.

The staircase was only half-finished when Tiepolo began to paint it, and the interior fittings visible today were added during a later construction phase (see fig. 31). With their straight lines and plain surfaces, these early neo-classical elements present an unfortunate contrast to Tiepolo's frescos, which rely entirely on movement and lightness for their impact. The transparency of Neumann's architecture has also suffered, especially at the half-way landing, the front of which was designed to be open: the arches in the original plan were subsequently walled up.

The composition of the staircase fresco is orientated around the pilasters and the cornice. It is uncertain whether these were in place when Tiepolo started work, or whether he knew about them only from the architect's plans. In contrast to the staircase, the Kaisersaal was largely completed by the time Tiepolo arrived in Würzburg.

The following account, tracing the progress of the eighteenth-century visitor, will show how Tiepolo integrated the frescos into the sequence of rooms.

America

The visitor catches a first glimpse of the fresco on emerging from the vestibule and approaching the bottom of the stairs (fig. 27). A strange and exotic world begins to unfold on the ceiling, which is strongly reminiscent of a stage set (fig. 33). The subject is the continent of America, personified by a female figure wearing a magnificent headdress of brightly coloured feathers and sitting astride a giant crocodile (plate 2). America, the image suggests, is still in a primeval state, untouched by civilization. There are no buildings, no signs of cultivation or industry. The people sleep under the stars, and sustain themselves mainly by hunting wild animals and gathering berries and fruits. However, as Cesare Ripa claims in his *Iconologia* (a standard manual of iconography first published in 1593 but still widely used in Tiepolo's day), the native tribes of the American continent also practise cannibalism. Their reputed habit of eating the flesh of their enemies is signalled by the clutch of severed heads in the middle of the foreground.

The figure of America is pointing with her outstretched arm towards the right, the direc-

facing page
Fig. 31 The top of the staircase in the Würzburg Residenz

tion in which she and her attendants are travelling. She is also gesturing towards a banner, inscribed with runic signs and bearing the image of a mythical beast. Ripa mentions a species of large, wild lizard, allegedly indigenous to America, that preys on other animals and even on humans. His book includes an illustration of this apocryphal creature, which he calls a *liguro*. Tiepolo uses the same image to symbolize America, but modifies it by adding a pair of wings, which give it the appearance of a gryphon – a punning reference to Greiffenclau's coat of arms. America's message to the visitor, seeing the fresco for the first time, is therefore that his path is taking him to the Prince-Bishop.

This clarifies the meaning of the procession: America and her retinue are accompanying the visitor as he makes his way up the staircase to pay his respects to the ruler. A joyful dance is already being performed in anticipation of this auspicious event. Clutching a plate, apparently made of silver, America is glancing over her shoulder towards a group of men on the left, one of whom is parcelling up a hoard of silver and gold objects. Another is holding up a large cornucopia filled with fruits. America is beckoning to all these figures to accompany her, together with the

three Indians on the left, one of whom is bearing a magnificent parrot (fig. 32), while another carries a torch filled with glowing coals: evidently the day has only just dawned. The procession already includes a page with a chocolate pot, a man with what appears to be a dead alligator slung over his shoulder, and a bare-breasted beauty carrying a vessel on her head (frontispiece). Clearly, these various burdens are gifts destined for the Prince-Bishop. Tiepolo undoubtedly took part of the inspiration for the scene from traditional depictions of Bacchus accompanied by maenads and satyrs.

From the perspective of the visitor walking up the stairs, the picture is framed by the architectural features of the room: the curve of the vault at the top, the cornice at the base, and the banisters of the staircase on either side. As far as the subject-matter is concerned, it must have been immediately clear to contemporary viewers that the image was part of a depiction of the four continents. But what we see is not a random fragment: on closer inspection, it becomes apparent that this section is a fully coherent composition in its own right. The parts that stand out from the main body of the picture – the image of America and the group of motifs around the banner –

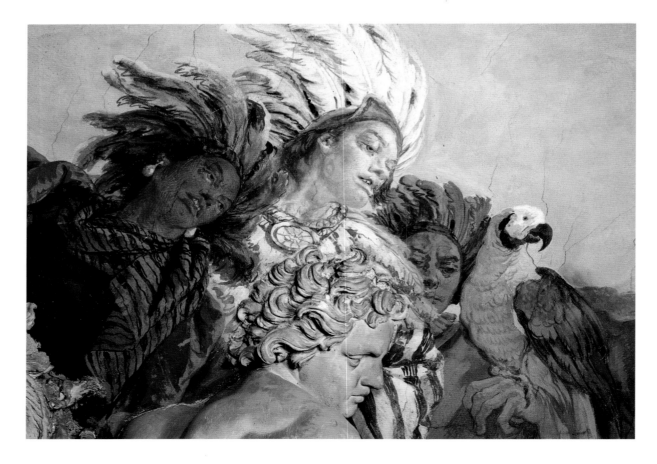

Fig. 32 Indians; detail of *America*

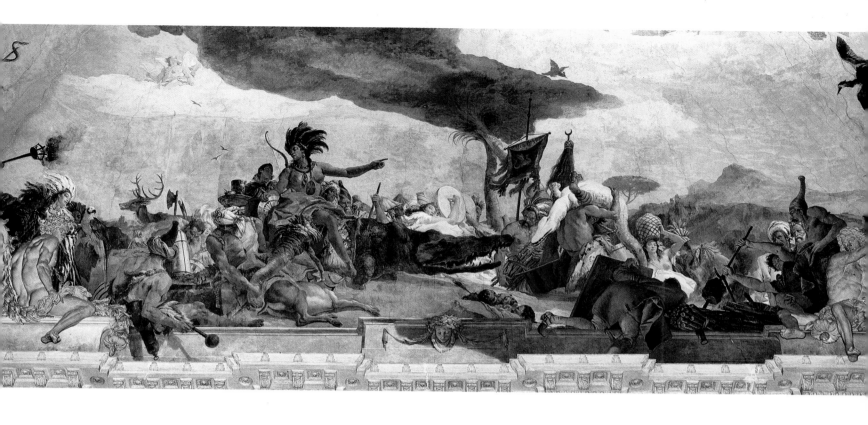

are arranged above the central pilasters. They give the composition a balanced, rhythmical feel. From the left an ascending line connects America's headdress with the banner and completes the movement on the right-hand side, unifying the composition in the manner of a garland.

Apollo

Joining the procession led by America, and slowly approaching the first landing, only a few steps away, the visitor witnesses the emergence of a breathtaking new picture (fig. 28, plate 1). The dark cloud, barely discernible from the foot of the stairs, suddenly appears massively enlarged, and the figures of Mars and Venus can be seen seated above it. Significantly, there are no figures below the cloud. Any such details would have been amputated in the middle when seen from the first viewing point, thus seriously disrupting the initial composition. On the right one sees a rift of brightly billowing clouds populated by the winged figures of the Hours. In classical mythology the Hours, or Horae, are the divinities that preside over the changes of the

seasons. They personify the notions of time and natural growth, and also lend their name to the hours of the day. As the custodians of the skies, it was their task to roll away the clouds and clear a path through the gates of Olympus when a god wished to ride out in his chariot. This is what they are doing here: to the right of the air-vent in the ceiling, they are pushing a large ochre-coloured cloud aside, as if it were a piece of theatrical scenery. A clock-face, almost concealed from view, shows that the time is between six and eight o'clock in the morning: in other words, it is daybreak, the hour when Apollo, the sun god, is accustomed to leave his palace in the sky. In his left hand he is holding up a miniature statue of the goddess Athene (plate 9). As Ripa tells us, this traditional image evokes the notion of achieving nobility and wisdom through distinction in the arts. Apollo's expression clearly indicates a sense of delight at the thought of the person to whom he is bringing the statuette. His chariot, half-concealed by the dark cloud, is being rolled out into the open by *putti*, while the Horae bring the four prancing steeds that draw the vehicle (fig. 35). The year, too, is still young: above

Fig. 33 *America*

the horizon one notices the image of Pisces, the twelfth and last sign of the zodiac. As the sign associated with the period between late February and the end of March, Pisces symbolizes the start of spring and the renewal of life. Thus the image as a whole embodies the idea of rebirth and the dawning of a new age, which the gods have come out to welcome.

Again, Tiepolo has painted a highly successful picture that could easily stand on its own. Here, as in *America*, there is no suggestion of fragmentariness or randomness. None of the figures is inverted, and there are no distractions caused by other parts of the fresco. The composition uses *America* as its base, from which the clouds rise up towards the light. One notices that the clouds are arranged in the asymmetrical form of the *rocaille*, the main ornamental device of Rococo art. Especially in Venetian painting, the *rocaille* was often used as a basis for composition because of its lively, spirited rhythm.

The Journey Continues

A further picture begins to emerge when the viewer reaches the half-way landing (fig. 29). If he pauses and looks up at the ceiling, he will see an extension of the previous scene on the two longer sides of the ceiling. Although the full extent of the allegory does not become apparent until later, parts of the remaining continents can be identified above the balustrades that run along the upper half of the staircase. The group of merchants on the right are clearly visiting Africa, while the pyramid on the opposite side is located in Asia.

Tiepolo arranges the figures on a painted plinth, which has the practical function of raising them well above the jut of the cornice and thus preventing them from being obscured when seen from below. Yet when viewed from this angle, they seem at the same time to be sited immediately above the balustrades at each side. Looking upwards, it is impossible to see past Apollo's halo of light; to discover any further details, the viewer has to turn right round on the landing, which would be impossible while ascending the staircase in a ceremonial procession.

As he progresses, the guest gradually loses sight of the fresco. Arriving at the half-way landing, he then turns to walk up the last section of the staircase in the opposite direction. At this point his field of vision ceases to be

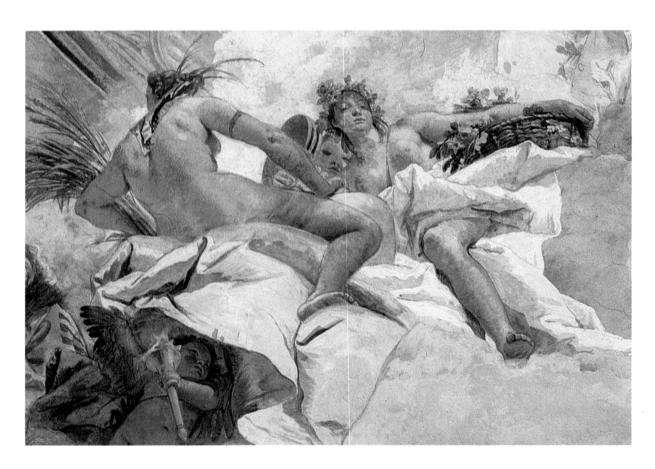

Fig. 34 Personifications of Summer and Spring from the Apollo fresco

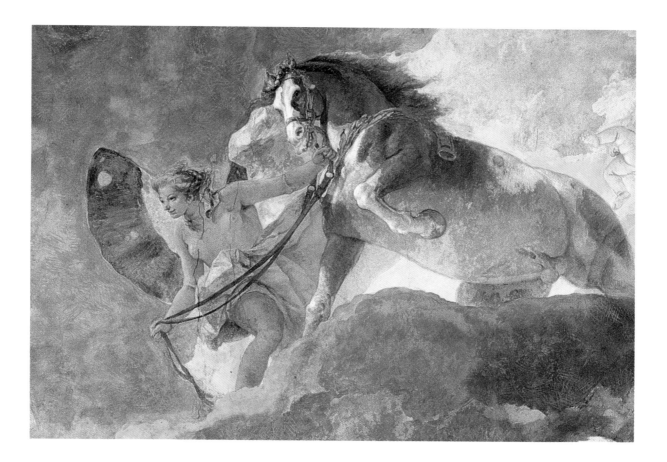

Fig. 35 One of the Hours from the Apollo fresco

restricted by arches and balustrades. Here, the frescoed ceiling finally reveals its full glory, if not its full expanse. To the left and right, the remaining sections, *Africa* and *Asia*, come into view, and between them, on the south side, one's gaze falls on the depiction of Europe (fig. 30).

Africa

A fair way along the side of the ceiling, above the penultimate pilaster, a giant dromedary has lowered itself to the ground to allow its rider to dismount (fig. 36). The rider, a Nubian princess, is the personification of Africa; in her right hand she holds a bundle of bulrushes from the Nile (plate 4). A page kneeling before her is burning incense as a gesture of homage and has unfurled a parasol to shade her from the burning African sun. Her journey is over; she has reached her destination, in front of Europe, where she has caught sight of the medallion bearing the Prince-Bishop's portrait – in the sky diagonally opposite (fig. 10) – and is hailing the image in a gesture of salutation.

One of the princess's followers, in the group on her right, is pointing in the same direction. Her retinue seems to consist largely of big-game hunters, as indicated by the elephant tusks in the foreground. Like the various other typically African offerings arrayed in front of the princess, the tusks are intended as presents for the Prince-Bishop. The river-god of the Nile – the bearded old man in the bottom right-hand corner – is observing these goings-on with great interest.

The picture suggests that Africa has reached a higher stage of civilization than America. The figure of Africa herself has a more regal air than her American counterpart, although she is not a monarch in the 'proper', European sense. The people evidently live in tents, rather than sleeping rough, and have abandoned the primitive hunter-gatherer economy; instead, they earn their living through trade, with Europe as their main partner. The scenes on the left point this out very clearly. One seemingly minor detail in the centre is particularly noteworthy: the ostrich that has jumped over the edge of the painted platform in order to escape from a monkey trying to pull out one of its tail feathers. Ostrich feathers, one remembers, were among the luxury commodities that Africa supplied to the courts of Europe.

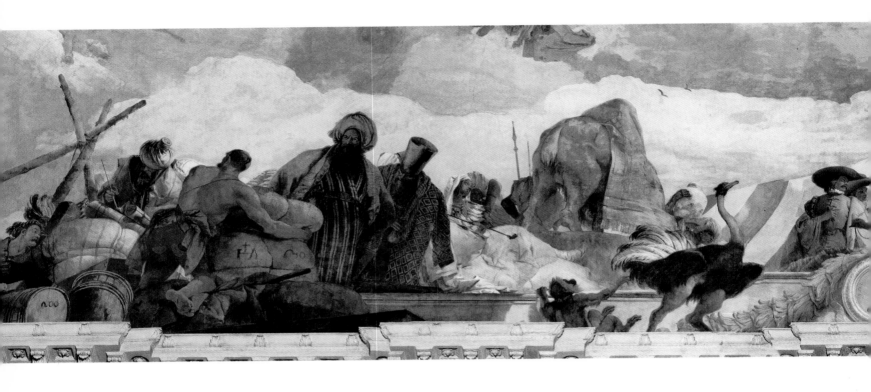

Fig. 36 *Africa*

Fig. 37 *Asia*

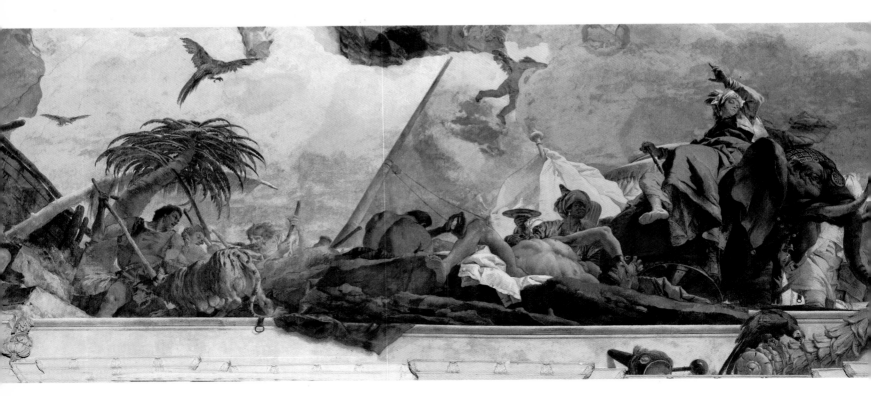

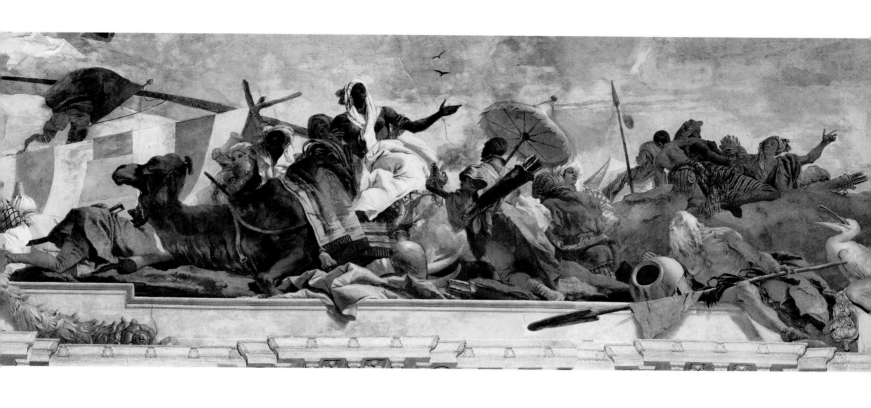

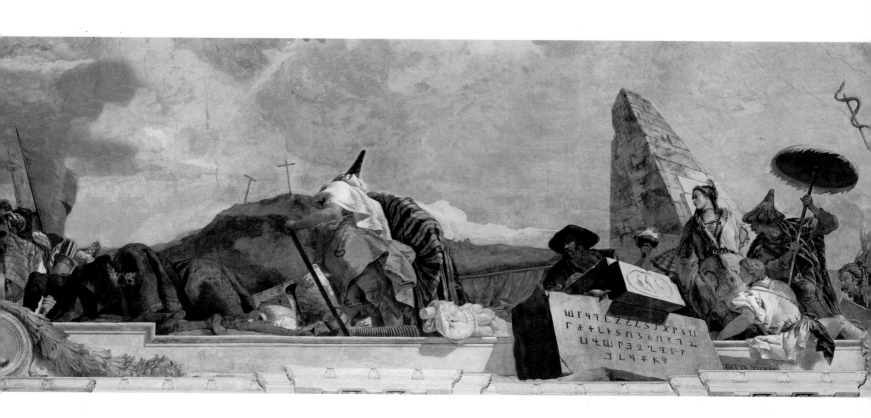

Asia

On the opposite side of the ceiling the personification of Asia rides towards the viewer on an elephant (fig. 37, plate 5). The details of the animal's anatomy mostly derive from the painter's own imagination. Asia, too, is *en route* to Europe, where she and her retinue of dignitaries and soldiers – replacing the group of hunting companions in *Africa* – intend to visit the Prince-Bishop and pay their respects to the great magnate. But the road is long, and, moreover, it has initially taken the party in the wrong direction; hence the positioning of the figure of Asia herself, who is closer than Africa to the centre of the frieze.

A man brandishing a mallet is driving the elephant towards the two prostrate figures in the foreground whose task was to assemble the collection of porcelain vessels, fine fabrics and other articles that are laid out on the ground for Asia's inspection. These, too, are gifts for the Prince-Bishop, as Asia's gesture clearly indicates: once again, we find that the central figure in the picture is pointing in the direction of the Greiffenclau medallion. In accordance with contemporary ideas about the political conditions of supposedly less developed societies, Tiepolo portrays the continent of Asia as a region of despotism and violence, epitomized by the recently landed consignment of slaves on the left of the princess. The slaves are Europeans, and the ship's mast in the background would seem to indicate that they have been captured by pirates, whose appearance might well resemble that of the savage-looking hunters who are catching or killing a tigress on the far left (plate 6). Judging by her lactating condition, the tigress has only recently given birth, which makes the hunters appear particularly cruel.

Whereas the left-hand section of the frieze focuses on violence and depravity, the right-hand side depicts Asia as the cradle of civilization. An especially prominent feature is the block of stone, carved with rows of letters, that appears to project out over the cornice. These hieroglyphs are supposedly the Armenian alphabet, symbolizing the birth of literacy in Asia. On top of the stone is a second block with a relief portraying Athena as the goddess of knowledge and wisdom, framed by a snake biting its own tail, an image that represents the idea of eternity. The bearded man using the second stone as a writing desk is also holding a torch, which signifies intellectual illumination. According to Ripa, the elegantly dressed woman to the right of this figure symbolizes the generosity displayed by the pyramid-building princes. All the members of

this group are looking towards Asia, indicating that she is the incorporation of the wisdom and generosity to which praise is due. Tiepolo, too, has laid a claim to the attentions of posterity by including an inscription, located just to the right of the larger stone, which reads 'BATTA. TIEPOLO F. 1753'.

Asia is not only the fount of wisdom and learning; it is also the source of Christianity, symbolized by the crosses on the hill of Calvary in the background. It is far from coincidental that the two figures in the centre of this section are facing in the direction of Calvary, not towards Asia. For this reason they have been interpreted as pilgrims. They have turned their backs on the sculpture of the many-breasted goddess Artemis of Ephesus, which has fallen to the ground as a sign that the heathen idols have been cast down. The two pilgrims are dressed in oriental costume, as was the custom in order to avoid recognition by the Muslim natives when visiting the shrines of the Holy Land.

A further interesting motif at the far end of the frieze, just before the transition to Europe, is the dwelling built of branches and roughly hewn planks. This is a primitive shelter of the kind described by the Roman architectural theorist Vitruvius as the source of all subsequent architecture.

Europe

The portrayal of Europe is quite different from the depictions of the other three continents (fig. 38). Here, the theme is no longer movement towards a goal; instead, the viewer sees the goal itself: the continent to which tribute is being paid from all sides. In the centre of the frieze, though not quite at the forefront of the action, the personification of Europe is seated on a throne atop a stone plinth, rather in the manner of a Madonna in a Venetian *sacra conversazione*. Her arm is resting lightly on the neck of the bull, the animal disguise adopted by Zeus to abduct her. According to Ripa, the splendour of her robe signals the immense wealth of the region she represents. Her crown and sceptre show that Europe is seen as the premier continent – the natural sovereign, as it were, of the entire world. This is further emphasized by the globe at her feet. Behind her throne, a grand house or palace is under construction, with a monumental pillar on which some form of canopy is eventually to be mounted. The continent of Europe is the home of the world's most powerful men, including the Holy Roman Emperor and the Pope. This is suggested by the figure of the page bearing a

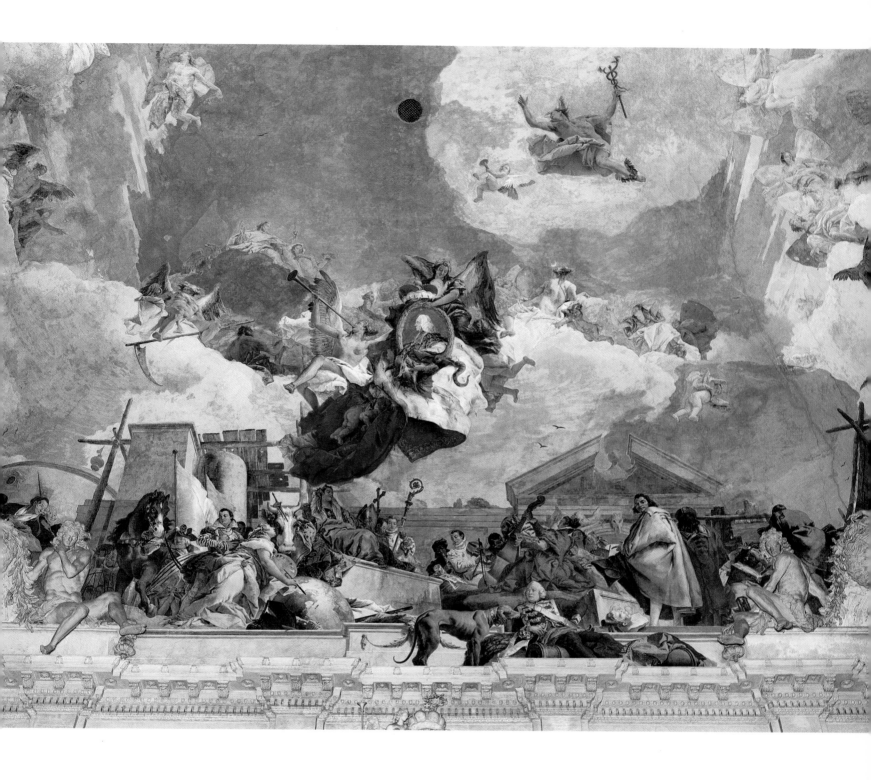

crown on a tray or dish. The crown is not specifically identified, but the motif is probably a reference to the Emperor, echoing the reddish flag, which alludes to the Imperial banner. The horse is painted in striking terms that clearly convey the idea of military and political superiority. No specific reference is made to the Pope, but the episcopal accoutrements are obvious pointers to the person of the Prince-Bishop. Towards the right of the picture, the representatives of the arts are gathered in a group emphasizing the elevated position of Europe as a continent of famous and greatly esteemed figures. The cluster includes several of the artists whom Tiepolo had encountered at the court in Würzburg.

Europe is listening, evidently with close attention, to the efforts of the musicians immediately in front of her. One figure stands out particularly, by virtue of his white cos-

Fig. 38 *Europe*

tume: this is the violinist and composer Giovanni Benedetto Platti, whose wife has been identified as the singer. Balthasar Neumann is the artillery officer reclining on the gun-barrel at the edge of the cornice, listening to the music in the background but looking over in the direction of Africa. He stands for architecture, which is also represented by the image of one of the slate-roofed domes of the Würzburg Residenz at the far left of the picture. The significance of the dog has been the subject of much speculation. Some scholars have wondered whether the animal might have belonged to Neumann himself, but even if the architect did in fact own a dog, it is unlikely that he would have brought it with him to a court concert. One can only assume that an animal allowed to roam at will around the cornice must be one of the Prince-Bishop's dogs, which may well serve the function of symbolizing loyalty, as a quality imputed to Greiffenclau himself. The figure in the voluminous coat, standing to the right of Neumann, is no less striking (fig. 40). He, too, is listening to the music, but his concentration has been disturbed by the appearance of the visitor on the staircase: gesturing towards the group of musicians, he is enjoining us to remain silent so as not to disrupt the concert. The portrait bust and the relief at his feet identify the figure as the stucco-worker Antonio Bossi. Behind him is an older, anonymous man, who is immersed in a book and is paying no attention to the events round about. This figure represents philosophy: judging by the hour-glass in front of him, he is pondering on the finitude of human existence.

Painting is represented by the female allegorical figure known as Pittura (plate 8). Her billowing robe is pinned together at the hip with a brooch bearing the relief image of a mask. Ripa tells us that the mask symbolizes the idea of *imitatio*, the imitation of nature, to which the artist must aspire. Pittura's attention is not directed to the music; instead, she is looking upwards with an expression of surprise, as if she cannot understand what is happening in the area above. The situation is defined thus: at the very moment when the visitor turned round on the half-way landing to begin ascending the last flight of stairs, the allegorical figures Fama and Virtus have literally grabbed the portrait of Greiffenclau from Pittura's easel to present it to the Prince-Bishop's guest (fig. 10). Fame is represented by the female figure with the trumpet, who is broadcasting the Prince-Bishop's name in every direction, while the winged figure of Virtue, above the medallion, makes it clear that such attentions are reserved for the

noblest individuals, whose peculiar merits entitle them to be elevated from the depths of the ordinary world to the status of a god-like figure hovering in the sky. At first glance, Pittura appears to have been engaged in painting the globe in front of her, but this is clearly not the case: she has been making a portrait of the Prince-Bishop, which has been seized from her in such haste that the easel has been knocked over – looking carefully, the viewer can see one of its legs projecting out from under the globe. The whole sequence of events has evidently taken place very quickly: thus one can almost hear the fluttering of Greiffenclau's cloak as it is whisked up into the sky, and his personal emblem, the gryphon, has barely managed to cling on to the portrait's gilded frame.

Greiffenclau is already expected on Mount Olympus, where Zeus, clutching a bunch of

Fig. 39 *Antonio Bossi.* Red and white chalk on blue paper, 44.5 x 28.5 cm. Venice, Museo Correr

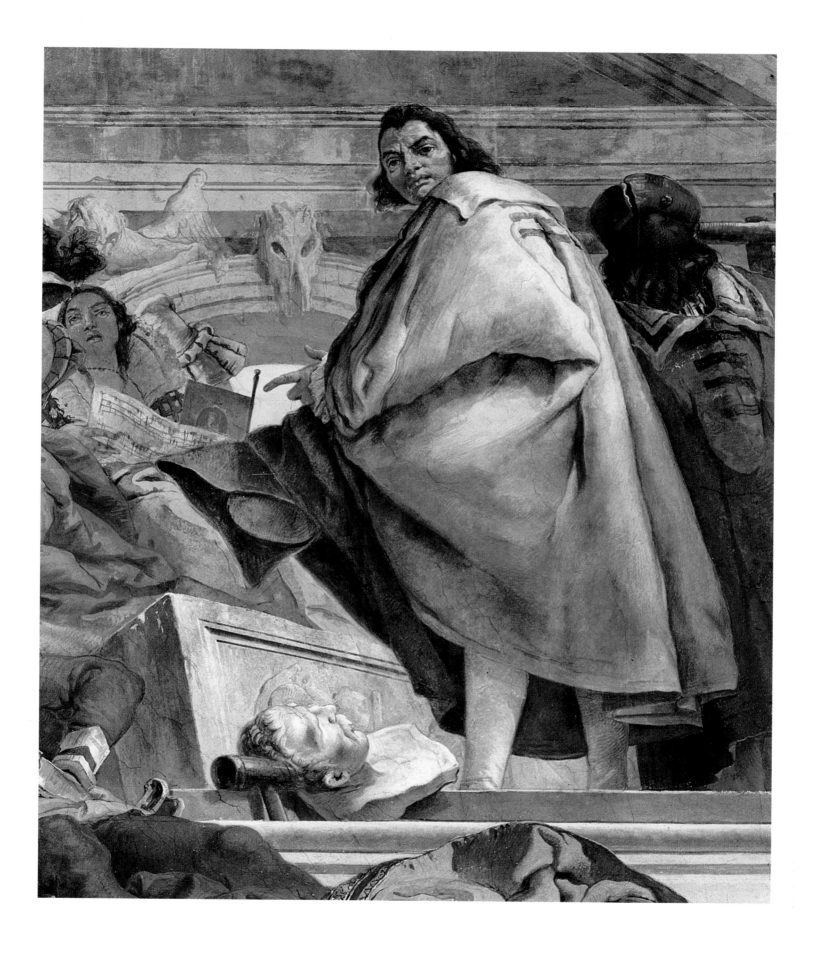

Fig. 40 Antonio Bossi; detail of *Europe*

thunderbolts in his right hand, is enthroned on a cloud. Next to him lies Ganymede, who has suffered a fate resembling that which has befallen the Prince-Bishop, albeit for a different reason: his appointment to the ranks of the immortals is due to his exceptional beauty. His fate on Mount Olympus is to serve as Zeus' cupbearer, and in this capacity he is welcoming Greiffenclau with a dish of wine raised in a gesture of greeting. The Prince-Bishop, of course, was still alive when the fresco was painted, and the visitor was in the palace to pay tribute to him in person. It would therefore have been highly inappropriate to portray him actually ascending to heaven, especially where the heaven in question was a specifically heathen paradise.

The reason for Greiffenclau's elevation to Olympian status lies in his virtues as a ruler. As the fresco argues, the quality that particularly distinguishes his reign is the skilful exercise of power. Europe is not only the most civilized, but also the richest of the continents, and this applies to Franconia, too, as a court society whose members no longer need to work; thus the activities depicted in the fresco have nothing to do with the mundane business of earning a living. While Asia still retains a strong element of wildness and barbarism, these less attractive features have been eliminated from Europe, which is now given over entirely to learning and the arts – hence the gratitude of the artists to the figure of Europe herself. It is no coincidence that the composition follows the well-known scheme of the *sacra conversazione*, which shows saints grouped around the Virgin and Child.

The central and right-hand sections of the frieze are delimited at the rear by a wall with a door in the style familiar in Venice since the sixteenth century. Two striking elements included here are the *bucranium*, the horned ox-skull at the top of the doorway arch, and the winged creature in the spandrel immediately next to it. These bizarre motifs have little in common with the comparable depictions in classical friezes; instead, they have a ghostly, sinister appearance that seems designed to convey the message that our earthly span is limited, in Europe – and Franconia – as everywhere else. 'Et in arcadia ego' is the melancholy motto attached to this world of success and happiness. Perhaps for this reason, the figure of Chronos, sitting on the edge of the group of gods above the head of Europe (plate 7), is endowed with an especial sense of presence, serving as a very pointed reminder of the momentariness of human existence. And yet, even in death, certain things survive, among them the fame of the truly great artist.

Painting is the only art portrayed in allegorical terms. Instead of using the figure of Pittura, Tiepolo could have included a self-portrait, but it seems that he wished to avoid depicting himself as merely one person in a crowd. He has left his mark in the far left-hand corner, where he and his son Giandomenico are seen admiring their own handiwork (fig. 7). Giambattista is clearly dressed as an artist; on his head, he wears only a plain cap, instead of a wig, and a white scarf or cravat is draped loosely around his neck. His son, however, is portrayed in the costume and attitude of an elegant courtier.

The Composition of the Fresco

The staircase fresco owes much of its impact to the interplay of different positions in time. Most of the events in the first section have to do with beginnings: the day is dawning; America and her retinue are embarking on a journey; Apollo is leaving his temple and preparing to travel across the sky. This corresponds directly to the situation of the viewer, who is just beginning to ascend the stairs. When he turns at the landing, the story moves on, and offers a further parallel with his own situation. Asia, like the visitor, is half-way along her chosen path, whereas Africa, the subject of the next section, has completed her journey. At this point, the viewer's progress, like the progression of the continents, comes to a standstill. Thus the movement is divided into three stages: beginning/departure, middle/journey, and end/arrival. The goal is the continent of Europe, and within it, the court of the Prince-Bishop, where the whole world – including the viewer – has gathered to pay tribute to the ruler. This is underlined by the static arrangement of the figures. The compositional scheme is comparable with that of *America*. Above the two central pilasters, from the point where the cornice juts out, the figures are connected by a roughly triangular line that gives them coherence and rhythm. The difference here is that the gaze cannot travel any further: unlike in *America*, it is directed into the picture before being caught and arrested by Bossi, who directs it straight back at the viewer. The suddenness of the guest's arrival is underlined by two details that refer to a single, fleeting instant – the figure of Bossi, turning to face the viewer and bidding him to be silent, and the seizure of the portrait medallion. The buildings at the rear, blocking off the background, serve to amplify the message that Europe is a terminus, a definitive end-point from which no further development or for-

ward movement is possible. This is partly compensated by the upward movement suggested by the triangular form on which the composition is based. However, the triangle has a dual function: although it emphasizes the elevation of the medallion, it also anchors the portrait to the ground. This, as already noted, is only logical, given that Greiffenclau was still alive and firmly installed on a throne in Europe. The same compositional scheme is repeated in the tympanum of the building on the right.

A quite different situation is found on the other side of the ceiling. The group of figures surrounding the personification of America does not extend upwards; instead, all the movement is horizontal, and the picture is structured like a frieze. The clouds billowing up into the sky belong to a quite separate world that has no connection with earthly existence. This is why Tiepolo has used the open, asymmetrical form of the *rocaille* as a compositional structure. Although he sets the clouds on a kind of pedestal, the link between the sky and the scene on the ground is a purely formal matter and has no significance in terms of content.

As in the case of *America*, the depictions of Asia and Africa are conceived and laid out in strip form, with no real connection between the sky and the human events. The pictures can be viewed from two quite different angles. Ascending the staircase, the visitor initially sees only about a third of the total area. Parts of the image – the figures on the left and right, and especially the pyramid – are skewed slightly to one side in order to compensate for the perspective distortion. Tiepolo applied the same technique to the sections that come into view after the turn, although here, of course, the figures lean in the opposite direction. These modifications are so discreet as to be hardly noticeable when the frescos are seen frontally from the gallery, the second of the two viewing positions, to which the guest at the Prince-Bishop's court might be conducted after the main ceremonial proceedings were over. To avoid any impression of randomness in the selection of images discernible to the viewer, Tiepolo divides each picture into two distinct sections by introducing a compositional break. In *Africa* this pause occurs at the point where the gaze falls on the ostrich; in *Asia* the necessary interruption is supplied by the hill of Calvary. If one views the frescos as a whole, rather than looking at individual sections, the breaks do not suggest a hiatus; instead, they seem to contribute a further rhythmical element that helps to accentuate the sections closest to *Europe*.

Using this new method of integrating individual compositions in an overall scheme, Tiepolo succeeded in devising a structure that enables the viewer to experience this huge fresco as a coherent sequence, although it can never be seen at a single glance. Here, the large and almost empty expanse of sky

between the medallion and the figure of Apollo has an important function. If one looks at the fresco in the manner described above, this supposed gap remains unseen, because it is always outside one's field of vision. Hence it is hardly surprising that Tiepolo refrained from filling the space with figures, which would only have served to confuse the visitor ascending the staircase.

The 'gap' has puzzled art historians, who have argued, on the basis of expectations shaped by traditional fresco painting, that Tiepolo's staircase decoration in Würzburg lacked a central motif, and that he had ultimately failed to find a suitable compositional strategy for dealing with the vast surface. Yet if one looks at the work as a whole, it soon becomes apparent that the open sky contributes very substantially to the mounting visual excitement. In his depiction of the continents Tiepolo heightens the sense of drama by alternating sections of densely packed detail with areas of relative calm. The same principle applies in his treatment of the sky.

Fig. 41 Tiepolo's eye; detail of the self-portrait in *Europe* (cf. fig. 7)

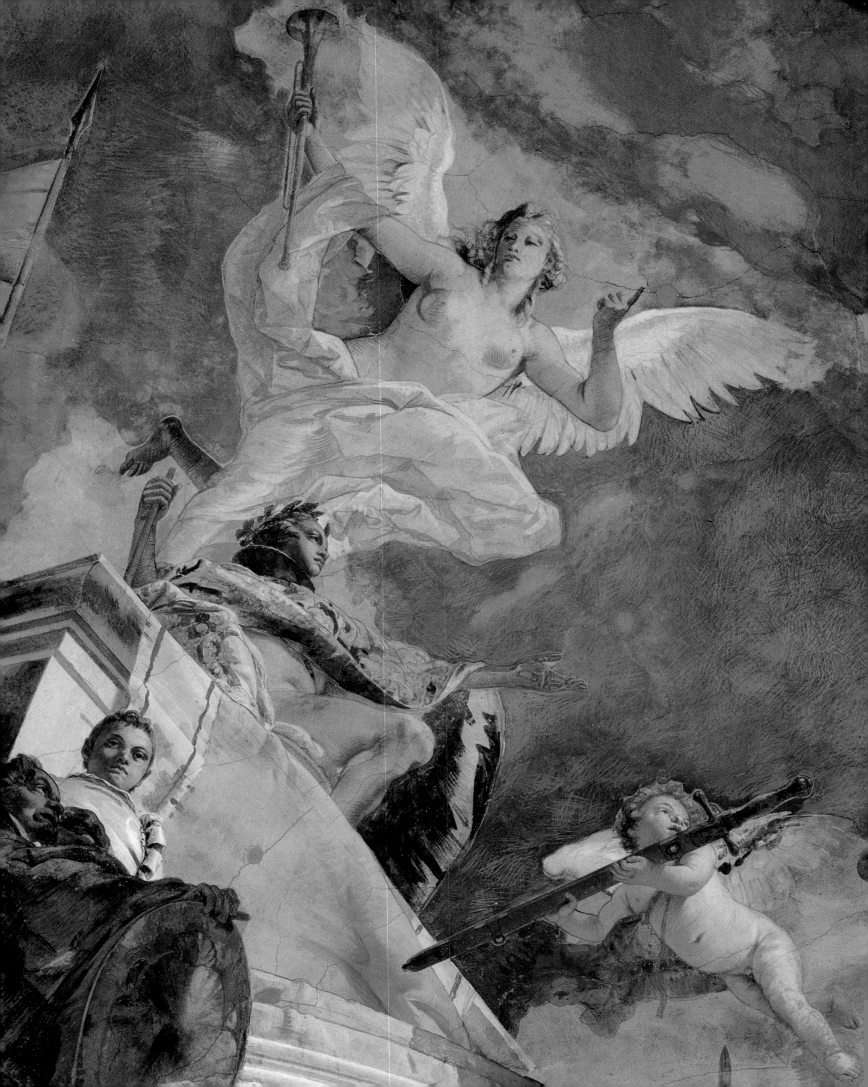

The Kaisersaal Frescos

Leaving the staircase, the visitor enters the Weisser Saal (fig. 43). The transformation is astonishing. Instead of sumptuous fresco decoration, one sees unpainted stucco, designed by Antonio Bossi, which was the sole form of ornament envisaged in Balthasar Neumann's original plans for the walls and ceiling of the staircase and the Kaisersaal (see fig. 11). As its name indicates, the room is entirely white, with slight tonal variations supplied by the grey of the shadows from the relief patterns in the stucco. In Tiepolo's day the white would have been relieved by the red of the uniforms worn by the Prince-Bishop's palace guards, who were posted in front of the door leading to the Kaisersaal: hence the name Gardesaal (guardroom), by which the Weisser Saal is also known.

The aesthetic function of this room, which was completed before Tiepolo arrived in Würzburg, is to provide a brief breathing space between the staircase and the Kaisersaal, where the ceremonial itinerary reaches its exuberant conclusion. On the left, the visitor immediately notices the three arches whose shape echoes that of the triumphal archway at the main door of the palace. Moving forward into the middle of the room, one turns and walks towards the central arch, and is confronted with a surprise that directly recalls the visual *coup de théâtre* at the foot of the staircase. Through the open doorway one can already see the huge gilded crest of the Greiffenclau family on the opposite side of the Kaisersaal, together with part of the wall mouldings and the three-quarter profile columns of marbled stucco. As one advances, the room gradually reveals its full splendour. On finally entering the Kaisersaal (fig. 44), most visitors pause involuntarily when they catch sight of the frescos, whose impact is very different from that of their counterparts above the staircase. The room is an octagonal oval shape, and the entrance is in the centre of one of the longer walls; consequently there is no visual inducement to carry on walking: the entire space can be grasped at once from a single viewing point.

The lower section of the room is set some way forward from the outer wall of the Residenz. Here, there are five tall windows, while above the imposing cornice, which runs round the chamber at a height about half-way

between the floor and the top of the ceiling, the oval form of the vault is interrupted by five curved niches with smaller, semi-oval windows on each of the longer sides of the room (the three windows at the rear are blocked off). Together, these various apertures guarantee an ample supply of light.

The marble floor was installed after the decorations were completed. It was evidently designed with the intention of underlining the various other visual clues that tell the visitor what to do and where to look on entering the room. The checker-board pattern of white and purple tiles is offset by an ornament in a delicate shade of ochre, and a contrasting circular design is found at the most advantageous point for viewing the room as a whole.

A set of written proposals for the frescos in the Kaisersaal had been drawn up some time previously. This detailed and lengthy

facing page
Fig. 42 The *Genius imperii* with the personification of Fame (above), the *Genius Franconiae* (lower left-hand corner) and a *putto* bearing the sword of the Dukes of Franconia (lower right); detail of the ceiling fresco in the Kaisersaal

this page
Fig. 43 The Weisser Saal

document, generally known as the 'programme', was sent to Tiepolo in 1750, before he left Venice, to give him an approximate idea of the Prince-Bishop's wishes. He was expressly permitted to amend the proposals as he saw fit, but the alterations he made were largely confined to the arrangement of the figures: the iconography remained substantially unchanged.

The thematic intention of the Kaisersaal frescos is to emphasize the closeness of the relationship between Franconia and the Holy Roman Empire. The painting on the south wall depicts the marriage – solemnized by the Bishop of Würzburg in 1156 – of Emperor Frederick Barbarossa to Beatrice of Burgundy. Since Beatrice was the heiress of Burgundy, the marriage brought the area back into the Imperial fold. Here, therefore, the Emperor is portrayed as the recipient of a benefaction, but in the painting on the facing wall the roles are reversed: Barbarossa himself is shown in the capacity of a donor, investing Herold, the first Prince-Bishop of Würzburg, in 1165 and confirming the rights and privileges originally conferred on the duchy of Franconia by Charlemagne. The ceiling fresco then links these two events in what the programme calls 'poetic form', i.e. by fitting them into a composite allegorical image.

Apollo Conducting Beatrice of Burgundy to the 'Genius imperii'

Here, in the main fresco, a number of narrative strands are brought together in a single, fleeting moment of culmination (fig. 46). It is midday, and the sun has just reached its zenith. Rearing above a bank of cloud, the fiery horses of Apollo have conveyed their master and his charge to the goal of their journey. The figure in the sky, bearing a torch and beckoning, is Hymen, the Greek god of marriage, who has guided the chariot bearing Apollo and Beatrice, the Emperor's intended consort. She has just caught sight of her bridegroom, the 'Genius of Empire' seated on the left, and the couple are enthusiastically hailing one another with outstretched arms. Apollo, too, is wearing an appropriately joyful expression.

This complex drama takes place the moment that the Prince-Bishop's guest enters the Kaisersaal. And here, the story of the Würzburg frescos comes full circle. The start of Apollo's journey at daybreak is the first image that becomes visible in the staircase area. During the visitor's progress up the staircase and through the Weisser Saal, the god has disappeared from view, but we now

realize that he has been busy collecting Beatrice and conveying her across the skies in the chariot of the Sun to meet her designated husband.

The *Genius imperii* (fig. 42) is an allegory of the Holy Roman Empire, portrayed as a semi-naked youth wearing a crown of laurels; a cloak of sumptuous material is loosely draped around his shoulders, and he clutches a sceptre in his right hand. As the personification of wisdom and good government, he is the intended recipient of the statuette of Athene carried by Apollo, which, one remembers, he had held in his hand in the daybreak fresco above the staircase (plates 9, 10).

At the base of the throne is a cluster of figures described in the programme as 'several Genii of Empire holding all manner of insignia or trappings which they have bestowed upon the land of Franconia to dignify it or enlarge its wealth; for example, the ducal banners, the ceremonial sword of the Prince-Bishop, the Duke's hat, the purple mantle of Empire, a cornucopia with a selection of coins, and maps serving to depict the extension of the country's borders'. Here, Tiepolo departed some way from the court's specification, portraying the 'Genii' as real human beings rather than purely imaginary figures, and assigning the hat and the purple cloak to the *putti* above the group, right at the fresco's edge, while the Duke's sword is held aloft by a further *putto* hovering in front of the throne and facing towards Apollo (plate 11). This *putto* is bringing the sword to the *Genius Franconiae*, the allegorical figure kneeling by the throne with his right hand resting on the shield in front of him, who embodies the spirit of Franconia. On the other side of the throne, we find the white-robed personification of Religion, the ultimate fount of secular power. Floating above the group, the figure of Fame is greeting the deputation of heralds and standard-bearers who have come to announce Beatrice's arrival; in a moment, she will go on to trumpet the praises of the *Genius imperii*. Nearly the whole area on the left above the latter's head is enveloped in a dramatic, purplish red cloud.

On the right-hand side of the fresco Beatrice's arrival is being observed by a group of classical deities who represent various aspects of Franconia. The depiction of Ceres, perched on the top of the cloud, serves to remind the viewer of the region's fertility and prosperity, while the figure of Bacchus, festooned with the customary grapes, underlines the importance of wine-growing for the local economy (plate 12). The programme stipu-

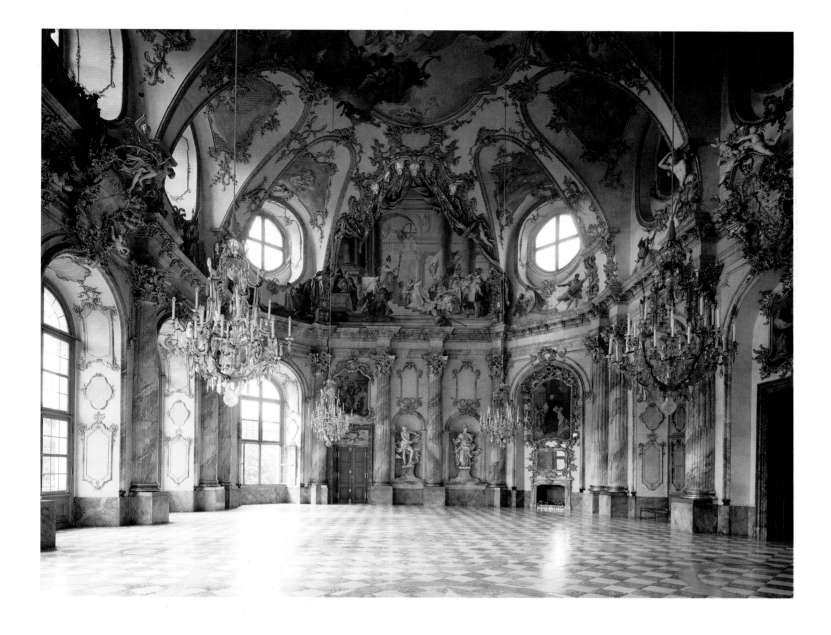

Fig. 44 The Kaisersaal, view to the south wall

lated that Diana, the huntress, was to be included as a pointer to Franconia's abundance of game. Tiepolo changed the plan and replaced Diana with the figures of Venus and Cupid, which doubtless seemed more appropriate to the scene as a whole. At the far right-hand end of the oval Concordia holds aloft a ring of olive branches as a symbol of the peace that results from 'concord', while the sceptre in her other hand indicates that she will rule over the marriage and ensure that it remains harmonious.

Finally, just above the ceiling surround, there is the personification of the River Main, portrayed as a naked old man and accompanied by a nubile nymph reclining lasciviously on a piece of cloth whose blue colour refers to the water of the river. As well as dallying with the elderly river-god, the nymph also catches the viewer's eye and begins to flirt with him as soon as he enters the room. The blatantly sensual character of this part of the fresco forms an earthily 'natural' complement to the idealized love of the central couple, whose mythical significance effaces the physical aspect.

Apollo, the Emperor's Patron

In the programme setting out the iconographical guidelines for the Kaisersaal, Apollo is given the name 'Phoebus Orientalis'. Since the marriage is described as taking place in 'Francia orientali', there would appear to be good grounds for interpreting the figure of Apollo as referring to Franconia or its ruler.

Corroboration for this reading can be found in contemporary sources, which often link the Prince-Bishops of Würzburg, including Greiffenclau, with the symbolism of light and the sun, an image that was also in common use elsewhere – and had been so ever since the days of Augustus, when the name of the Roman emperor first became associated with the sun-god. The latter aspect also makes it possible to see Apollo as a reference to the Holy Roman Emperor.

Both these identifications are plausible, but they pose problems with regard to the internal logic of the paintings. On the one hand, if Apollo is the Emperor, it makes no sense to show him leading Beatrice to the *Genius imperii*, which would mean that the Emperor was bringing his own bride to himself, or to the allegorical figure that represents him. On the other hand, it would be a colossal impertinence for the Prince-Bishop, as a provincial ruler, to usurp an attribute belonging to his Imperial master. In pictures showing the Emperor with one of his princes the most powerful symbols had to be assigned to the former, as the highest-ranking sovereign. Only where the Emperor was not involved, as in the local panegyrics to the Prince-Bishop, could a prince allow himself to flatter his own vanity by using the attribute of the sun; anything else would have been a gross violation of the conventions of precedence.

The most convincing reading of Apollo, one that best accords with the overall context of the frescos, is to view him as the Olympian patron of the Emperor. In other words, Apollo has decided to act as a protector to Barbarossa – and to all the latter's heirs, including Francis I, the Emperor of the day. He will accompany the Emperors and light their path, as befits their majesty and dignity.

This would make the work a new variant in a series of depictions associating Apollo with the Emperor. For example, Paul Troger's ceiling fresco of 1739 for the Imperial staircase in the monastery of Göttweig in Lower Austria represents Emperor Charles VI as Apollo crossing the sky in a chariot of fire (fig. 45). In similar renditions of the motif, such as the portrayal of Apollo in the staircase at Pommersfelden (fig. 85), the connection with the patron is not explicitly spelled out, but it is implied by the spatial situation. In Würzburg the intention was to laud the Emperor and the patron in equal measure, so an alternative solution had to be found. Tiepolo seems to have played a part in this; at all events he succeeded in modifying the subject-matter so that it fitted the requirements of narrative structure.

The Marriage of Barbarossa

The two wall frescos belong to a quite different world. Instead of using allegorical stylization, they portray historical scenes in a relatively straightforward, documentary style. In both pictures the events unfold as if on a stage. This effect is emphasized by the curtains of moulded plaster that are drawn back by the winged *putti* at the moment when the viewer enters the room. The resultant sense of sudden, concentrated drama is similar to that evoked by the surprise appearance of Apollo in the ceiling fresco.

The first painting the viewer sees is the one on the south side, showing the marriage of Frederick Barbarossa and Beatrice of Burgundy (fig. 47). Although the scene is clearly set in a church, the spatial disposition makes little sense in concrete architectural terms: instead, it is governed by thematic considerations and by the desire to achieve maximum artistic impact. On the left, the stucco 'curtain' is still partly lowered, with the result that only the legs of Christ are visible on the crucifix above the altar. The two massive pillars opposite the altar lack any obvious architectural function, and would thus appear to be merely symbols of Imperial grandeur.

Barbarossa and Beatrice are kneeling on the altar steps, with the Emperor holding his

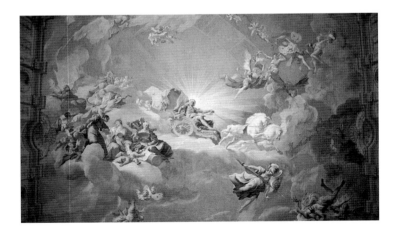

bride's hand while the Bishop, towering above the couple, bestows his solemn benediction upon their union (plate 13). Beatrice is dressed in luminous, shimmering silks. Immediately behind her, a page is bearing the Imperial crown on a cushion. The description in the programme continues with the stipulation: 'On the right of the bridal couple shall appear the attendant persons of royal and noble blood, whose ranks may also be permitted to include members of the clergy or papal ambassadors.' The figures in the back row

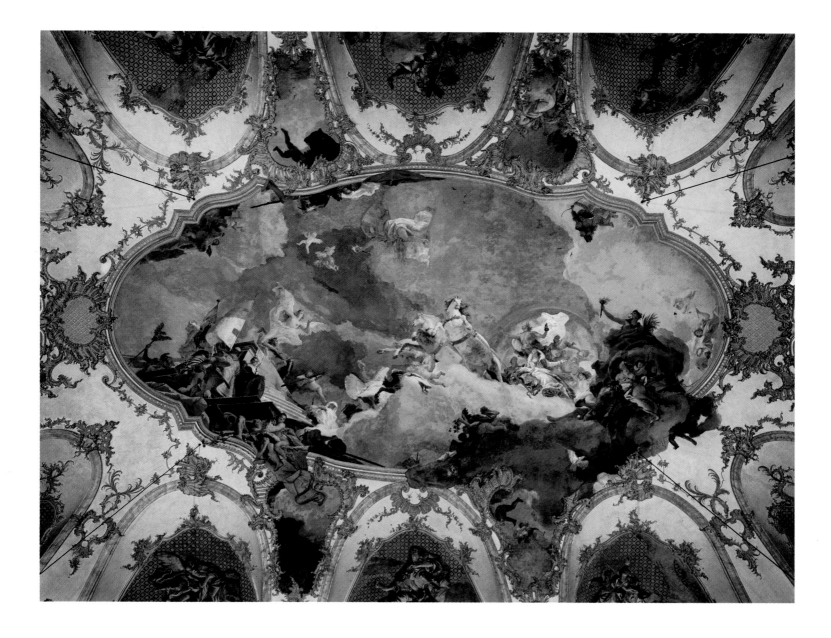

clearly fall into the latter category. Above the heads of the group we see the flag of the Holy Roman Empire, with the symbol of the double-headed eagle, and the purple banner of its purported historical forerunner, inscribed with the initials SPQR (short for *Senatus Populusque Romanus*, i.e. the Senate and people of Rome). The Imperial Marshal, also clad in purple, is presenting an unsheathed sword as a sign of the Empire's power. With an expression of curiosity he is looking to the rear; the gaze of some of the other figures is fixed in the same direction. On the far right the major-domo of the Franconian court is also carrying a sword. This is an allusion to the right of the Bishops of Würzburg to be preceded by a sword-bearer on

special ceremonial occasions, even when celebrating a religious service. The programme makes it possible to identify the male figure kneeling on the left as Beatrice's father, Count Rainald of Burgundy, attended by members of his retinue.

The wedding scene is framed at the rear by an arch, which supplies a further image of pomp and triumph. Through the arch the viewer sees a group of court musicians, who are accompanying the ceremony from a gallery overlooking what might be termed the aisle of the church.

It has been noted that this painting can be viewed from two directions. Looking at it from the entrance area, one can enter the composition from the right. In this case, one's

Fig. 46 *Apollo Conducting Beatrice of Burgundy to the 'Genius imperii'*; ceiling fresco in the Kaisersaal

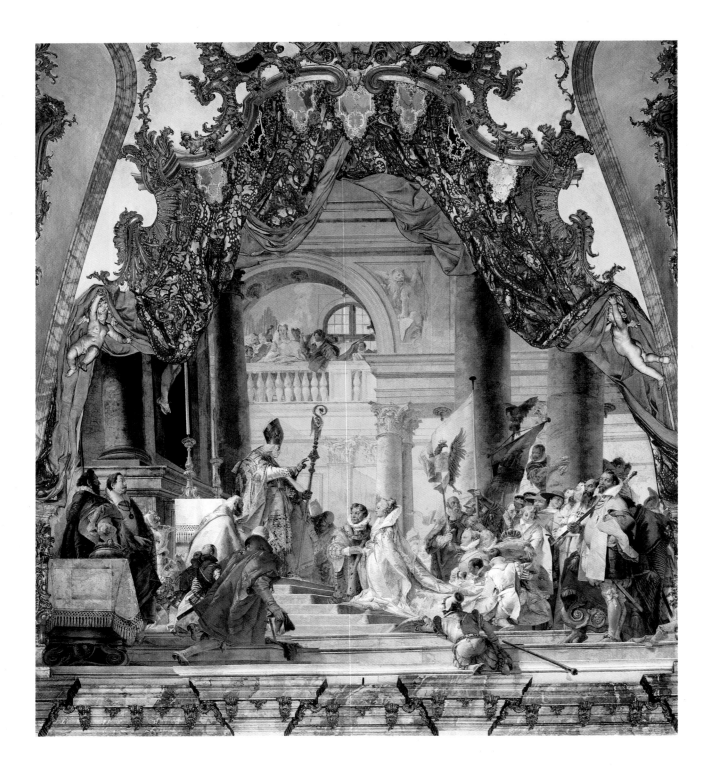

eye follows the line marked out by the dwarf herald and his staff. The gaze is arrested by the figure of the Bishop, who directs it – via his gesture of blessing – towards the bride. This movement is echoed by the curve of the arch behind the two figures. If one advances into the room and looks at the picture face-on, the gaze then begins to move to the right, guided by Count Rainald with his red cloak. Beatrice becomes the main motif, and from

her the gaze wanders on via the group of Imperial dignitaries to the major-domo, who catches it and, by the turn of his head, sends it back to the viewer.

Thus the scheme is almost identical with that found in the depiction of Europe on the staircase ceiling, where the same functions are served by the figures of Pittura and Antonio Bossi. Even the dwarf has a compositional equivalent in the figure of Balthasar Neu-

Fig. 47 *The Marriage of Frederick Barbarossa and Beatrice of Burgundy*; fresco on the south wall of the Kaisersaal

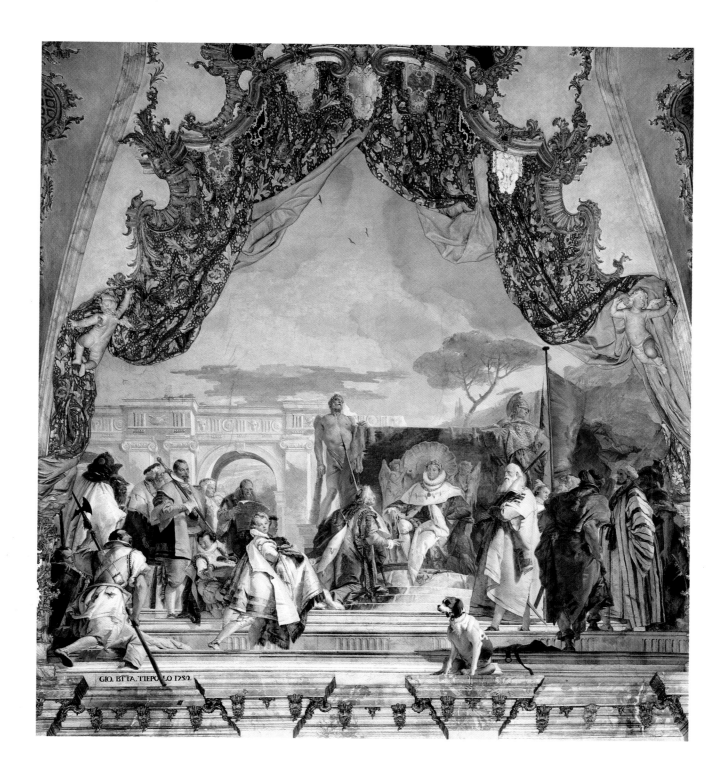

mann reclining on the gun-barrel. Again, the overall sense of rhythm is enhanced by the vertical lines of the two central pilasters, which are continued in the painting itself. Several especially striking motifs are arranged round this zone of the fresco; most notably, the father of the bride and the dwarf are positioned in such a way that their lower extremities appear to be resting right on the edge of the cornice.

The Investiture of Bishop Herold

In the Investiture fresco on the opposite wall, the relative positions of Church and State are reversed: the Emperor, seated on a monumental throne, is extending his sceptre to Herold, the Bishop of Würzburg, who is kneeling before his secular master and swearing the oath of fealty while touching the sceptre with the first two fingers of his right hand (fig. 48).

Fig. 48 *The Investiture of Bishop Herold as Duke of Franconia*; fresco on the north wall of the Kaisersaal

Fig. 49 Group above the cornice on the west wall
of the Kaisersaal

Figs. 50–7 Figures above the cornice on the east (upper row)
and west walls of the Kaisersaal

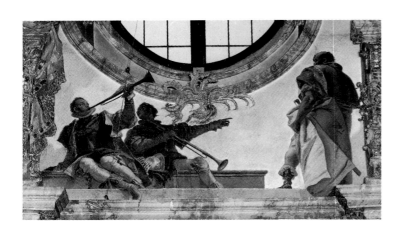

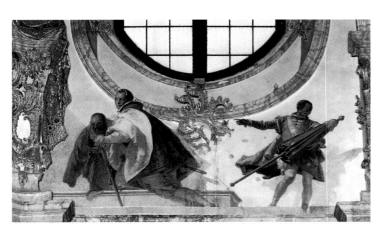

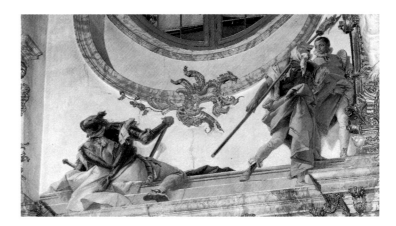

The throne is an artfully contrived structure incorporating a plethora of symbolic allusions (plate 15). Its armrests are carved in the shape of an eagle, an image that not only has general connotations of power and grandeur but also underlines the purportedly Roman origins of the Empire. The angels on the throne-back signify 'holiness', and the shell that they hold aloft resembles a halo or glory around the Emperor's head. Behind the throne, the imposing figures of Hercules and Athene testify to the ruler's virtue and wisdom.

The figures assembled to the right of the throne are members of the Emperor's retinue. Again, the group includes the Imperial Marshal shouldering the unsheathed ceremonial sword. He is accompanied by soldiers and men in Oriental dress, whose function is to emphasize that the Empire extends as far as Sicily, although, in fact, this was not yet the case at the time of the investiture. The purple

banner of Empire, with its laurel crown, flutters above the heads of the group. On the other side of the throne, the Bishop's retinue comprises Electors, Church dignitaries, and soldiers. To mark his investiture, Herold has been given custody of Barbarossa's red-and-white flag. His further badges of secular office are the ermine cloak slung over his shoulder and the 'Duke's hat' borne on a cushion by the page at the rear; his status as a spiritual ruler is indicated by the vestment held by the page in front (plate 14). The major-domo, presenting the Bishop's sword, makes a further appearance.

The programme particularly stresses that the painting must show the confirmation of the privileges previously granted to the Bishops of Würzburg, although the *diploma confirmationis* was not in fact conferred until three years after the investiture. Tiepolo fulfils his patron's wish by placing the figure reading

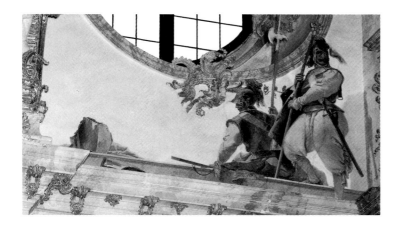

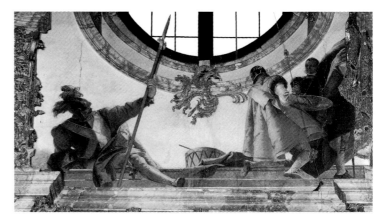

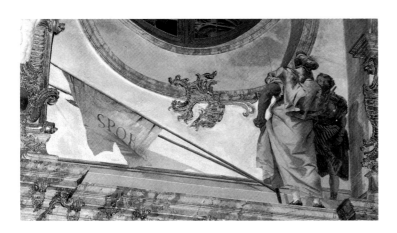

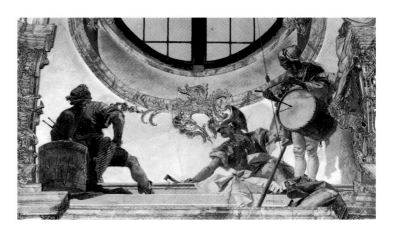

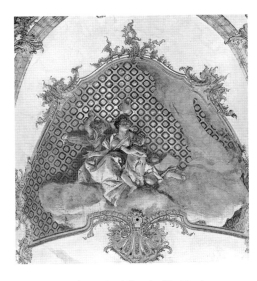

Fig. 58 Giandomenico Tiepolo (?),
Virtue and *Merit*

Fig. 59 Giandomenico Tiepolo (?), *Peace*

Fig. 60 Giandomenico Tiepolo (?), *Charity*

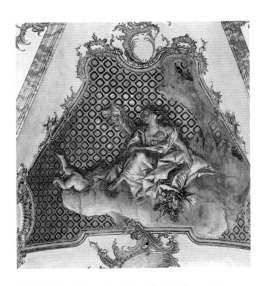

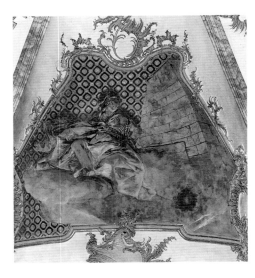

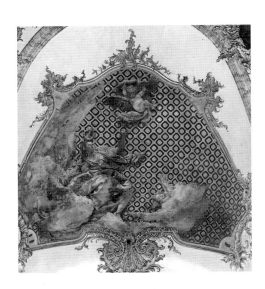

Fig. 61 Giandomenico Tiepolo (?), *Generosity*

Fig. 62 Giandomenico Tiepolo (?),
Magnanimity of Princes

Fig. 63 Giandomenico Tiepolo (?), *Hope*

Fig. 64 Giandomenico Tiepolo (?), *Faith*

Fig. 65 Giandomenico Tiepolo (?), *Mercy*

Fig. 66 Giandomenico Tiepolo (?), *Religion*

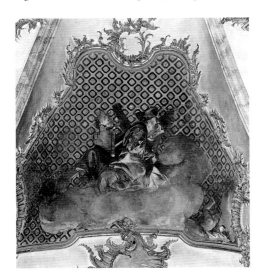

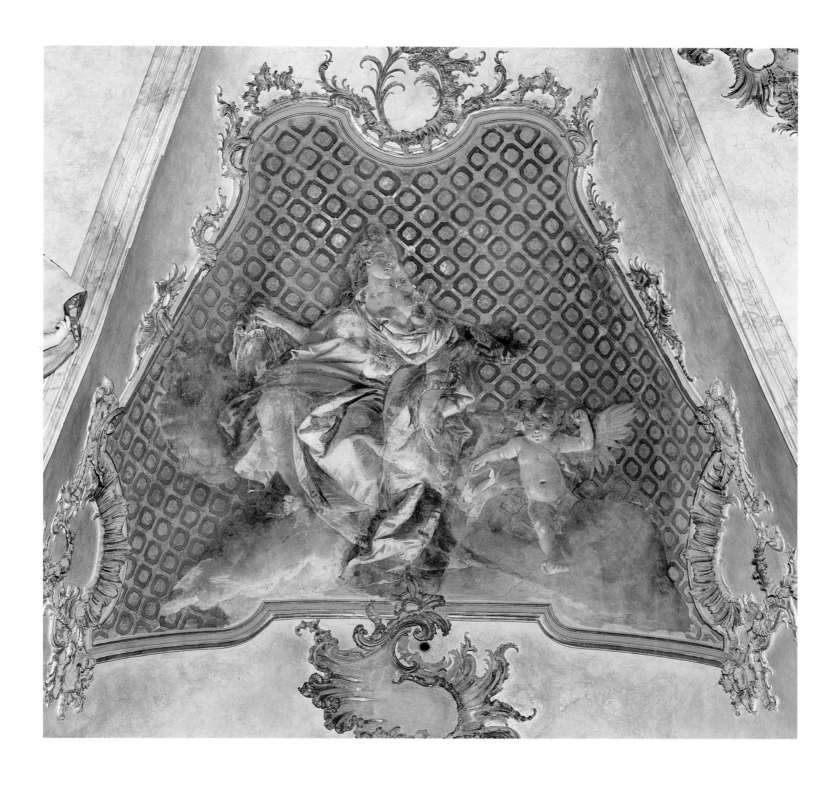

Fig. 67 Giandomenico Tiepolo (?), *Prudence*

out the proclamation in front of a Roman arch that frames his head like a ceremonial canopy. The dog in the foreground – painted with such verisimilitude that one feels it would jump out of the picture and come running to heel if somebody whistled – symbolizes the loyalty of the newly appointed prince to the Emperor. Although Tiepolo knew that the investiture took place in Franconia, he gave it a Mediterranean setting in order to strengthen the association with ancient Rome and the Latin Empire.

Despite the reversal of roles and the corresponding inversion of the composition, the picture is structured along lines similar to those found in the marriage fresco. Entering

from the left, the eye automatically travels along the path that leads to the Emperor. The movement is initiated by the halberdier on the far left and finally arrested by the Imperial Marshal on the right, who directs the gaze back to the viewer. And once again, we find Tiepolo employing the *trompe-l'œil* device of the projecting cornice immediately above the pilasters, which supply a 'platform' for the seated dog and the first of the pages.

Here, as in the Marriage fresco, the Bishop is given the features of Greiffenclau. This serves as a signal that the implied view of the relationship between Church and State, and province and Empire, is still relevant to contemporary conditions.

Subsidiary Images

The two wall frescos are augmented by a series of figures painted immediately above the cornice of the Kaisersaal (figs. 49–57). They consist of soldiers awaiting the end of the ceremonial events, trumpeters blowing celebratory fanfares (fig. 1) and minor courtiers who have failed to find any other vantage point from which to observe the scene. Depicted in strikingly realistic arrangements and poses, the figures are masterpieces of illusionistic painting. Some of them are built up with stucco moulding that extends beyond the immediate window area, so that they appear to be suspended in space; this impression is

Fig. 68 *Portrait of Lorenzo Tiepolo*, 1746–7.
Chalk on paper, 27.4 x 20.3 cm.
Paris, Fondation Custodia, Collection Frits Lugt

reinforced by the shadows they cast. They are set on the same level as the main wall frescos, which amplifies the theatrical, stage-like character of the latter.

Painted in a luminous silvery green that stands out sharply against the gold background, the allegories in the lunettes (figs. 58–67) inhabit a realm that is far removed from the illusionistic sphere of the other images. Instead of depicting specific historical events, these paintings are symbolic evocations of qualities presumably meant to be associated with the Prince-Bishop. Yet despite their 'literary' character, the figures are not stiff and static. On the contrary, one senses that a very concerted attempt is being made to render them as lively and immediate as possible, chiefly by depicting them in complex poses. It has often been surmised that these works may have been painted by Giandomenico Tiepolo. Occasional anatomical infelicities and the hint of heaviness in the drapery would tend to confirm this attribution.

Giandomenico certainly painted the overdoors in the Kaisersaal. The records of the court treasury show that he executed them in the summer of 1751, and presented the bill for his services on 18 September. As the terms of remuneration had not been agreed in advance, he was allowed to name his own fee – the sum demanded was 180 ducats. The subject-matter, which had to harmonize with the overall iconographical plan for the room, was of course dictated by the court, which requested three images dealing with the rights and duties of Church and State.

Over the middle door from the Weisser Saal the Emperor Justinian is depicted in the role of lawgiver (fig. 69). In his left hand he holds the *Corpus juris civilis*, the collection of laws and legal interpretations published under his sponsorship between AD 529 and 565. His other hand contains a sword as a sign of judicial authority. According to Ripa's manual of iconography, the significance of the sword as an attribute is that Justice's power is independent of the obligations of friendship or enmity. Justice can be depicted staring straight at the viewer, with *occhi di acutissima vista*, but she may equally well be blindfolded: in either case, the implication is that she is all-seeing. The large sheet of parchment held by the kneeling page bears the names of the authors of previous legal codes. The young Giandomenico has left his own mark at the bottom of the sheet, where the inscription reads: '1751 /D:° T:° / ETTATIS. / XXII.' In order, perhaps, to emphasize the magnitude of his own achievement, the painter has made himself

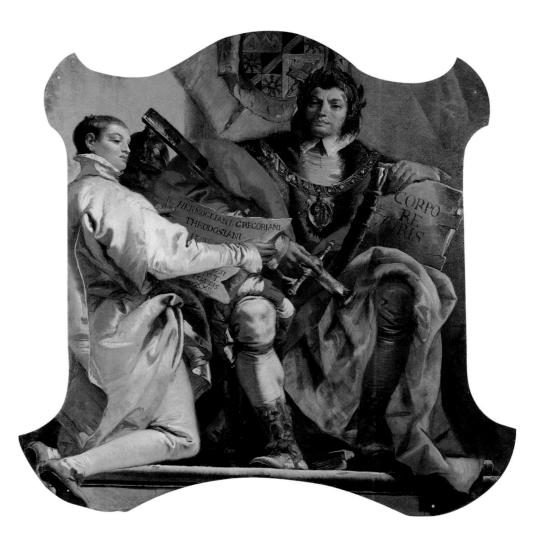

two years younger than he actually was. The page's features bear a strong resemblance to the face of Tiepolo's youngest son, Lorenzo, who was aged fifteen at the time when the painting was made (fig. 68). Greiffenclau's personal coat of arms, which can be seen behind the Emperor, is intended to convey the message that the Prince-Bishop, too, is a worthy representative of justice and authority. The picture also seeks to emphasize the unbroken continuity of the legal system from Roman times to the present.

The theme of the overdoor on the south side is still a matter for conjecture (fig. 70). However, a convincing case can be made for the view that the painting depicts the Roman emperor Constantine the Great, who ordered the execution of his co-emperor Licinius as a punishment for persecuting Christians. The men on the right would then be followers of Licinius, who are being called upon by Constantine to place themselves under the protection of the Cross. This follows Constantine's victory over his brother-in-law Maxentius at the Milvian Bridge, achieved by complying

Fig. 69 Giandomenico Tiepolo, *Emperor Justinian as Lawgiver*, 1751. Oil on canvas, 178 x 177 cm. Overdoor in the Kaisersaal

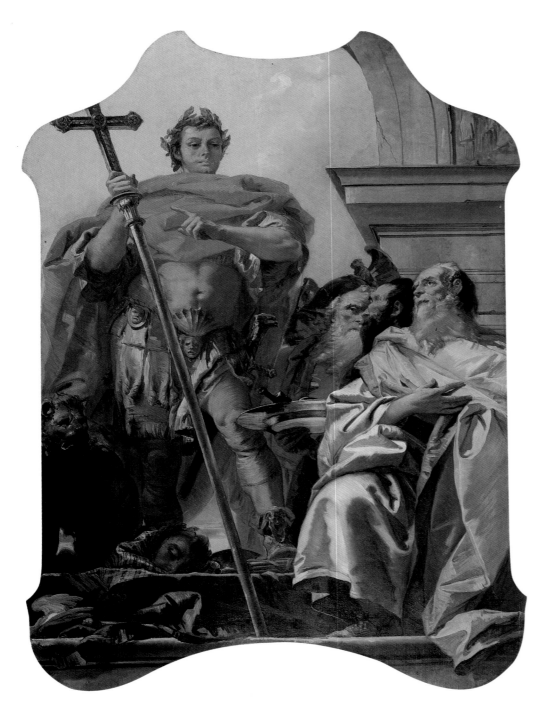

left

Fig. 70 Giandomenico Tiepolo, *Constantine the Great as Defender of the Christian Faith* (?), 1751. Oil on canvas, 238 x 174.5 cm. Overdoor in the Kaisersaal

Fig. 71 The *Kirchenvätermitra, c.* 1600. Würzburg, Diözesan-Archiv

with instructions received in a dream to paint the Christian monogram on his troops' shields. The purpose of the picture is therefore to portray the emperor as a defender of the Christian faith.

The third overdoor painting shows an episode from the legend of St Ambrose, Bishop of Milan (fig. 73). With an imperious gesture he is refusing to allow Theodosius, the last Roman emperor of the East, to enter his church. Ambrose is expressing his outrage at the emperor's cruelty in staging the massacre of several thousand innocent citizens of Thessalonica by way of retaliation for the murder of one of his generals. For this, Theodosius was ordered to do public penance by appearing in church in the garb of a sinner, having removed all his marks of worldly office. The painting therefore asserts the authority of the Church over the power of temporal rulers,

Fig. 73 Giandomenico Tiepolo, *St Ambrose Bars Emperor Theodosius from Entering the Church*, 1751. Oil on canvas, 239 x 175 cm. Overdoor in the Kaisersaal

Fig. 72 Giandomenico Tiepolo, *St Ambrose*; drawing after fig. 73. Pen and ink and wash over black chalk on paper, 34 x 16.5 cm. Harvard University Art Museums, Bequest of Meta and Paul J. Sachs

even if they hold imperial rank. Greiffenclau evidently claims the same authority for himself. This is indicated by the fact that Ambrose is wearing the so-called *Kirchenvätermitra* (Mitre of the Early Fathers), which the Bishops of Würzburg customarily wore on special occasions (fig. 71). Like the Greiffenclau insignia in the picture of Justinian, this detail establishes a symbolic link between the past and the present.

The Genesis
of the Frescos

One of the first things Tiepolo will have done after his arrival in Würzburg on 12 December 1750 was to carry out a careful inspection of the Kaisersaal. He probably cast an eye over the staircase, too, but this was not yet under discussion: for the time being, the scope of the commission was limited to the Kaisersaal.

Initially, the painter's main task was to revise the programme for the room, endeavouring to reconcile the court's wishes with his own ideas and stylistic idiom. The programme had clearly not been drawn up by an artist: it was couched in ostentatiously 'learned', academic terms, and Tiepolo had to discard or rework parts of the material to fit the narrative framework. It seems to have been his suggestion to switch the positions originally envisaged for the Marriage and Investiture frescos. Quite why this was done is uncertain: it can scarcely have had anything to do with the ceiling fresco, but there must have been some very cogent reason for wanting to change the order, as this meant reversing the chronological sequence, with the result that the pictures now had to be read from right to left.

The architecture of the Kaisersaal proved easy to handle, and Tiepolo seems to have had little difficulty in making the oil sketch for the ceiling fresco. The degree of congruence between the sketch and the finished work tends to confirm the supposition that he found the task of designing the picture relatively simple. Contemporary records show that it was completed in the space of about four months. On 17 April 1751 the court harbinger wrote: 'After dinner, his Grace betook himself to the Chamber wing to see the drawing that the artist Tiepolo has begun to make for the room that is to be painted.' This 'drawing' can only be the oil sketch that now hangs in the Staatsgalerie in Stuttgart. Tiepolo is said to have 'begun' the sketch, but his ideas must already have been fully formed at this point, because only ten days later he began to transfer the design to the ceiling. The courtier writes: 'Today, the artist Tiepolo embarked upon the painting of the main chamber.' Work proceeded at a brisk pace, and on 8 May we are told: 'The painter Tiepolo is coming on well with his decoration.' Two months later, on 8 July, the feast day of

St Kilian, the fresco was unveiled after a celebratory luncheon in the Weisser Saal. The occasion was attended by twenty-eight people, including the Prince-Bishop's brother, who had travelled specially from Mainz to be present. Unfortunately, the official's brief comments give no indication of the company's reactions to the painting: 'Music was played, and after table the ceiling decoration by the Italian Tiepolo was uncovered and examined.'

The Oil Sketch and Drawings for the Ceiling of the Kaisersaal

Instead of confining his attention to the area covered by the fresco, Tiepolo made the oil sketch (fig. 75) with an eye to the entire room, allowing the picture to spill out over the edge of the ceiling surround and invade the adjoining space. The *trompe-l'œil* effect was entirely dependent on the successful integration of architecture, stucco-work and painting. Tiepolo's idea was to paint the room in such a way that the sky seen through the windows would echo its painted equivalent on the ceiling and walls. The sections that extend over the edge of the picture had to be modelled in stucco before they could be painted. This required careful planning, in consultation with the *stuccateur*, Antonio Bossi, and the gilder, Franz Ignaz Roth. Tiepolo's involvement in every aspect of the decoration work is indicated by the documented stipulation that the gilding work was to be carried out 'under the supervision of the painter Tiepolo'.

The Stuttgart oil sketch is one of Tiepolo's most remarkable performances in this genre. It was the first painting he showed to the Prince-Bishop, and one senses his eagerness to impress his patron. Since many of the motifs are modelled in detail, the picture amounts to far more than just a sketch: in truth, it is a fully-fledged painting in its own right. Even the elements that are only outlined, such as the figures at the edge, possess great artistic charm. Tiepolo draws with the brush as if it were a pen or pencil, wielding it with the same lightness and sureness of touch as in his virtuoso ink drawings.

When preparing the sketch Tiepolo made a number of studies which he subsequently assembled into a whole. Certainly, this is the impression one receives if one looks at the sketch more closely. The individual sections are balanced and internally coherent, but there is little sense of connection between them: the group on the left, with the *Genius imperii* and the various figures gathered around his throne, appears quite separate

Fig. 74 *Nude Study: The Back of a Seated Man.* Red and white chalk on blue paper, 34.4 x 28 cm. Stuttgart, Staatsgalerie, Graphische Sammlung

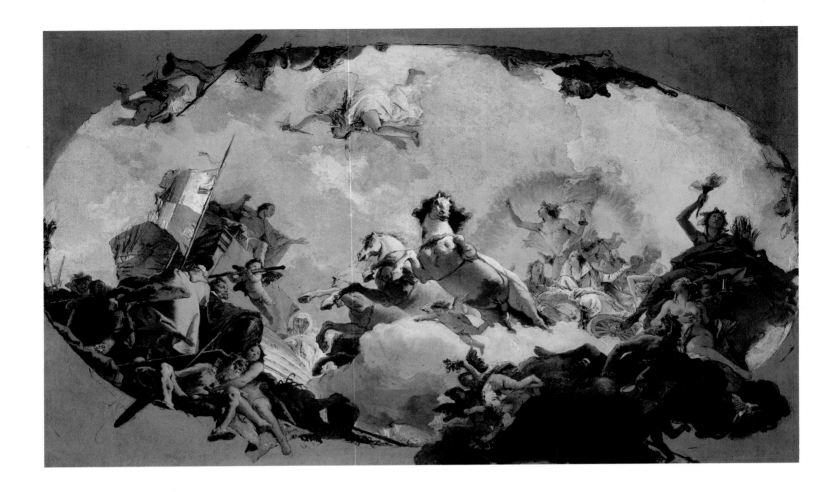

from the cluster of figures surrounding Apollo, and from the group of classical deities arranged on the dark cloud in the lower right-hand corner. Compared with the rest of the picture, the latter figures have a somewhat rudimentary, silhouette-like appearance. The overall effect is as if Tiepolo had taken his preliminary studies and simply stuck them together, without leaving enough space between them. In the fresco (fig. 46) the spatial situation is quite different: the figures are smaller and set further apart, which makes for a far less cramped atmosphere and enhances the sense of rushing movement by giving the horses room to gallop.

Tiepolo presumably made these general changes when he was sketching the design on the plaster. At this stage of the proceedings, he will have continually monitored the results of his labours by inspecting the ceiling from the viewing point at the entrance to the room. He also modified a number of details, introducing new figures, such as that of Fame, and relocating some of the existing ones: for example, the *putto* bearing the Duke's ceremonial sword is placed higher up and further

to the right. He also rectified his initial mistake in reversing the order of the squares on the Franconian flag.

Although the fresco contains well over forty figures, very few preparatory drawings have survived. Among them, however, is a work of outstanding quality. It consists of a dorsal nude study of a male figure, identified as a river-god by his crown of tangled reeds (fig. 74). A comparable figure is found in the fresco, reclining at the base of the throne with one foot dangling, as it were, over the edge of the picture. Tiepolo often drew several variants on the same motif and, although the poses are different, it seems reasonable to posit a connection between the fresco and the drawing, which clearly accords with Tiepolo's style of the Würzburg years. Having outlined the pose in red crayon, the artist did the basic modelling with damp chalk, rubbing over the surface to blur the individual lines, and emphasized the shadows with hatching. He then retraced the contours and added several small clusters of thicker lines – for example, under the left hip and on the right thigh – as elements of formal contrast. Finally, he went

Fig. 75 *Apollo Conducting Beatrice of Burgundy to the 'Genius imperii'.* Oil on canvas, 65.3 x 106.5 cm. Stuttgart, Staatsgalerie

over the modelling again and inserted the white chalk highlights. The means are simple, but they are used with exceptional delicacy and skill; on the blue Venetian paper the crayon and chalk have a painterly effect, conveying a sense of animation, and even of colour, that is typical of Venetian painting.

The Oil Sketches and Drawings for 'The Marriage of Barbarossa'

Tiepolo probably embarked on the Marriage fresco shortly after completing the ceiling decoration. He may have begun work as early as July 1751; at all events, he must have finished the picture by the winter of that year, when he was obliged to take an extended break from frescoing and devote himself to oil painting instead.

Looking at the fresco of Barbarossa's wedding, it is difficult even to imagine the complexity of its genesis. The two surviving oil sketches indicate that the path from idea to execution was rather convoluted, involving a number of separate, distinct stages. It has recently been demonstrated that these works were not painted by Tiepolo himself but by his son Giandomenico – this became apparent during the 1996 Tiepolo exhibition in Würzburg, which provided an opportunity to see the two sketches side by side and compare them with the Stuttgart oil sketch for the ceiling fresco. However, we can assume that the sketches are faithful copies of Giambattista's work, since at this point Giandomenico was still trying to absorb his father's techniques and pictorial ideas.

The Boston painting is the earlier version (fig. 76). At first sight the arrangement of the many figures is somewhat confusing: identifying the main actors requires a certain preliminary effort in getting one's visual bearings. The focus lies in the centre, where the Bishop is dispensing the marriage sacrament. Kneeling in front of him are the bride and groom: Barbarossa, attended by a page with the Imperial crown, is on his right, and Beatrice is seen in profile on his left. Thus the depiction follows, approximately, the classic compositional scheme of the equilateral triangle. The figures immediately behind Beatrice are members of the Emperor's retinue; the Bishop's co-celebrants are assembled on the other side, behind his back. A statue of a saint on the church wall overlooks the group. In general, the picture has the air of a summary attempt to translate the official programme for the frescos into a provisional artistic form. Although the painter has a rough idea of how the work should be structured as a whole, his main concern is to come to terms with the content and sort out the various motifs. This point in the process of composition is comparable with the stage documented in the drawing, discussed in the preceding section, that is presumed to relate to the ceiling fresco.

Tiepolo's next step was to confront the composition with the reality of the spatial situation in the Kaisersaal. This revealed three aspects that needed improvement. The first thing that struck Tiepolo was the muddled arrangement of the figures, which makes it difficult to grasp exactly what is happening and tends to obscure the significance of the Bishop as a central participant in the scene. He also realized that the background

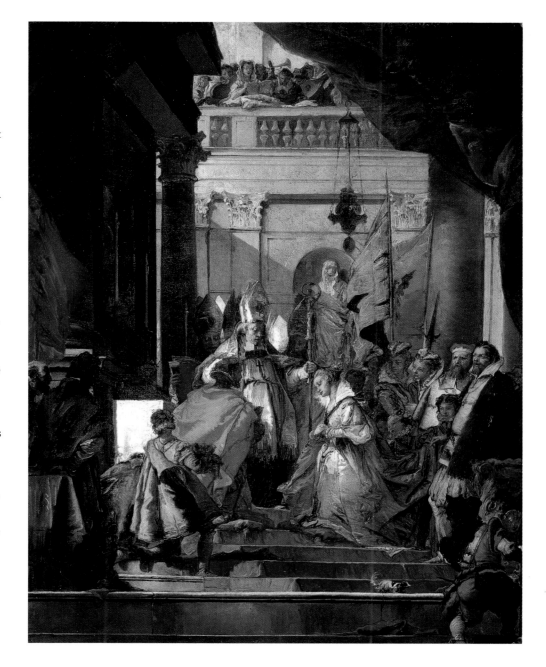

Fig. 76 Giandomenico Tiepolo, *The Marriage of Frederick Barbarossa and Beatrice of Burgundy.* Oil on canvas, 71 x 55.3 cm. Boston, Isabella Stewart Gardner Museum

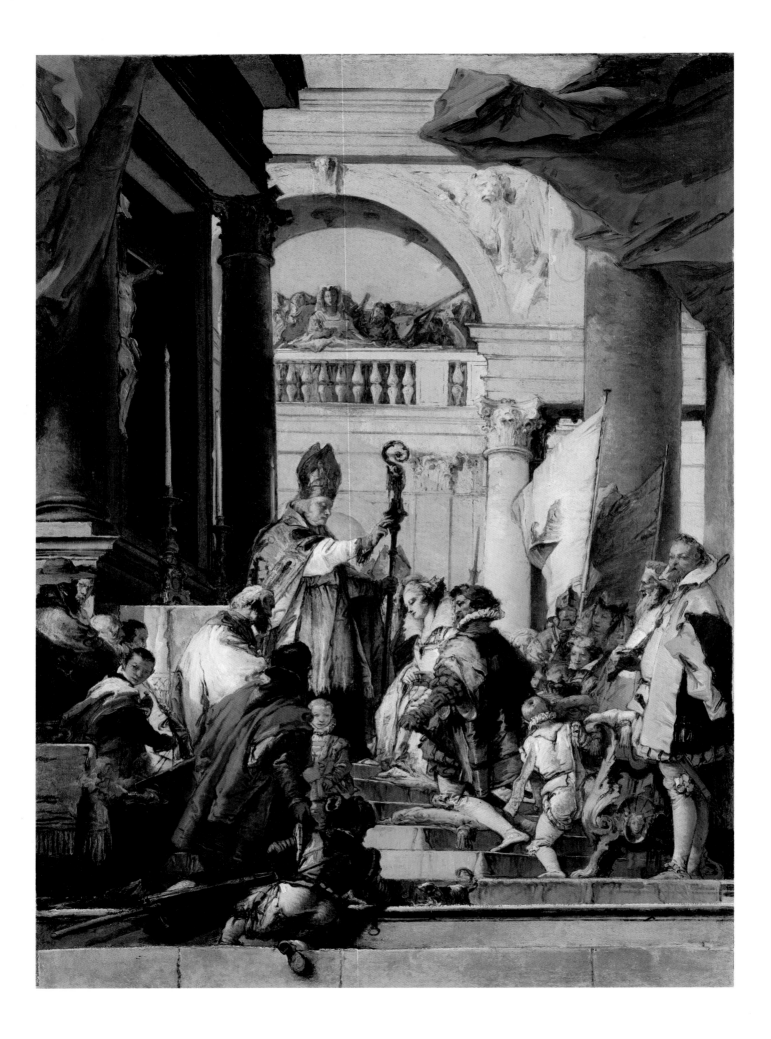

area lacked depth and space. The ceiling fresco shows that Tiepolo was intent on dissolving spatial barriers. In the Kaisersaal the walls were to be seen merely as a kind of framework, like the trellis of an arbour or summer-house, allowing the light to pass unimpeded into the room. The wall frescos therefore had to be given more depth, so as to avoid detracting from the general impression of space and airiness.

Tiepolo also noticed that it would be difficult to lure the gaze into the composition if the viewer stood at the required spot in front of the entrance. He had already tried to address this problem by introducing an oblique viewing angle, based on the positioning of the altar on the left and the slight turn of the Bishop's head to the right. But this was not enough: a more radical solution was needed.

These various insights were incorporated into the second sketch, now in the National Gallery in London (fig. 77). Here, the Bishop, depicted with the features of Greiffenclau and wearing the *Kirchenvätermitra* (see p. 81), is clearly identified as the central figure. His significance as a protagonist is indicated by his elevated position, well above the couple kneeling before him to receive the blessing that he is bestowing, and also by the suggested path of the gaze from the bottom right-hand corner to the centre. In the background the cramped feel of the Boston oil sketch is alleviated by introducing a further layer of space and allowing parts of the architecture to overlap.

Tiepolo continued to make adjustments when he transferred the sketch to the wall. At this point, the broader format of the fresco helped to clarify the composition; as a result, the Bishop moves even further into the forefront of attention (fig. 47). It is interesting to note how – and why – Beatrice's position has changed. In the London sketch Tiepolo places the figure of Barbarossa in the foreground, as befits the latter's status in relation to his consort. This no doubt produced objections among the court advisers inspecting the sketch, who will have pointed out that Tiepolo had forgotten a minor but crucial detail of the wedding ceremony: the bride always knelt on the left of the groom, so that he could lead her out on his right arm when the couple turned round to leave the church at the end of the service. Tiepolo took the correction of this deviation from the requirements of verisimilitude as an opportunity to rethink the layout of the central section. Placing more emphasis on the figure of Beatrice, whose resplendent gold-trimmed blue robe and silvery-white silk dress have a dazzling sensuous impact, he transformed the picture into a celebration of female beauty. In the final version Beatrice fills the entire fresco with her radiance.

The amount of sheer hard work involved in making a fresco of this kind is also indicated by two surviving drawings – based on the London painting – of the arm and hand with which the Bishop is blessing the couple (figs. 78, 79). In themselves, these sketches are unspectacular, but they demonstrate that Tiepolo left nothing to chance. For example, he would have had no difficulty in painting the embroidery on the sleeve spontaneously, relying on his skill in freehand drawing, yet everything, even down to the smallest detail, is meticulously planned and prepared in advance. And the sketch of the hand displays qualities that one might expect to find only in a fully formed work of art. With a few sparse but eloquent lines, Tiepolo even contrives to make the back of the Bishop's hand visible underneath the surface of his glove.

As the genesis of the Marriage fresco shows, Tiepolo took great pains to get these pictures exactly right. Yet the results of his labours always seem entirely natural and convincing. This is the real secret of his art.

Lightness of touch had been prized as the supreme artistic quality since the early sixteenth century, when the Italian statesman and author Baldassare Castiglione decreed that the nobleman must take care to avoid ornament or affectation in speech and behaviour, and extended this principle to the visual arts. In *Il libro del Cortegiano* (1528), his celebrated treatise setting out the principles underlying what became known as the Renaissance ideal, Castiglione wrote: 'In painting, too, the excellence of the artist may be revealed by a single effortless line, a single brushstroke executed in such a way that the hand seemingly hastens of its own accord to carry out the creator's intention, instead of being forcibly guided by mere diligence or artifice.' True art, according to this view, is precisely that which appears artless.

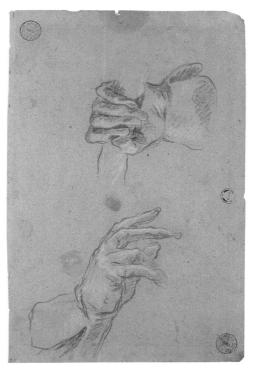

Fig. 79 *Study of Two Gloved Hands.* Red and white chalk on blue paper, 44.5 x 28.5 cm. Venice, Museo Correr

Fig. 78 *Study of an Arm.* Red and white chalk on blue paper, approx. 11 x 20 cm. St Petersburg, State Hermitage

facing page
Fig. 77 Giandomenico Tiepolo, *The Marriage of Frederick Barbarossa and Beatrice of Burgundy.* Oil on canvas, 72.4 x 52.7 cm. London, National Gallery

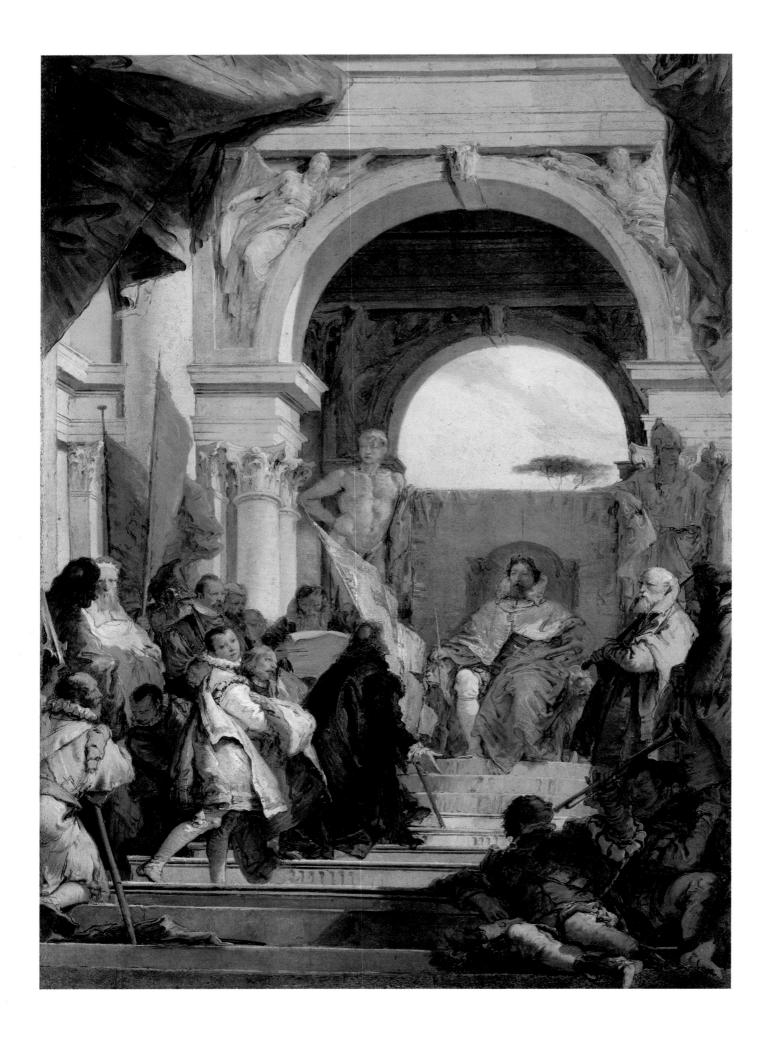

The Oil Sketch and Drawings for 'The Investiture of Bishop Herold'

Castiglione's words could well serve as a characterization of the oil sketch, now in the Metropolitan Museum of Art, New York, for the Investiture fresco (fig. 80). The sketch is a minor masterpiece in its own right. Tiepolo made it in the winter of 1751–2; the fresco itself was completed and signed in early July 1752.

The programme for the fresco had stipulated that the investiture ceremony be set in 'a spacious and sumptuously appointed chamber'. Tiepolo's sketch does not entirely fulfil this requirement. As in the Marriage fresco, the architecture follows a logic of its own that has little or no connection with the normal principles of building; instead, it is governed solely by the motif and the urge for maximum dramatic effect. It is even unclear whether the setting for Barbarossa's throne is a triumphal arch, a passageway, a loggia or a free-standing vaulted canopy. Elements of all these are to be found in the structure, which serves, in the first place, to convey a general feeling of grandeur and pomp, but is also a convenient formal device that combines tight planar organization with a sense of depth. In these terms, the 'building' is perfect: it is constructed so coherently that one begins to question it only on closer inspection.

In the fresco (fig. 48) the ceremony is transferred to an open-air setting, presumably after the iconographical advisers had remembered that this was the custom in the Middle Ages: it was not until the Baroque era that the Empire began to conduct investitures indoors. However, Tiepolo was reluctant to forgo the dramatic possibilities of architecture altogether; hence the decision to frame the figure reading the patent of confirmation by a triumphal arch in the background.

The intensity of the consultations on the oil sketch may be gauged from the drawings of details, such as the arm-rest of the throne (fig. 82). Here, the lion motif that Tiepolo originally intended to use has been replaced by the head of an eagle, whose pose and expression suggest the combination of arrogance with passive stoicism that might be etched into the features of a long-suffering courtier. As a study in psychological irony, the drawing is highly impressive, but one is equally astonished by its technical virtuosity and sureness of touch. There is not a single line that suggests so much as a second's hesitation or doubt: Tiepolo must have taken the image in his mind's eye and transferred it directly to the paper. The energetic lines and

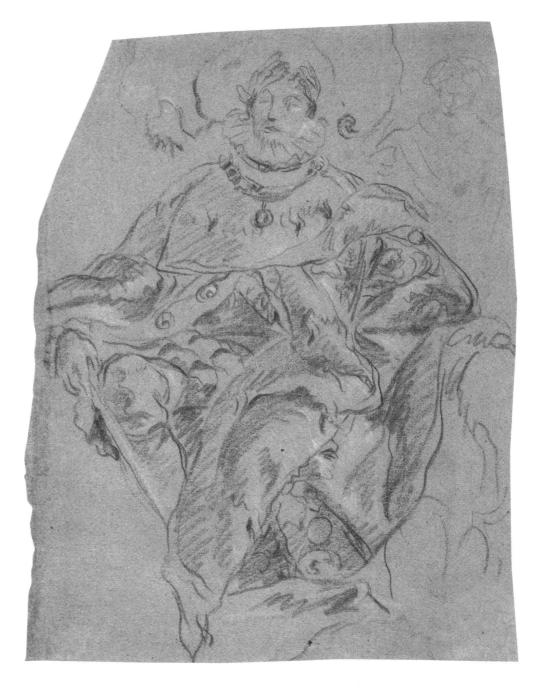

hatchings are combined with dramatic chiaroscuro notes in a manner that is artistically fascinating and endows the creature with a touching yet comical pathos.

A further very fine drawing shows Barbarossa seated on his throne (fig. 81). The light yet confident line of this work led scholars to assume that it must have been made by Tiepolo in connection with the preparations for transferring the image from the sketch to the wall. However, the comparisons facilitated by the 1996 exhibition in Würzburg revealed that it was in fact executed by Giandomenico, as one of the many so-called *ricordi* of his

facing page
Fig. 80 *The Investiture of Bishop Herold as Duke of Franconia.* Oil on canvas, 71.7 x 51.4 cm.
New York, The Metropolitan Museum of Art

this page
Fig. 81 Giandomenico Tiepolo,
Emperor Frederick Barbarossa.
Red and white chalk on blue paper, 25 x 18 cm.
Stuttgart, Staatsgalerie, Graphische Sammlung

father's frescos. When sketching the figure, the son was evidently trying to capture the lightness of his father's brushwork in the oil sketches.

Comparing the preliminary designs with the finished fresco, one notices that the depiction of the oath of fealty has also undergone a significant change. The sketch focuses on the moment immediately before the oath is to be sworn; the Bishop has taken custody of the ducal flag and is kneeling before Barbarossa, waiting for the ermine robe to be brought. Meanwhile, the heralds in the foreground are raising their trumpets to their lips to blow a fanfare advertising the momentous event. In the Kaisersaal, however, these two figures have been placed beneath the window to the right of the main fresco (fig. 1); from here they are gesturing across the room towards the marriage scene, establishing a visual connection between the two events.

Few viewers of the fresco would think to ask why the various figures are posed in the way they are, and no other, so perfectly judged and so exactly attuned to the overall arrangement of the composition are they. Yet both the differences between the sketch and the fresco and the surviving preparatory drawings show that Tiepolo gave the matter a great deal of thought. A sheet containing five different ideas for the portrayal of the halberdier provides an indication of this (fig. 83). The images are drawn swiftly and nimbly in thin, swirling lines of black chalk, supplemented in four of the five cases with ink wash. Clearly, the artist's main concern is with the

physical facts of the pose, rather than with 'painterly' issues, and for this purpose a plain white surface was more suitable than blue paper. Drawings of this type belong to the earliest stages in the genesis of a motif.

The study of the halberdier's right arm (fig. 84) was probably executed immediately before frescoing began and served a quite different purpose. Here, the aim is to convey an idea of sheer physical power. The combination of the taut muscles with the bulging blood vessels makes the arm look like a gnarled but sturdy tree-trunk. An interesting aspect is the correction of the contour line, which was initially far straighter. The extreme emphasis on muscular tension, which is always subject to change, introduces a sense of animation and, with it, an allusion to the dimension of time. In the fresco, by contrast, Tiepolo has downplayed this element to give the arm a more static and monumental form.

The Oil Sketch for the Staircase Fresco

The staircase fresco at Würzburg is a painting of quite exceptional complexity, and it therefore comes as no surprise that even a genius of Tiepolo's stature undertook extensive preliminary work before executing it. The history of this prolonged preparatory phase, with all its many twists and turns, its continual setbacks and fresh starts, can no longer be reconstructed in full detail, principally because very few of the original drawings and none of the cartoons have survived. Moreover, when creating the fresco, Tiepolo first

Fig. 82 *Eagle.*
Black and white chalk
on blue paper, 20 x 14.7 cm.
Würzburg, Residenz

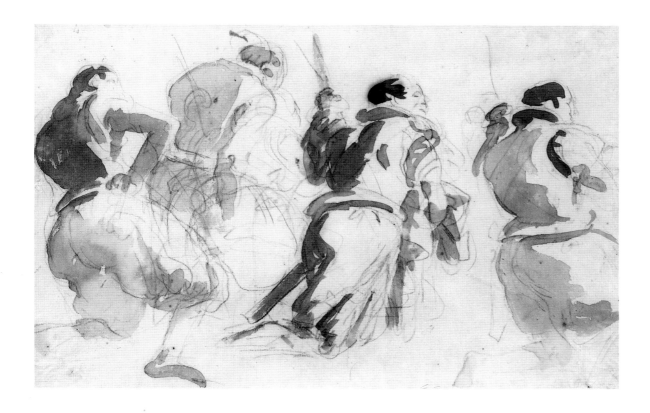

Fig. 83 *Studies for a Halber-dier*. Brown wash over black chalk on paper, 21.5 × 32.7 cm. London, Victoria and Albert Museum

below
Fig. 84 *Study of a Right Arm*. Red chalk on paper, 31.3 × 13.4 cm. Venice, Museo Correr

sketched the design on the underlayer of rough plaster known as the *arriccio*, and these steps in the creative process are now concealed under the fresco. Yet the small quantity of surviving documentation does make it possible to trace at least the basic outlines of the story and to obtain some idea of how Tiepolo's artistic thinking evolved.

On the strength of his work on the frescos in the Kaisersaal, Tiepolo was commissioned at the beginning of 1752 to draw up a general plan for the decoration of the ceiling above the staircase. The subject had already been decided, either by the court scholars or, possibly, by the Prince-Bishop himself, who was well acquainted with the staircase fresco on the same theme that had been created by Johann Rudolf Bys in Schloss Pommersfelden in the 1710s (fig. 85). Tiepolo may have visited Pommersfelden, which is not very far from Würzburg. If he did so, he would have realized immediately that the Bys frescos were unsuitable as a model for his own projected picture. Firstly, the spatial situation is quite different, since the Pommersfelden painting can be seen from a single viewing point. Secondly, Bys's work completely lacks the sense of dynamic narrative development found in the Würzburg fresco. Instead of being incorporated into a continuing story, the figures are arranged in a static decorative pattern: the only visual link between them is supplied by

the painted architecture, and this emphasizes their allegorical, emblematic character.

Tiepolo was undoubtedly familiar with the subject-matter of the frescos at Pommersfelden. He himself had painted a version of the four continents at the Palazzo Clerici in Milan in 1740. Several of the figures from this earlier work are also found in the Würzburg fresco, although the overall conception of the latter is quite different.

A considerable amount of work must have preceded the production of the first overall design, the oil sketch now in the Metropolitan Museum of Art in New York. On 21 April 1752, according to one contemporary source, 'His Grace and the members of his entourage saw the plans of the painter Tiepolo for the main staircase, and then went for a stroll in the garden'. A further document then records that, on 30 June, 'His Grace the Prince-Bishop…decided in his wisdom that the ceiling above the main staircase, or the entire vault from the cornice upwards, should be painted al'infresco by Sig. Giovanni Baptista Tiepolo. The said artist gratefully accepted the commission and undertook to paint the aforementioned staircase in accordance with the sketch as approved by His Grace, employing all the skill at his disposal and following his customary style.'

It would be illusory to suppose that Tiepolo could have worked up a complete design

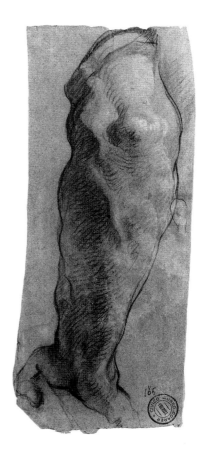

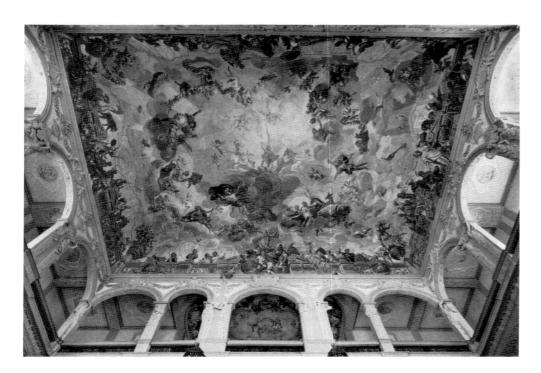

Fig. 85 Johann Rudolf Bys,
Apollo and the Four Continents, 1716–17;
staircase fresco in Schloss Pommersfelden

from the initial sketch in only two months –
not least because, during the first half of the
year, he was occupied with the Investiture
fresco in the Kaisersaal, which the court har-
binger records as finished on 4 July. The most
likely explanation for this interval is that the
Prince-Bishop's iconographical advisers had
spent several weeks examining the oil sketch
and considering new proposals with regard to
the subject-matter.

Tiepolo probably started work on the
painting itself in the course of 1752 but had
to take an extended break during the winter,
because fresco painting can be carried out
only under favourable weather conditions.
This would mean that he had to complete
the designs within a period of three to six
months – hardly a long time, given the com-
plexity of the task.

This time-scale would imply that the oil
sketch in the Metropolitan Museum (fig. 87)
was made right at the outset. The basic idea
was that the figures representing the conti-
nents should be arranged along the edges of
the picture, with Apollo setting out on his
daily journey across the sky in the centre. In
the finished work, this middle section was
almost unchanged, but the continents were
modified considerably (fig. 86). As work pro-
gressed, the *Africa* and *Asia* frescos also
switched positions, and the entire sky was
rotated through 180 degrees. However, to
convey the idea of a hierarchical progression
from America to Europe, these two conti-
nents continued to occupy the same positions

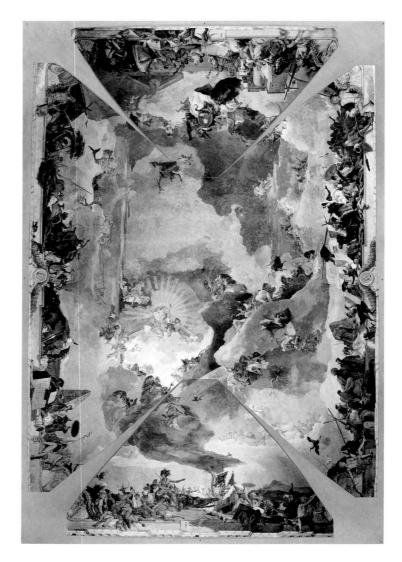

Fig. 86
Digitally enhanced
photograph of the
staircase fresco in the
Würzburg Residenz

facing page
Fig. 87 *Apollo and
the Four Continents*,
1752. Oil on canvas,
184 x 132 cm.
New York, The Metro-
politan Museum of Art,
Wrightsman Collection

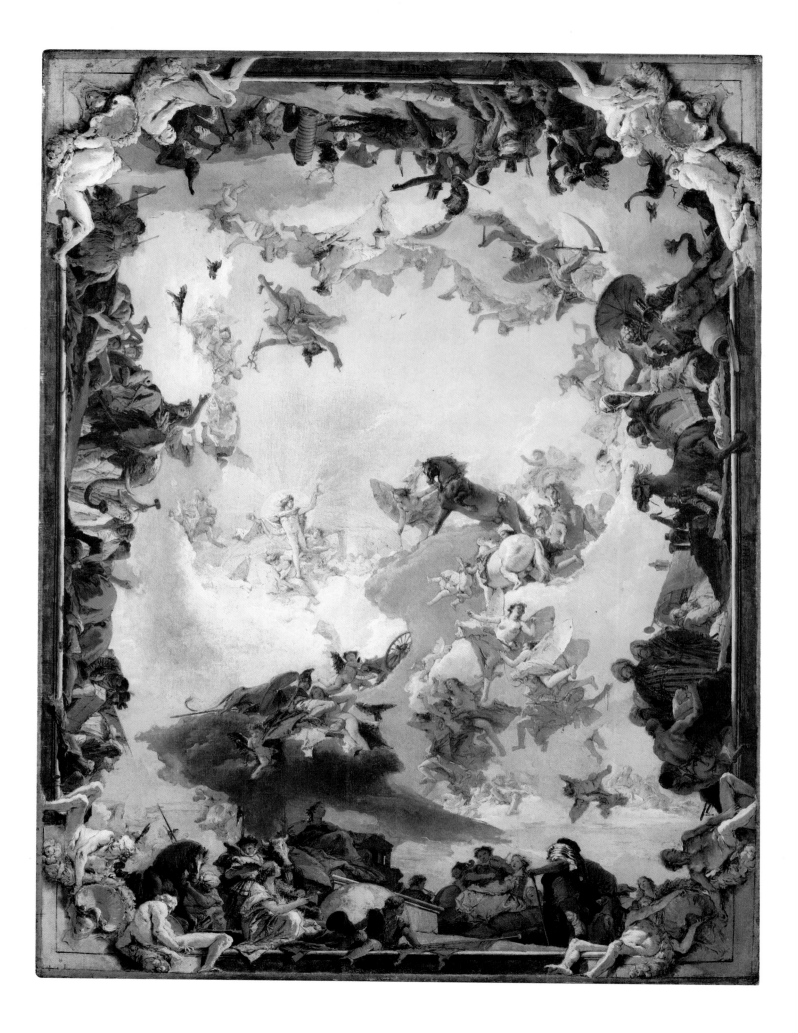

Fig. 88 Unknown artist, Design for the south wall of the staircase, *c.* 1752. Pen and ink and wash on paper, 35×67 cm. Formerly Würzburg, Mainfränkisches Museum

as in the oil sketch. In the original version the personification of America would still have guided the visitor up the staircase, but above her head the figure of Mercury, gesturing in the opposite direction, supplied an additional indication of what was to follow. This view, including the figure of Chronos on the left-hand side, would have fitted very pleasingly into the architectural framework at the foot of the stairs.

As in the finished version, the image of the dawn above the head of Europe – heralding a new era – would have been revealed at the turn on the landing. Even at this early stage, Tiepolo had clearly acknowledged the problem that the fresco could be viewed only in sections, instead of being seen as a whole. Yet he contrived to compose the oil sketch in such a way that the experience of seeing it remains satisfying to the viewer trying to take it in at a single glance.

Over the next few months, when he began transferring the design to the surface of the ceiling, Tiepolo's first task was to tailor the depiction of the continents to the vast dimensions involved. There was no question of simply scaling the figures up, as this would have made them gigantic, and all sense of naturalness would have been lost. A partial solution lay in the inclusion of additional motifs, but it also became necessary to modify the sequence of views. The first consequence of this was the switching of Africa with Asia. Secondly, the personifications of these two continents had to be positioned closer to Europe, so as to create a firmer sense of connection between the three more civilized regions. As a result,

the animals appeared to be moving away from Europe, but this was compensated by skilfully relocating some of the other motifs. The overall effect of this general process of adjustment is to establish a more densely meshed network of relationships between gaze, gesture and action. More specifically, the extra figures also add interest to the characterization of the continents. *Europe* particularly benefits from this.

The most important difference between the oil sketch and the fresco concerns the inclusion of the medallion bearing the portrait of the Prince-Bishop. An image of Greiffenclau had always been a central feature of the projected work. At the stage when the oil sketch was made, the idea was to depict him standing on a painted balcony in the centre of the wall under *Europe*. The names of the figures in this section were listed on the reverse of a preparatory drawing that was destroyed by fire in 1945 (fig. 88). This shows the Prince-Bishop standing on the right, identifiable by his ecclesiastical garb. The figure to his left is his brother, Lothar Gottfried Heinrich von Greiffenclau, the major-domo of the episcopal household. On the far right, the court treasurer, Franz Ludwig von Fichtel, is talking to Balthasar Neumann, whose body can scarcely be seen: only his face is fully visible. Tiepolo himself is depicted on the far left. Recent commentators have surmised that the drawing may well have been made by Tiepolo's fellow artist Georg Anton Urlaub.

This original and attractive idea can have been discarded only because it was felt that the Prince-Bishop's portrait had to appear on

the ceiling. And this, in turn, meant swivelling the whole of the sky to face the other way; otherwise there would be no room for the medallion. Tiepolo managed to solve this problem, like all the others, and in the process he contrived to ensure that the idea of the new beginning or new dawn was emphasized more strongly, and to establish a more definite parallel between this imaginary trajectory and the progress of the visitor ascending the stairs. Here, as in all the other aspects, the adjustments to the original design ultimately represented an improvement that increased the complexity of the work and intensified its impact.

Drawings for the Staircase Fresco

When transferring the fresco from the sketch to the ceiling, Tiepolo had to stand on a scaffold and modify the design as he worked, continually adjusting the composition to fit the dimensions of the vault. He must have clambered down countless times from his platform

to examine the figures and check that they were in exactly the right position. As noted above, the dramatic impact of the fresco on the viewer ascending the staircase depends on absolute precision in the placing of the figures – a difference of only a few centimetres one way or the other can be crucial. Recent technical investigations have uncovered a number of areas at the edge of the fresco where the plaster tapers off to reveal fragments of drawing, in charcoal and a brown pigment mixed with lime-water, that evidently date from this preparatory phase.

At the same time – while he was transferring the design – Tiepolo began to work on the fine detail of the fresco, paying particular attention to the poses and the garments. An especially impressive example of his preparatory work at this stage is supplied by a drawing from the Kupferstichkabinett in Berlin (fig. 90). The athletic young man who served as the model for this sketch appears in many of Tiepolo's drawings. He is probably the manservant said to have accompanied the

Fig. 89 Mars; detail of the staircase fresco

Fig. 90 *Two Studies of Nudes.* Red and white chalk on blue paper, 27.5 x 41.8 cm.
Staatliche Museen zu Berlin –
Preussischer Kulturbesitz, Kupferstichkabinett

painter to Würzburg from Venice. A similar, albeit clothed, figure – the depiction of Mars above *America* – is to be found in the staircase fresco (fig. 89). After studying the model in various attitudes, Tiepolo evidently opted for the pose with the body turned to the right. In the detailing of the shoulder and chest muscles, the portrayal of Mars follows the sketch very closely, yet despite this and other similarities, there are a number of significant differences. The nude study is closer to the live model than the fresco, where Tiepolo has

flattened the figure and emphasized the fore-shortening, thereby striking a more stylized, monumental note. The drawing also shows the figure in close-up, whereas the fresco is designed with a more distant viewing point in mind.

It is indicative of Tiepolo's artistic approach that he should have based the depiction of a figure that includes relatively little anatomical detail on a drawing from life. Although he relies heavily on existing formulas, the motifs seldom appear empty and lifeless, because all his work is ultimately founded on the observation of nature.

One of the most successful decisions taken with regard to the staircase fresco was to show the personifications of the continents mounted on a selection of exotic animals. It has gener-

ally been assumed that this was the artist's own idea, but this does not seem to be entirely accurate. For the figure of America, at least, a possible source of inspiration has now been identified, in the shape of a sculpture by Johann Joachim Kaendler that forms part of the so-called 'small' series of Four Continents made in Meissen in about 1745 (fig. 92). The resemblance is remarkably close, especially if one imagines the sculpture minus the cornu-copia and with its left arm outstretched. It is of little consequence where Tiepolo first saw the figure, whether in the Prince-Bishop's porcelain collection or in the print, probably of Flemish origin, that served as Kaendler's model; what matters is the way in which the artist incorporated it in his own ideas. Instead of removing the cornucopia altogether, he has given it to the turbaned native kneeling in the foreground (plate 2).

For this latter figure, too, a nude study exists (fig. 91), which was made after the oil sketch. The figure in the sketch is depicted in a schematic pose which Tiepolo considered particularly effective, and which the live model was therefore made to replicate for the drawing. Thus the study offers a further example of Tiepolo's method of combining the formulaic with the real.

The two stags to the right and left of the figure holding the cornucopia in the fresco are missing from the oil sketch. Inspiration for this motif seems to have come from a series of etchings by the Augsburg artist Johann Elias Ridinger. This should not be confused with plagiarism: the adoption and partial reworking of existing models was a common and fully accepted artistic practice that Tiepolo saw no reason to abandon. A further instance is provided by his son Gian-domenico, who, some twenty years later, made a pen-and-wash drawing of the dead stag together with the head and front legs of America's crocodile (fig. 93).

The vast hoard of extant drawings, comprising several hundred items, indicates that Tiepolo probably made life studies for all the figures in the fresco. An interesting example is the drawing of the man holding a bale of goods on the left of *Africa* (fig. 94), which is accompanied by a seperate study of the right shoulder. One notices that the man is lifting the bale higher than in the oil sketch and the fresco – when positioning the model in the studio, Tiepolo apparently failed to replicate the exact pose of the figure in the oil sketch. His main interest was in the modelling of the muscular back, which has a marked plastic quality, with areas of light and shade that merge almost imperceptibly into one another:

Fig. 92 Johann Joachim Kaendler, *America*, from a series of the Four Continents, *c.* 1745. Porcelain, h. 29 cm. London, Christie's

left
Fig. 91 *Study of a Male Nude*. Red and white chalk on blue paper, 25 x 15.8 cm. Venice, Museo Correr

contours are entirely subordinate to the sculptural effect.

A recently discovered drawing shows that Tiepolo set particular store by the exact study of faces (fig. 95). This work is one of the finest in the artist's entire oeuvre. The idea of the gaze focused over the shoulder came from his mentor Piazzetta, but the specific combination of this motif with the image of the turbaned head is seen only in the Asia fresco in Würzburg. Although none of the painted figures corresponds exactly to the drawing, it is clear that Tiepolo must have used the same model in each case.

The gaze directed out of the picture, which makes the sketch so impressive, occurs only in the figure of Asia herself (plate 5). It is fully conceivable that Tiepolo based the portrayal of her face on the drawing, but perhaps the closest resemblance between the latter and the fresco is to be found in the central figure in the group of men harassing the tigress (plate 6). Here, too, there are notable differences, yet the raised eyebrows and furrowed brow seem to follow the model proposed in the drawing.

The drawing is a psychologically incisive study of facial expression. Its impact is reinforced by the partially concealed chin and the foreshortening of the face, which is seen at very close quarters. Tiepolo changes all this in the fresco, where the emphasis on psychology is curtailed and the depiction of the face is governed by the requirements of action and drama. Although the drawing was made from a live model, it does not portray the sitter in terms of individual physiognomy. Instead, Tiepolo is chiefly interested in studying a certain type of facial expression, which he has instructed the model to imitate. This explains how he was able to use the same sitter as the basis for several different figures, including, probably, the hunter on the left.

Special interest attaches to the sketches for the figures of Balthasar Neumann and Antonio Bossi, since these are among the most striking in the Europe fresco and Tiepolo was, of course, on familiar terms with both men. In the earlier of the two extant drawings of Neumann the artist focuses on the uniform, with its wealth of picturesque detail, and glosses over the facial features, which

Fig. 93 Giandomenico Tiepolo, *A Stag Lying Down; Head of a Crocodile.* Pen and brown ink and brown wash over black chalk on paper, 28.5 x 20 cm. New York, The Metropolitan Museum of Art, Robert Lehman Collection

Fig. 94 *Man with Bale.* Red and white chalk on blue paper, 27.5 x 30.5 cm. Venice, Museo Correr

Fig. 95 *Head of a Young Man Wearing a Turban.*
Black and white chalk on blue paper, 22 x 18.3 cm.
London, Hazlitt, Gooden & Fox

makes it seem unlikely that Neumann himself was the sitter (fig. 97). The second sketch makes a more concerted attempt to achieve a portrait likeness of the architect and corresponds more closely to the fresco (fig. 96). The relatively 'finished' appearance of this drawing indicates that it was made as part of the preparations for transferring the motif to the *arriccio* layer of plaster. This was done in order to check the proportions before finalizing the design and making the cartoons, from which the image was transferred to the final, smooth layer of plaster, the *intonaco*.

The rendering of Bossi in the fresco (fig. 108) appears to be based entirely on life rather than invention: it looks as if Tiepolo had simply taken his colleague up onto the scaffold and painted his portrait directly on the plaster. But the large number of drawings that Tiepolo made during the preparatory phase tell a quite different story (figs. 98–107). Although it is no longer possible to reconstruct the exact sequence in which these fascinating sketches were made, it is obvious that Tiepolo endeavoured systematically to familiarize himself with the figure and to find the most suitable form for depicting it. For example, one of the drawings shows the figure in a fur-collared coat of the kind that Bossi could well have worn in winter, but nothing remains of this detail in the fresco. Other drawings show Bossi with or without a hat, or feature slight variations in the detailing of the folds in his cloak.

Fig. 96 *Balthasar Neumann.*
Red and white chalk on blue paper,
16.5 x 28.7 cm.
Staatliche Museen zu Berlin –
Preussischer Kulturbesitz,
Kupferstichkabinett

Seeing this extraordinary number of studies, one begins to appreciate the methodical precision with which the figure in the fresco was designed and constructed. In its final form it displays a specific combination of simplicity and complexity that could be achieved only by long and painstaking study. The viewer can scarcely fail to admire the skilful reduction of the cloak to the bare essentials, the masterly way in which the three-cornered hat and the garment are enclosed by a single contour, and the artful concealment of the hand holding the hat. These details, and the judicious decision to omit the sword in the final version, illustrate the process by which a simple portrait becomes a true work of art. The figure has tremendous expressive power; it dominates the entire right-hand section of the picture and instantly commands the beholder's attention, even at a distance of thirty metres. However, in view of the amount of thought and preparation that went into the finished product, it is surprising to find that the position of the head, which was also studied very carefully, is modelled on an idea that originally came from Piazzetta. Tiepolo must have been familiar with the self-portrait etching made by his erstwhile mentor in 1738 (fig. 109). Again, we find that the use of a stock motif need not imply creative sterility, as one might – from a modern point of view – imagine. Instead, Tiepolo exploits existing formulas for his own ends, and con-

trives to strike a perfect balance between tradition and invention on the one hand, and the requirements of naturalness and artistic impact on the other. This is one of the main reasons why the human figures in his pictures show such a convincing sense of physical presence.

Fig. 97 *Study of Balthasar Neumann's Uniform.*
Red chalk on blue paper, 15.4 x 23.8 cm.
Venice, Museo Correr

98

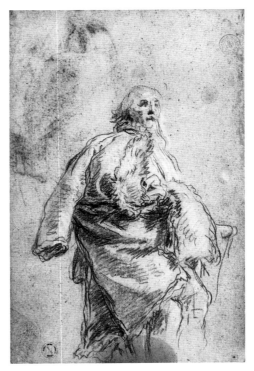

99

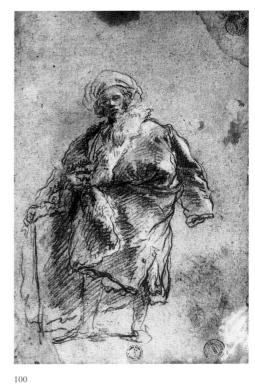

100

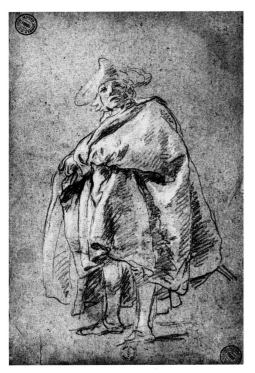

104

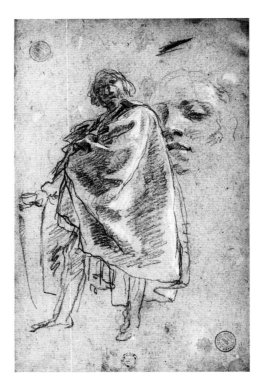

105

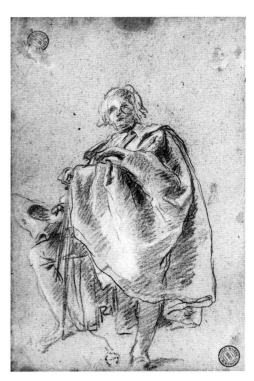

106

Figs. 98–107 Studies for the figure of Antonio Bossi,
from Tiepolo's *Quaderno Gatteri* sketchbook
in the Museo Correr, Venice

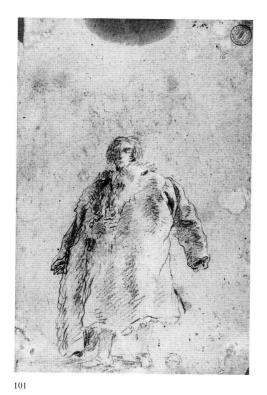

101

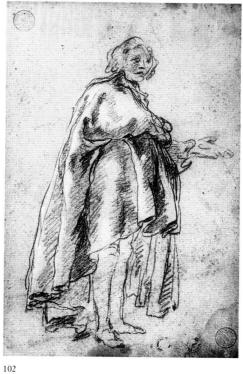

102

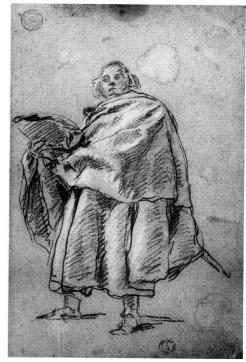

103

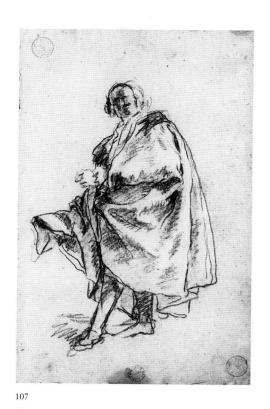

107

Fig. 108 The figure of Antonio Bossi as
it appears in the staircase fresco

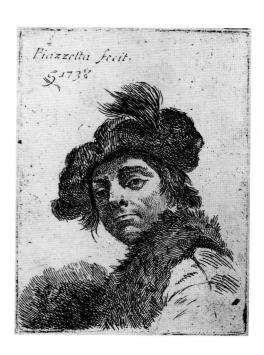

Fig. 109 Giovanni Battista Piazzetta,
Self-Portrait, 1738. Etching, 7 × 5 cm

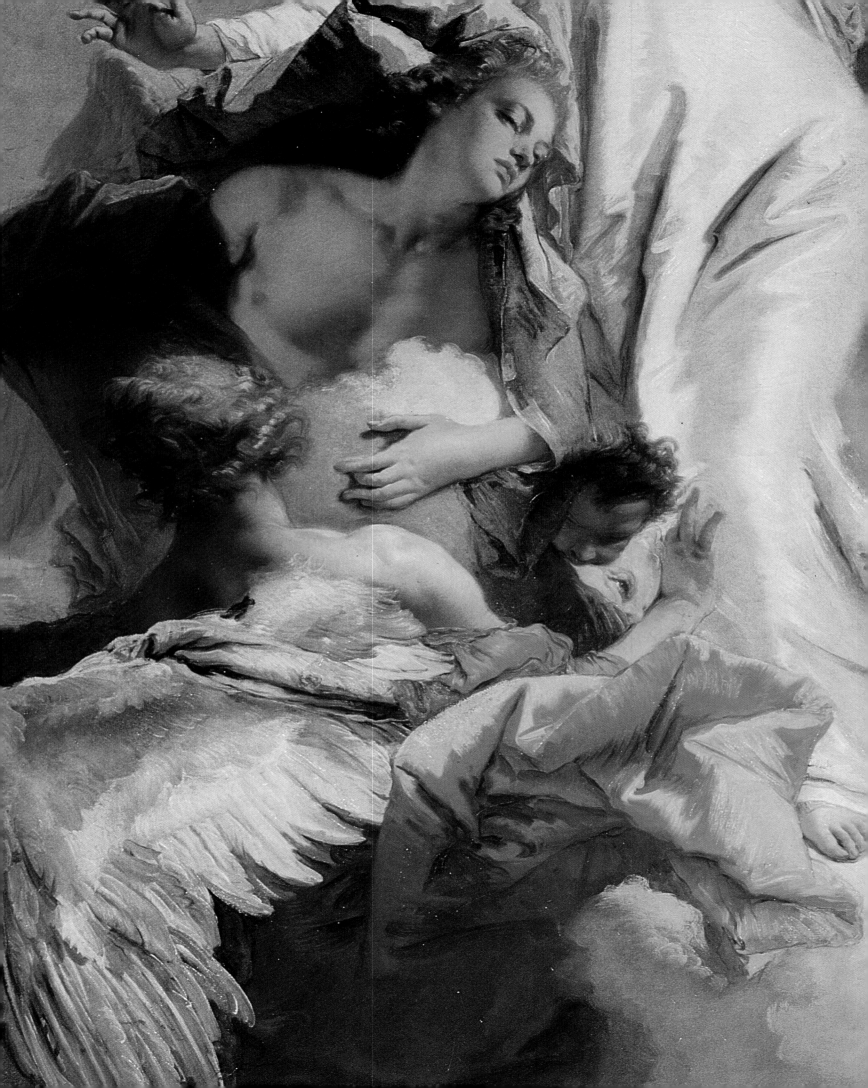

Other Works of Tiepolo's Würzburg Period

The vast majority of visitors to the Residenz come to see the frescos; few people realize that the creator of these superb paintings also painted two altarpieces in the Court Chapel (fig. 111). Tiepolo was not only the eighteenth century's foremost fresco painter but also one of its leading exponents of religious art. In the winter months, when work on the frescos was suspended because of the cold weather, he found the time to tackle several further commissions. These works were painted in the studio used by Giambattista and his two sons, which was probably located in the north Oval Chamber. The sophistication of Greiffenclau's taste is evidenced by the fact that, at some point in 1751, he commissioned Tiepolo to paint two altarpieces to replace the pictures made by Federico Bencovich in 1738 at the request of Friedrich Carl von Schönborn, the Prince-Bishop of the day (figs. 112, 113).

Did Tiepolo use the works by Bencovich, who had certainly influenced his ideas in the past, as a model or guideline? Or did he make two entirely new paintings? The question is unanswerable, as Bencovich's pictures have long been lost, but it would certainly be interesting to know exactly what happened, not least because scholars have tended to see the Tiepolo altarpieces as less successful than much of his other work. Indeed, it has often been surmised that Giandomenico may have had a significant hand in their making. All the evidence points the other way, however. In the court records the father is unambiguously described as the author of the paintings. On 7 February 1752, for example, a courtier writes: 'Altarpieces in the Court Chapel. His Grace heard Mass in his chamber and afterwards, accompanied by his ministers, visited Tiepolo to see the new altarpiece, which is already completed.' The fact that the pictures are signed with the artist's full name also suggests that they were made by the father, rather than the son, and the argument is surely clinched by the style: seen at close quarters, the paintings display all the characteristic virtuosity and sensuous appeal of Giambattista Tiepolo's work. Certainly, the painter's oeuvre could be said to include more elaborate and exciting examples of ecclesiastical art, but some features of these pictures are nevertheless very impressive – notably the modelling of the bodies and the agonized faces in the depiction of the fallen angels, and the detailing of the group of angels in the Assumption (fig. 110). Particularly noteworthy in the latter are the magnificent wings and the folds in the red garment of the lower angel, and the pose and adoring expression of the companion assisting him in bearing the Virgin up to Heaven.

facing page
Fig. 110 *The Assumption of the Virgin,* 1752; detail of fig. 113

this page
Fig. 111 The Court Chapel of the Würzburg Residenz

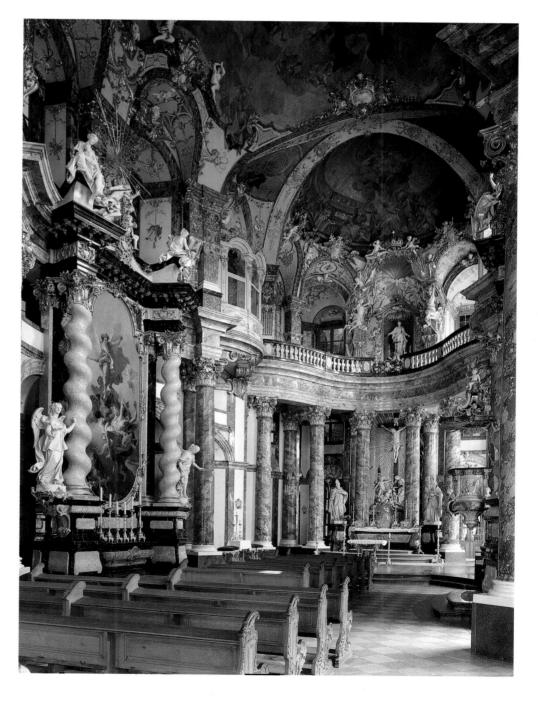

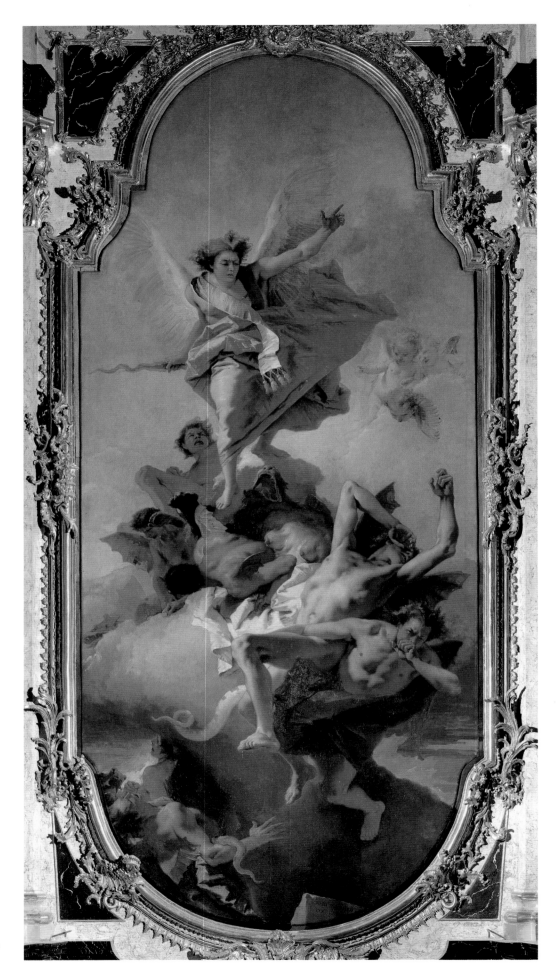

Fig. 112
*The Fall of
the Rebel Angels,*
1752.
Oil on canvas,
700 × 250 cm.
Würzburg, Residenz,
Court Chapel

Fig. 113
*The Assumption
of the Virgin*,
1752.
Oil on canvas,
700 × 250 cm.
Würzburg,
Residenz,
Court Chapel

composition, the dramatization of the motifs and the use of colour, the work is very nearly perfect. Its central thematic focus is on the humility of the elderly king kneeling before the infant Christ, who, together with the Madonna, provides the source of divine illumination around which the other three main figures are disposed. Joseph is standing at the rear, his gesture conveying a certain puzzlement. The African king entering the picture from the left, dressed in exotic Oriental costume, is looking straight at the Child but is about to fall on his knee in a gesture of homage, as the page on the far right has just done. One notices that the ribbons on the back of the page's garment are still fluttering in the air from the movement of kneeling. Tiepolo's technique of concentrating on a single, highly charged moment is strongly reminiscent of

left
Fig. 114 *The Adoration of the Magi*, 1753.
Oil on canvas, 425 x 211 cm.
Munich, Alte Pinakothek

below
Fig. 115 Head of the Virgin;
detail of fig. 114

facing page
Fig. 116 *The Adoration of the Magi*, c. 1758–9.
Oil on canvas, 60.3 x 47.6 cm.
New York, The Metropolitan Museum of Art,
Rogers Fund 1937

The Altarpieces for Schwarzach

The criticisms frequently levelled at the two altarpieces in the Residenz become more understandable if one compares these works with the *Adoration of the Magi* that Tiepolo painted in the same year – probably in the spring – for the Benedictine abbey church at Schwarzach (now known as Münsterschwarzach). Built between 1726 and 1743, this church had been Neumann's first great masterpiece. Chiefly because of its sumptuous interior, it was said to be one of the finest examples of ecclesiastical architecture in Germany, but it was demolished between 1825 and 1841, following a general move by the state to assume control over Church property. Parts of the decoration had previously been sold or moved to other churches in the surrounding area, but some items were transferred to Munich, the capital of the newly amalgamated kingdom of Bavaria and Franconia. As a result, Tiepolo's altarpiece entered the collection of the Alte Pinakothek, Munich's leading museum of pre-nineteenth-century art.

The Adoration of the Magi can justifiably be said to be the most interesting of all Tiepolo's altarpieces (fig. 114). The artist clearly found the subject attractive, and in terms of the

Fig. 117 *The Adoration of the Magi*, c. 1753.
Etching, 41.7 x 28.3 cm

facing page
Fig. 119 *The Adoration of the Magi*, c. 1753.
Pen and brush and ink, and wash,
over pencil on paper, 42 x 29.5 cm.
Staatliche Museen zu Berlin –
Preussischer Kulturbesitz, Kupferstichkabinett

Fig. 118 Paolo Veronese, *The Adoration of the Magi*,
1573. Oil on canvas, 355 x 320 cm.
London, National Gallery

the frescos in the Residenz. The impression
of fleetingness and immediacy is reinforced
by the composition, which is constructed as if
the events were taking place on a stage before
the viewer's very eyes.

Tiepolo exploited the artistic potential of
this religious motif in several further works of
the same period. Probably immediately after
completing the altarpiece, he made a large-
format etching that belongs among the finest
of eighteenth-century prints (fig. 117). The
scene is the same, but the approach is very
different: the wider format makes the image
appear less like an altarpiece, and the single
moment is expanded into a narrative with a
far greater temporal scope. Moreover, the
point is evidently not to impress the believer
by emphasizing the humility of the kings, but
to demonstrate the artist's command of etch-
ing. Despite the relatively dry nature of

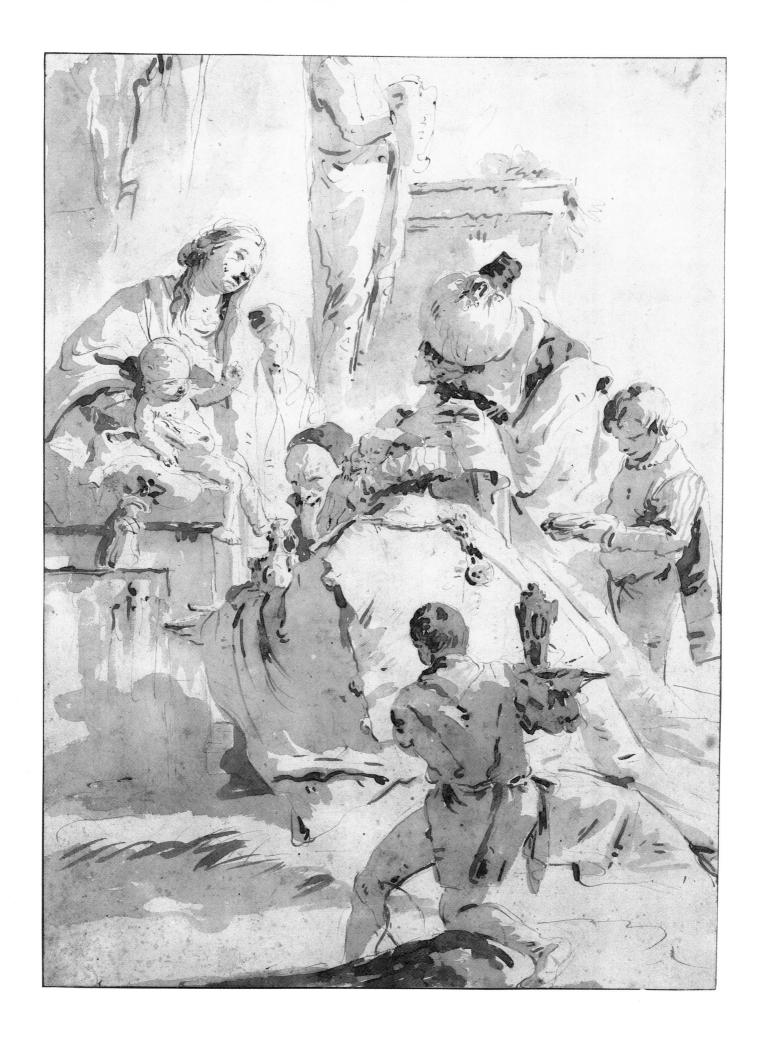

images produced in this medium, Tiepolo fully succeeds in conveying the differences between heaven and earth, or between surfaces such as silk, stone and animal fur, by describing the reflection of the light rather than the objects on which it falls. He brilliantly translates the characteristic features of Venetian painting, whose dominant concern is with light and colour, into the medium of etching. Given his mastery of the technique, it is regrettable that he made relatively little use of this exceptional talent.

An ink-and-wash drawing in the same format may be a preliminary sketch for this etching (fig. 119). Certainly, the drawing technique indicates that it is probably a study for a larger work. The composition has been lightly sketched, and the lines have then been retraced with the pen; in the process, the art-

ist has corrected a number of details, such as the positioning of the page's legs. The final addition of the wash gives the image a two-dimensional feel. Tiepolo often used this technique in the early stages of constructing an image: examples can be found in the study for the altarpiece at Diessen (fig. 19) and the sketch for the halberdier in the Investiture fresco (fig. 83).

Further evidence of Tiepolo's extraordinary range of expressive nuance is supplied by a small-format painting, now in the Metropolitan Museum of Art, New York, that was at one time believed to be a preliminary study for the Schwarzach altarpiece (fig. 116). Stylistic comparisons have since revealed that the painting must have been made some five years

later, but in some respects it is very close to the etching. The format is similar, the narrative is comparably detailed, and here, too, the main emphasis is on technique. Indeed, the virtuoso brushwork is so prominent that style and manner become the picture's real theme: the content is drained of religious significance, and one must assume that the work was painted for a collector and connoisseur whose motives were largely secular.

Tiepolo took his inspiration for these works from Paolo Veronese's treatment of the same theme in a painting created just under two hundred years before (fig. 118). This picture can also be seen as a virtuoso technical exercise, but there are several important differences between the two painters. In contrast to Veronese, Tiepolo has a hugely varied repertory of expressive possibilities, which he uses in the almost playful manner of a seasoned performer who can 'do' everything with equal facility, according to the requirements of the situation. Thus a religious motif may be treated with the greatest reverence in one context – this, for example, is the case with the altarpiece – and rendered as an object of purely aesthetic interest in another.

Giandomenico Tiepolo also created an altarpiece for the abbey church at Schwarzach (fig. 123). Painted in 1754, after the family's return to Venice, this treatment of the martyrdom of St Stephen was the young artist's most ambitious work to date; together with his overdoors for the Kaisersaal, it marked a major leap forward in the development of his

left
Fig. 120 Giandomenico Tiepolo,
Study for the Head of St Stephen, 1754.
Red and white chalk on grey paper, 27.3 x 23.5 cm.
Eichenzell near Fulda, Museum Schloss Fasanerie

above
Fig. 121 Giandomenico Tiepolo,
Study for the Hand of an Executioner, 1754.
Red and white chalk on grey paper, 24.3 x 16.2 cm.
Venice, Museo Correr

below
Fig. 122 Giandomenico Tiepolo,
The Martyrdom of St Stephen, c. 1754–5.
Etching, 46 x 26.3 cm (image)

facing page
Fig. 123 Giandomenico Tiepolo,
The Martyrdom of St Stephen, 1754.
Oil on canvas, 390.5 x 204.5 cm.
Staatliche Museen zu Berlin –
Preussischer Kulturbesitz, Gemäldegalerie

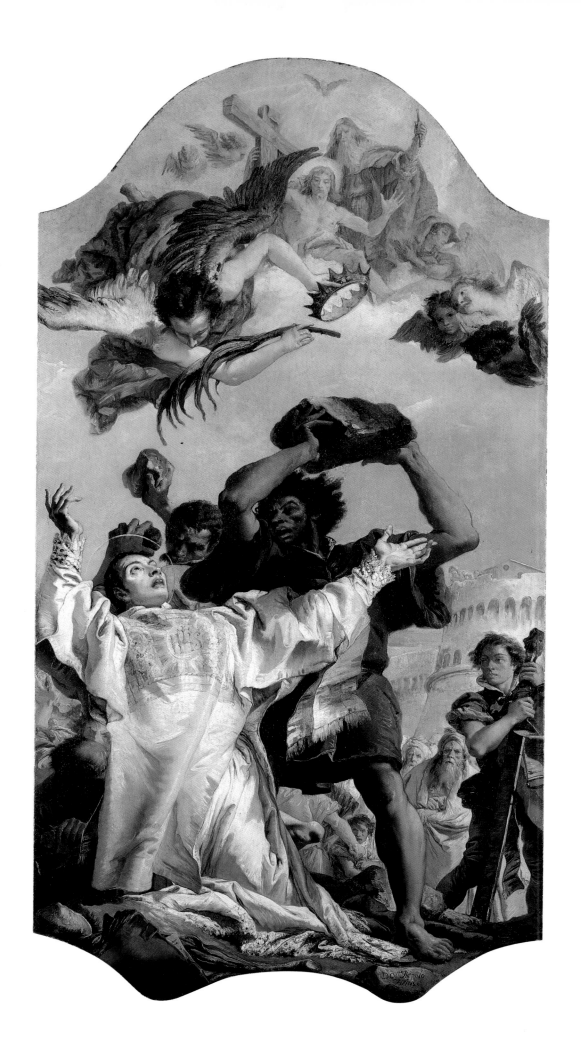

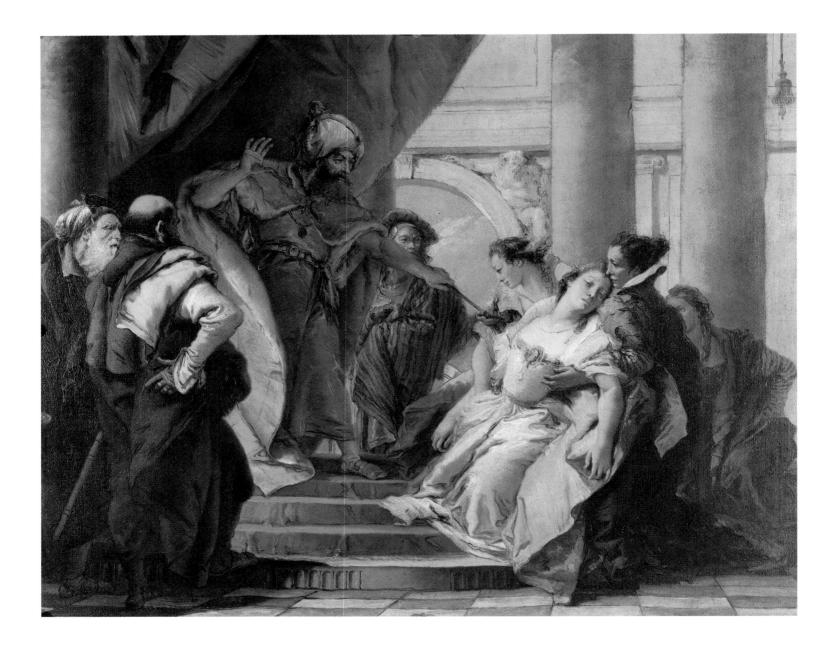

talents. For the sake of dramatic impact, he racked up the pathos in the gestures and facial expressions to the highest possible level of intensity. In this respect, Giandomenico's work differs markedly from that of his father, although he, too, had resorted to similar effects in some of his early paintings. A further characteristic feature of the son's work consists in the elimination of the foreground: the scene is set at the front edge of the canvas, which imparts an added sense of presence and urgency to the rendering of the figures.

Giandomenico's drawing technique, too, was heavily influenced by the example of his father. His preliminary sketches for the head

of St Stephen and the hand of one of the executioners are complex exercises in foreshortening (figs. 120, 121). Their graceful, sweeping lines lend them a special charm.

Probably just after he had completed the painting, Giandomenico made an etching based on it (fig. 122). For a long time, this was the sole surviving record of the altarpiece, which, following the demolition of the Schwarzach church, remained lost until 1978, when it was rediscovered in the storeroom of the East Berlin Gemäldegalerie. After being restored, the painting was shown in public for the first time in nearly two hundred years at the 1996 Tiepolo exhibition in Würzburg.

Fig. 124 Giambattista and Giandomenico Tiepolo, *Esther Before Ahasuerus*, 1751 (?). Oil on canvas, 84.5 x 106 cm. Switzerland, private collection

During his stay in Würzburg, Tiepolo also created a pair of paintings, titled *Esther Before Ahasuerus* and *David and Abigail*, that deal with the stories of biblical heroines noted for their intelligence and courage (figs. 124, 126). Esther, the beautiful Jewish wife of the Persian ruler Ahasuerus, ensured the deliverance of her people by appearing before her husband, in defiance of his order that no one, on pain of death, should enter his court. In the painting she has fainted with terror, but Ahasuerus is holding out his sceptre to her as a sign of favour. Abigail, the central figure in the second canvas, is throwing herself at the feet of King David to intercede on behalf of her husband, a wealthy merchant, who has incurred the king's wrath by refusing to supply provisions for his followers. Her plea for forgiveness is accepted.

These paintings were formerly in the possession of the Greiffenclau family, but it is unlikely that the Prince-Bishop himself was the owner. He would scarcely have identified with a female heroine, and the fact that both central figures are female is an almost certain indication that the works were commissioned by a woman. The most likely patroness would be Greiffenclau's sister, Anna Sophie von Sickingen, who stayed at the court for several months in 1752. In the diary of the courtier Johann Christoph Spielberger we find the following entry: 'Sunday, 23 April 1752. Frau von Sickingen today handed the clerk Andre a present for the painter Tiepolo as a reward for making several pictures. The gift comprised: 1 mirror with silver frame; 2 silver candlesticks; 1 ditto snuffer; 1 silver tooth-powder box; 1 ditto for soap-cakes; 1 ditto for sponge; 1 silver shaving mug.'

The wife of Baron von Sickingen, Anna Sophie lived at Schloss Ebnet in the Dreisam Valley near Freiburg im Breisgau. Assuming that she was indeed the patron, the canvases would have been kept in Ebnet before being returned to Würzburg as part of a bequest. Anna Sophie, too, no doubt wished to own a painting by the famous Venetian master, who, although already overburdened with work, was scarcely in a position to refuse the commission. The received view is that Tiepolo carried it out himself, but the pictures tell a different story: the figures are less elegant, less gracious and animated than in most of his work, and the architecture – in the Esther painting – is untypically lacklustre. This, together with the dull, pasty look of the drapery, recalls the work of Giandomenico from this period, while the composition fol-

Fig. 125 *Study of a Woman's Head.*
Red and white chalk on paper,
19.7 x 13.3 cm.
Private collection

lows exactly the same scheme as that found in a pair of canvases (examined below) on Roman subjects. Such a degree of repetition would be almost unthinkable in the work of the father. Nevertheless, there are some details of exceptionally fine quality, especially in the rendering of the faces, and in other areas where the artist draws with the brush, using it like a pencil. These touches indicate that Giambattista must have had at least some hand in the paintings. Corroboration for this assumption is provided by a preliminary

Fig. 126
Giambattista and
Giandomenico
Tiepolo,
David and Abigail,
1751 (?).
Oil on canvas,
82 x 105 cm.
Fürth, Stadtarchiv

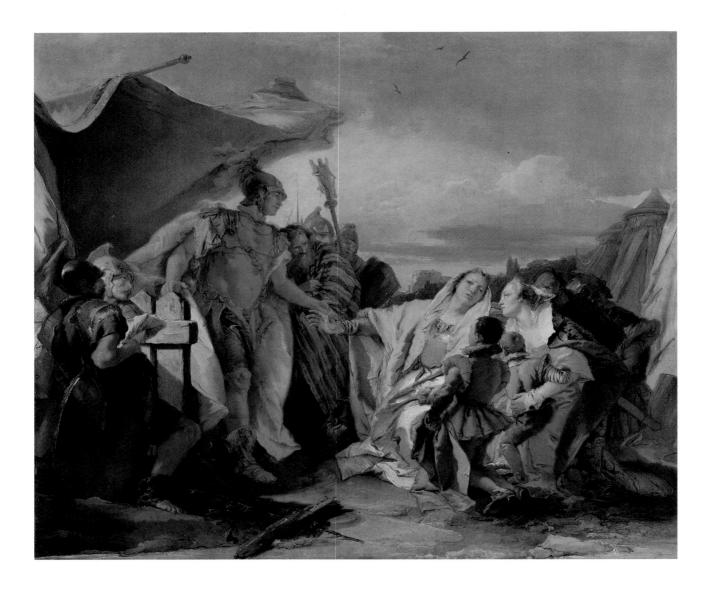

sketch of Abigail's head (fig. 125), which is undoubtedly by the father.

It would seem, therefore, that Giambattista acceded to Anna Sophie's request out of a sense of obligation to her brother, but then entrusted the task largely to his son. Officially, however, Giambattista created the paintings, as is indicated by the German wording of the entry in the courtier's diary, which shows that the 'present' was intended for Tiepolo *père*, not Tiepolo *fils*.

'Coriolanus Before the Walls of Rome' and 'Mucius Scaevola Before Porsena'

During his stay in Würzburg, Tiepolo created a number of paintings on subjects drawn from

ancient history and the poetry of Ovid and Tasso. Like most of his work of this period, these canvases show that the artist was at the zenith of his powers. Two of the most attractive were made for Balthasar Neumann and are still in Würzburg. Titled *Coriolanus Before the Walls of Rome* and *Mucius Scaevola Before Porsena*, they constitute a pair, illustrating supposed Roman virtues (figs. 127, 128).

Coriolanus, an exiled Roman hero who has taken refuge with the rebel Volsci people, is camped with the Volscian army outside the gates of Rome. After many vain attempts to induce him to end the siege, his mother courageously goes out to plead with him and succeeds in persuading him to relent and spare the city. Mucius similarly enters an enemy

Fig. 127 *Coriolanus Before the Walls of Rome*, *c.* 1751–2.
Oil on canvas, 103.3 x 122 cm.
Würzburg, Martin von Wagner-Museum der Universität Würzburg

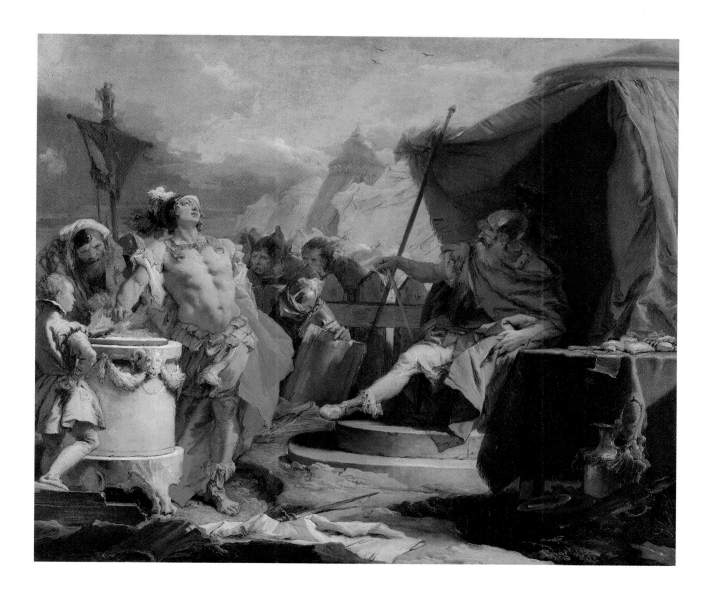

camp, with the intention of assassinating the Etruscan commander, Lars Porsena; but he kills his victim's attendant by mistake and is taken prisoner. As proof of his steadfastness and patriotism Mucius holds his right hand in a blazing fire, which so impresses Porsena that he decides to free the captive, withdraw his forces and make peace with the Romans. Mucius is henceforth known as Scaevola, meaning 'left-handed'.

Such depictions of exemplary virtue generally serve to glorify a king or prince, directly linking the past with the present and implying that the ruler himself is just as virtuous as the historical figure portrayed in the images. Allegorizing Neumann in this way makes no sense: the symbolic elevation of an architect to the status of a Roman hero would have

been seen as inappropriate and more than mildly ridiculous. It must be assumed, therefore, that Neumann bought the paintings for aesthetic reasons, as examples of Tiepolo's supple artistry. None the less, their value as such will have been boosted by the subject-matter, since in the eighteenth-century hierarchy of genres history painting held the position of highest esteem.

As already noted, the compositions of these canvases are repeated in the religious images created for Anna Sophie von Sickingen. This makes it possible to put a more accurate date on the pair of paintings for Neumann, which must have been made immediately before those for Schloss Ebnet, i. e. in the winter of 1751–2, a year earlier than most commentators have hitherto assumed.

Fig. 128 *Mucius Scaevola Before Porsena, c.* 1751–2. Oil on canvas, 103.2 × 121.7 cm. Würzburg, Martin von Wagner-Museum der Universität Würzburg

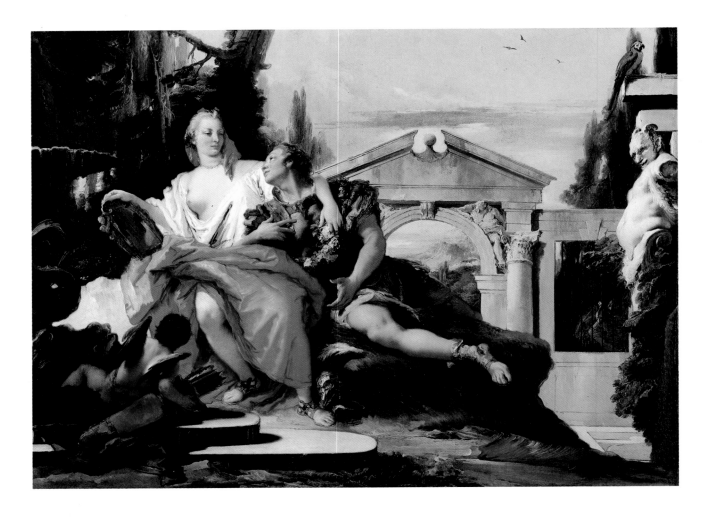

Rinaldo and Armida

The superlative quality of a pair of paintings on the theme of Rinaldo and Armida (figs. 129, 130) reflects the ambitions and high expectations of the man who commissioned them: Count Adam Friedrich von Seinsheim, the chief financial administrator of the Würzburg court, who succeeded Greiffenclau as Prince-Bishop. The subject-matter is taken from Torquato Tasso's epic poem *La Gerusalemme liberata* (Jerusalem Liberated), first published in 1581, but still widely read in the eighteenth century. The story is set in the year 1099, at the time of the First Crusade, when the Christian knights, led by Godfrey of Bouillon, set out to recover Jerusalem from the Turks. The sorceress Armida, a Saracen girl from

Damascus, is sent to sow confusion in the Christian camp. After the Italian hero Rinaldo has foiled an attempt to abduct a number of his comrades, Armida exacts revenge by casting a spell to put him into a deep sleep. However, looking at the handsome knight, she falls in love with him, and spirits him off to an enchanted garden on a remote island, where he succumbs to her charms. The pair are eventually discovered by two of Rinaldo's companions, Carlo and Ubaldo, who contrive to bring the knight back to his senses in order that he may resume the struggle against the heathen occupiers of the Holy Land.

To an even greater extent than in the pair of paintings made for Neumann, Tiepolo here combines his talent for 'drawing' in oils

Fig. 129 *Rinaldo and Armida, c.* 1752–3. Oil on canvas, 105 x 140 cm. Würzburg, Residenz

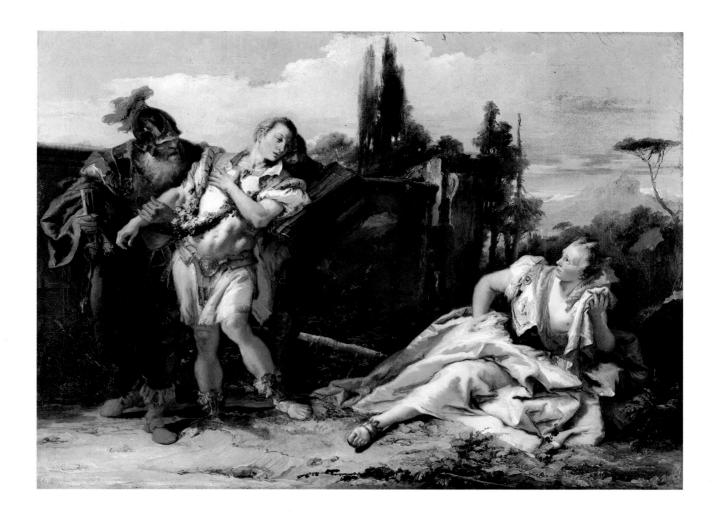

with his facility for three-dimensional model-
ling. The first aspect creates an impression of
lightness and virtuoso elegance, perfectly ful-
filling the ideal norms of eighteenth-century
Venetian painting, which in turn correspond-
ed to a more general model of aristocratic
thought and behaviour that prevailed through-
out Europe. The details that are painted in
this way are chiefly the 'soft' elements: the
garments, the plants and the ground, whose
style contrasts with that of the figures and the
architecture. The latter are built up in succes-
sive thin layers of luminous colour, which
impart a sense of volume to the parts in ques-
tion, especially to the flesh. The quite remark-
able presence of these areas can be fully
appreciated only by seeing the paintings at
first hand. The intensity of the colours gives

the figures an almost magically animated
quality. This has nothing to do with the
mimetic imitation of nature; in the first
instance, it is a manifestation of pure art,
exemplifying the non-figurative functions of
painting. It is difficult even to imagine paint-
ings of a higher quality than these truly
exceptional works.

The relationship between this pair of
paintings and two further pictures on the
same theme, now in Berlin (figs. 131, 133), has
long been a subject of art-historical contro-
versy. Discussion has revolved around the
purpose of the Berlin canvases and their date.
The degree of congruence in subject-matter,
the small formats and the loose, impromptu
execution have led some scholars to see the
works as preparatory sketches for the two

Fig. 130 *Rinaldo Leaving Armida*, c. 1752–3.
Oil on canvas, 105 x 140 cm.
Würzburg, Residenz

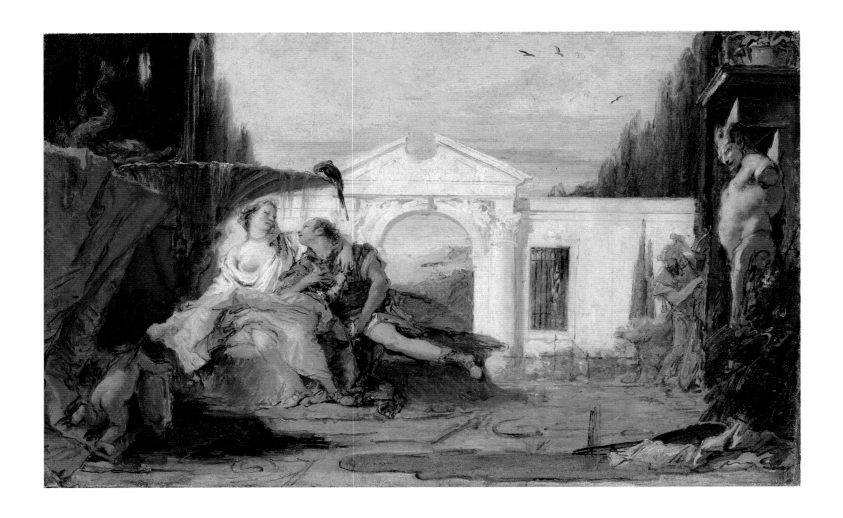

paintings originally owned by Seinsheim. Other commentators have argued that their style places them at the end of the 1750s, implying that they are finished paintings in their own right. I would incline towards the latter view, especially if one takes into account the strong similarities with the *Adoration of the Magi* painted in 1758–9 (see fig. 116).

First, it should be remembered that, as a rule, Tiepolo made preparatory oil sketches only for large-format works. This was necessitated by the sheer size of the altarpieces and the frescos, and also by the relationship between such images and their architectural setting, which called for special care in the disposition of the figures. For normal-sized

Fig. 132 *Rinaldo and Armida.*
Red chalk on paper,
16.7 x 23.2 cm.
London,
Victoria and
Albert Museum

easel paintings, it was unnecessary to work out all the details in advance: Tiepolo often contented himself with making a small drawing, which he then transferred to the canvas. The surviving drawing for one of the Rinaldo and Armida paintings (fig. 132) indicates that the canvases in Berlin can hardly be sketches; if this were the case, the difference between the drawing and the finished painting would be far greater.

Solving these dating problems is important, because it helps to assess the painting style. What is the reason for the summary, sketchlike quality of these pictures? Are the works preliminary studies, or do their easy, spontaneous lines and colouring constitute an

approach that Tiepolo considered valid on its own terms? The latter would seem to be the case.

Tiepolo's technique of brush-drawing requires relatively small figures in order to transform the surface of an image into a tissue of 'painterly' effects that has an aesthetic charm all of its own. The two paintings in Berlin exemplify this technique more satisfactorily than the 1758–9 *Adoration of the Magi*: in the former, lightness of touch is combined with the theme of love in a way that provides for the mutual reinforcement of medium and message, whereas in the latter, the content appears neutralized, or even desecrated, by the style.

facing page
Fig. 131 *Rinaldo and Armida Observed by Carlo and Ubaldo*, after 1753.
Oil on canvas, 39 x 62 cm.
Staatliche Museen zu Berlin –
Preussischer Kulturbesitz, Gemäldegalerie

this page
Fig. 133 *Rinaldo and Armida*, after 1753.
Oil on canvas, 39 x 61 cm.
Staatliche Museen zu Berlin –
Preussischer Kulturbesitz, Gemäldegalerie

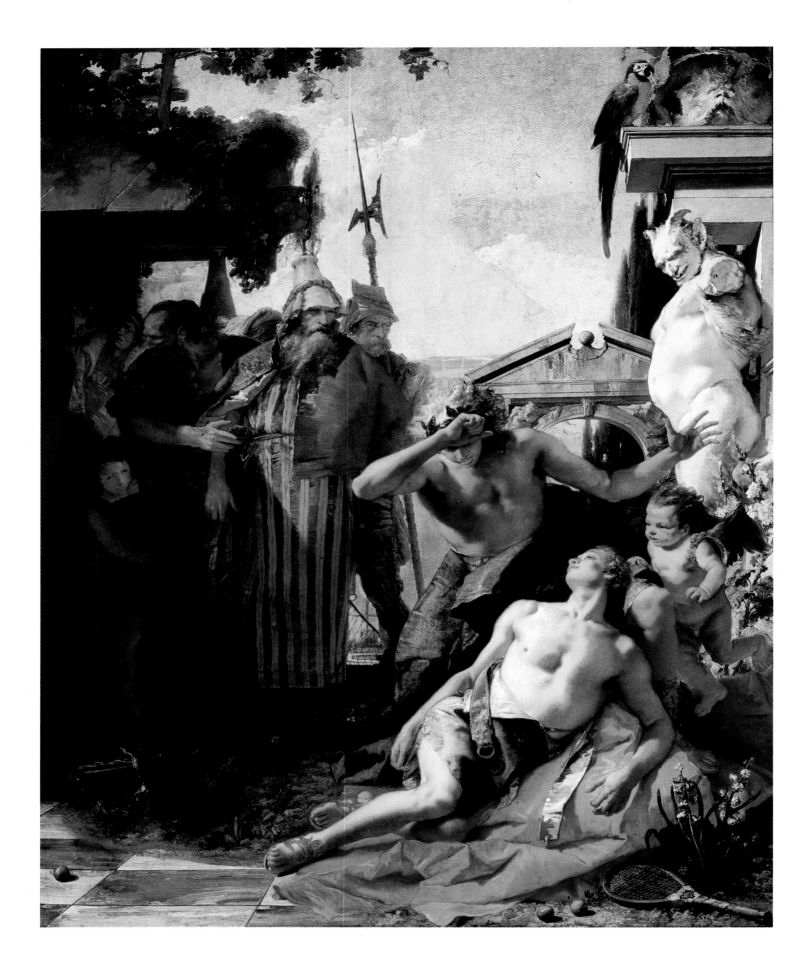

Fig. 134 *The Death of Hyacinth*, 1753. Oil on canvas, 287 x 235 cm. Madrid, Fundación Thyssen-Bornemisza

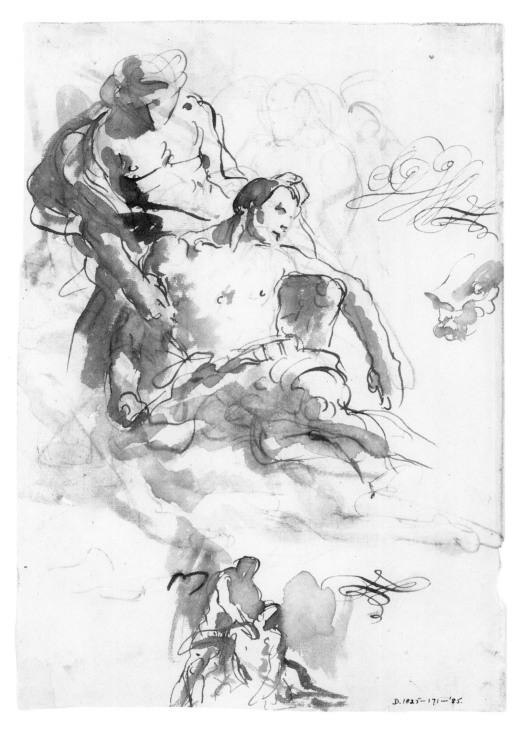

'The Death of Hyacinth'

Tiepolo's art appeals directly to the viewer's emotions, implicitly enjoining him or her to empathize with the mood of the figures. Other artists attempted to do the same, but Tiepolo is so outstandingly successful in achieving this aim that he may justifiably be counted among the greatest of all painters of human feelings. This is nowhere more apparent than in *The Death of Hyacinth* (fig. 134).

Figs. 135, 136 *Apollo and Hyacinth;*
recto (above) and verso.
Pen and bistre wash over
red chalk on oatmeal paper,
32.4 x 22.2 cm.
London, Victoria and Albert Museum

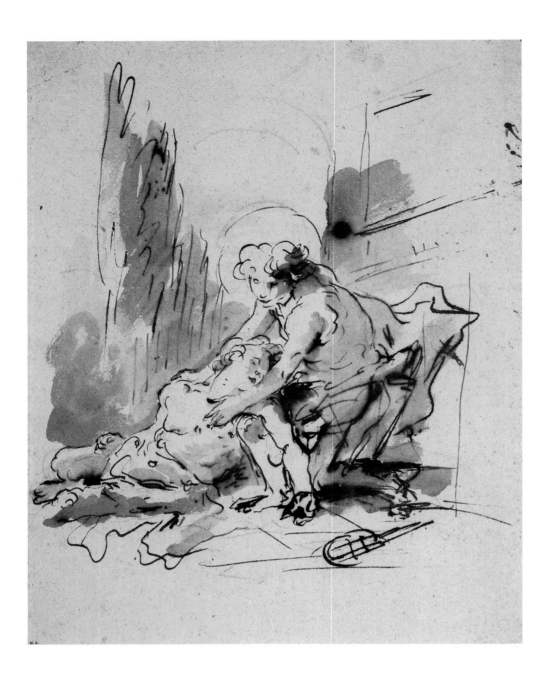

Too little is known of the circumstances surrounding the commission for the canvas to be dated with any degree of precision. The purchaser was Count Wilhelm von Bückeburg and, according to an inventory list, the work was bought in Venice in 1750. Yet there is good reason to suspect that the recorded price of 200 *zecchini* was an advance payment, and that the picture was not actually painted before Tiepolo's departure for Franconia. It is possible that the artist wished to avoid losing any more time before embarking on the Prince-Bishop's commission; executing the canvas in Würzburg would also have considerably eased the problem of transporting the work to Bückeburg's residence in Stadthagen, about forty kilometres west of Hanover. After settling in Würzburg, Tiepolo did not begin work on the painting immediately; first, he had to satisfy the demands of the various local patrons who were keen to avail themselves of his services. The inclusion of the male caryatid and the parrot, motifs that appear in the first of the Rinaldo and Armida paintings,

Fig. 137 *The Death of Hyacinth.*
Pen and bistre wash over
red chalk on oatmeal paper,
37.4 × 29.3 cm.
Würzburg, Martin von Wagner-Museum
der Universität Würzburg

indicates that *The Death of Hyacinth* must have been painted later than these, probably in the spring of 1753.

In Ovid's *Metamorphoses* Hyacinth, the son of King Amyclas of Sparta, is described as a youth of exceptional beauty who was loved by the god Apollo, and also by Zephyrus, the god of the west wind. Out of jealousy, Zephyrus deflected a discus thrown by Apollo so that it struck and killed Hyacinth. To commemorate the tragic accident, Apollo caused a flower bearing the loved one's name to spring from his blood. The painting shows the moment of Hyacinth's death: Apollo bends over his body in an attitude of anguished self-reproach as the youth breathes his last, stretched out on his flowing orange-red cloak. Beauty and death, love and pain: these are the constituents of the fateful scenario in which Apollo and Hyacinth are embroiled.

So intense are these feelings that the other figures in the picture are shy of approaching the dying youth and his involuntary assailant, and have opted to remain in the back-

ground. There, in the illuminated gap between the halberdier's legs, we find a limply drooping corner of a net. And in the lower right-hand corner there is a racket with two tennis balls. These, then, are the instruments of Hyacinth's death. Tiepolo took this idea from a sixteenth-century Italian translation of Ovid, which replaced the discus of Greek legend with a modern, and markedly unheroic, weapon. The resultant sense of bathos gives a humorous twist to the traditional story.

The Olympian remoteness of Greek mythology is additionally dispelled by transposing the events into the Arcadian setting of an Italian villa. Only one figure remains unmoved by the drama: the satyr on the right, who gazes down at Apollo and Hyacinth with an expression of leering mockery. As the embodiment of nature and the primordial promptings of the unconscious, he can feel nothing but ridicule and contempt for the distress of the two central characters. As mentioned, Tiepolo took this motif, and that of the parrot, from his painting of Armida weaving the spell that causes Rinaldo to fall in love with her (fig. 129). In Canto XVI (verses 14–15) of *La Gerusalemme liberata* Tasso introduces an enchanted bird – the parrot – which speaks of the wisdom of plucking the rose in the early morning, when the flower is still half-concealed by the green of the bud and is regarded with favour and desire by all who behold it. Love should be treated the same way, for just as the rose is doomed to wither and die, so, too, 'the verdancy and bloom of mortal life shall perish before the day has run its course'.

Very few of Tiepolo's paintings are so comprehensively documented by studies and drawings. These preliminary exercises fall into three categories, corresponding to the main stages in the genesis of the painting: designs for the composition of the group with Apollo and Hyacinth, individual nude studies of Hyacinth and sketches of the onlookers. The first two sets of drawings are especially noteworthy. They confirm the observation, already made in connection with the frescos, that Tiepolo was in the habit of outlining the complete image before going on to make detailed studies of the individual figures. In this case, however, the next step in the process of creating the painting is missing: after drawing the figures, the artist would normally have made a large sketch bringing together all the elements of the composition.

For the main figures Tiepolo made a series of wonderful sketches in ink and wash combined with red chalk (figs. 135–8). He amalgamates two quite separate motifs: the arrange-

ment of the pair of figures follows the familiar devotional image of the Pietà, but Hyacinth himself is based on the so-called *Pasquino*, a Roman copy of a Greek sculpture that often served as a model for depictions of lifeless bodies in post-Renaissance painting (fig. 139). Although it is by no means detrimental to the overall effect, the fact that Hyacinth and Apollo were separately conceived and elaborated remains apparent in the finished painting, where the two figures look rather like cut-outs that have been inserted into the composition after its basic structure had been determined. In this connection it is interesting to note that Tiepolo rearranged the two figures at least a dozen times in the drawings, without arriving at a definitive solution. The idea for the eloquent disposition of the arms evidently occurred to him at a relatively late stage, before he embarked on the detailed studies of Hyacinth, whose luminous flesh serves as the focal point of the completed picture.

Only in those drawings that reflect Tiepolo's study of the *Pasquino* can it be said with

certainty that the nudes in this series relate to Hyacinth (fig. 140). A number of other studies, however, have been cited in connection with the figure, and even if their poses offer no conclusive proof of such a link, it seems reasonably safe to assume that they are indeed preparatory sketches for Hyacinth – not least because the model remains the same throughout. In the first drawing Tiepolo experiments with the pose, before turning his attention to the modelling of the naked torso and the relief pattern of the muscles in the glancing sunlight (fig. 141). The drawings provide yet another demonstration of how Tiepolo uses the detailed observation of reality as his starting point but integrates these empirical elements into his specifically artistic universe.

Fig. 140 *Nude Study: A Man Reclining to the Left.* Red and white chalk on blue paper, 19.5 × 37.1 cm. Stuttgart, Staatsgalerie, Graphische Sammlung

facing page
Fig. 141 *Nude Study: A Seated Man.* Red and white chalk on blue paper, 29.5 × 20.5 cm. Stuttgart, Staatsgalerie, Graphische Sammlung

415.

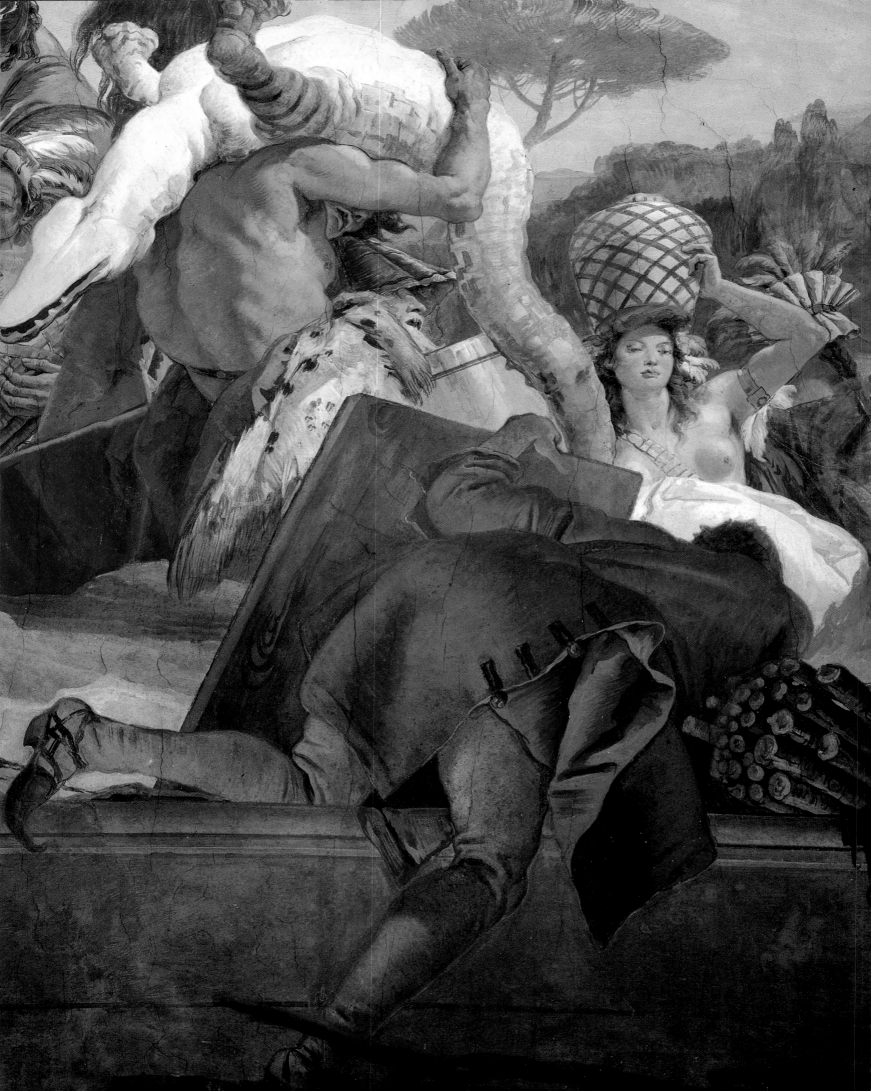

Tiepolo's Irony: Painting at the End of an Era

With its theme of the passing of beauty, *The Death of Hyacinth* can be viewed as a symbol of an age that was rapidly nearing its close. In the decades immediately following Tiepolo's departure from Würzburg the entire world was destined to change, in an upheaval of unparalleled dimensions that embraced every sphere of reality – the political and social order, art and culture, philosophy, science and religion. The sweeping transformations in all these fields still affect the way we act and think. Tiepolo's Würzburg frescos were not only to be the crowning artistic achievement of their century; they also became the last great monument to the *ancien régime*.

Since the days of Giorgione in the sixteenth century, Venetian painting had been characterized by the combination of picturesque beauty and strong sensuous appeal. Among the masters of the eighteenth century Tiepolo was uniquely faithful to these ideals, translating them once more into images of consummate perfection. The sense of painterliness, the delicacy of the colours, the hint of thematic indeterminacy: all these elements contributed to the idealization of the object, which is half-concealed under a veil of appearance and allusion, often conveying an atmosphere of almost magical eroticism. It is no coincidence that Tiepolo took so many of his themes from the writings of Tasso and Ovid. He was the last great painter capable of treating classical gods and heroes with the relaxed ease of a practised storyteller, and of using form and colour to magnify their doings.

Tiepolo also glorified the world of the court. His sumptuous painting style, combined with his talent for dramatization, makes his work the mirror image of a prince's delight in pomp and self-aggrandizing display. Yet in its virtuoso lightness, his painting is also the perfect embodiment of the aristocratic ideal of *désinvolture*. His model is Castiglione's nobleman, the man of true education and taste. In the context of the eighteenth century, painting of this kind is inevitably bound up with claims to authority and prestige. An alternative model is to be found in the middle-class world of Alessandro Longhi (1733–1813), whose paintings derive their charm from their programmatic plainness and modesty. But on closer inspection, Tiepolo's work reveals a number of surprising aspects that stand out from the general tendencies of its time and the circumstances of its genesis. Ultimately, his gods and allegories are human figures; they often seem like actors who know their lines perfectly but are, after all, merely playing a role, albeit with the same perfection as that shown by Tiepolo in the exercise of his painting skills. Tiepolo went to tremendous lengths in order to transform literary figures into living individuals, endowed with human feelings and capable of stepping straight out of his paintings into real life. For him, the world of symbols and allegories was no longer sacrosanct; he brought the gods down to earth and often injected a considerable quantity of irony into the treatment of his weighty themes.

The range of ironic motifs in Tiepolo's work is wide and varied. It includes the images, of exotic peoples and Europeans alike, in which details of costume, especially of hats and headdresses, are exaggerated to the point of caricature. It encompasses oddly foreshortened bodies and unexpected views: thus, for example, what looks like nothing more than a veritable cascade of fabric may turn out to be a dorsal view of a human figure. Grotesque contours and silhouettes are also employed to give an unusual twist to stock motifs. Moreover, Tiepolo has a great fondness for juxtaposing and conflating images in ways that deliberately confuse their meaning. Entire scenes can be cast in an ironic mould: for instance, when the gryphon is seen scrabbling to maintain its grip on the medallion containing the Prince-Bishop's portrait; when an ostrich jumps off the edge of the cornice to escape the attentions of an importunate monkey; or when a faithful dog is reluctant to leave its master (figs. 10, 36, 38). Irony can be detected in the Marriage fresco, where part of the august company has turned round to stare at some form of disturbance in the background (fig. 47); and there is a strong element of humour in the ceiling fresco, whose solemnity is rudely interrupted by the tableau – located directly beneath the personification of Religion – showing the nymph unabashedly groping at the river-god's private parts (fig. 46). On a further ironic note, the *Genius imperii* in the same fresco is stark naked under the cloak hastily thrown over his shoulders to welcome his bride, accompanied by Apollo. And his unclothed state is clearly not the heroic nudity of classical sculpture, but the straightforward nakedness of an ordinary human

Fig. 142 Figure of a European; detail of *America* from the staircase fresco in the Würzburg Residenz

body. These few examples may suffice to show that nearly every motif in Tiepolo's art has at least some form of actual or potential ironic resonance.

This element of irony has sometimes been interpreted as part of a socially critical agenda, but such readings are surely wide of the mark. Tiepolo's humour is never destructive, and it is entirely free of sarcasm. Instead of seeking to unmask people's weaknesses, he seems to solicit our sympathy for them, inviting us to view them in the mild light of a general human understanding. The same tolerance is extended to the world of mythology and allegory, whose inhabitants are also depicted as human beings, equipped with specifically human feelings and behaving in recognizably human ways.

It would be fascinating to know exactly what the Prince-Bishop and his courtiers made of Tiepolo's work. As they looked at the paintings, they can hardly have failed to detect the signs that the times were changing. The grand edifice of absolutism was doomed to crumble, and cracks had already appeared in the façade. Yet instead of welding his irony to a critical or satirical purpose, Tiepolo incorporated it into an aristocratic attitude of amused detachment, and thereby placed his art at the service of the *status quo*.

It is also regrettable that we know nothing of Tiepolo's thoughts about the historic changes taking place around him. We can be sure that he realized what was happening – and that he recognized the general drift of events from an early age, not only during the last eight years of his life, when he worked in Madrid and found himself competing with Anton Raphael Mengs, the leader of the neo-classical reform movement in painting. Only two years after the completion of the Würzburg frescos, Mengs created the first-ever neo-classical paiting (fig. 143), commissioned by the Margrave of Bayreuth, only a few kilometres away from the site of Tiepolo's recent triumphs. Tiepolo also had an opportunity to observe the impact of the times at first hand, in the work of his son Giandomenico, who had already lost much of the verve that enabled Giambattista to reconcile the divine with the human in his characteristically effortless fashion. To illustrate the differences of approach between father and son, one need only compare the latter's recently rediscovered painting of a monk (fig. 144) with the image of a saint produced only a few years previously by Tiepolo *père* (fig. 145). Giandomenico's style is more popular and down-to-earth.

As a parting gift, Giandomenico presented the Prince-Bishop with a suite of etchings

on the theme of the Flight into Egypt. The dedication image depicts angels carrying the Greiffenclau crest and insignia up to heaven; led by the personification of Fame, they are flying over the fortress of Marienberg, the former residence of the rulers of Würzburg (fig. 146). Here, Giandomenico has evidently taken his inspiration from the group sur-

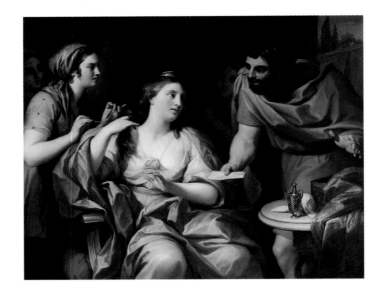

Fig. 143 Anton Raphael Mengs, *Semiramis Receiving News of the Babylonian Uprising*, 1755. Oil on canvas, 111 x 138 cm. Bayreuth, Neues Schloss

Fig. 144 Giandomenico Tiepolo, *Monk with a Crucifix*, c. 1751–3. Oil on canvas, 61 x 41 cm. Private collection

rounding the medallion in the staircase fresco (fig. 10), but the later works in the series document his efforts to find a language of his own, basing his ideas on those of his father, but placing greater emphasis on the human aspect. Seen as a whole, the etchings represent one of the finest examples of eighteenth-century printmaking. With warmth and sensitivity, they describe the flight into Egypt as a long and wearisome journey, culminating in the scene of arrival at the gates of the Egyptian city where Mary and Joseph finally find refuge from the executioners sent forth by King Herod (fig. 147).

In conclusion, let us return briefly to the Würzburg frescos and take a last look at the

depiction of America. There, on the right of the cluster of severed heads, a European has crept into the picture and is peeping out from behind a wooden panel to catch a glimpse of this fascinating world, full of mystery and exotic cruelty (fig. 142). What he sees is clearly the stuff of fantasy and fairy-tale: at the time when the fresco was painted, reality had already taken on a very different complexion. America had long since been invaded by Europe, and from 1755 to 1763 France and Britain were to vie on the battlefield for control of the continent. Barely a quarter of a century after Tiepolo's departure from Würzburg the United States of America declared their independence from the English crown. In Tiepolo's depiction of Europe the continent is seen as a place of leisure and contentment, entirely given over to the enjoyment of the arts and the cultivation of the

mind. But this, too, was soon to be a thing of the past: with the onset of the Industrial Revolution in the 1760s, the aristocratic ideal of *dolce far niente* was shortly to be displaced, radically and permanently, by the middle-class emphasis on work and discipline.

There is, of course, no direct sign of these imminent developments in Tiepolo's work. The contrast between artistic appearance and the reality of a changing world could hardly be greater. And yet, seen in this context, Tiepolo's irony acquires a latent edge, despite its overtly conciliatory tone, which strives to maintain a sense of coherence between things that are, in fact, drifting apart.

left
Fig. 145 *St James the Great*, before 1750.
Oil on canvas, 60x45 cm.
New York, Piero Corsini Collection

above
Fig. 146 Giandomenico Tiepolo,
Dedication image of *The Flight into Egypt*, 1750–3.
Etching, 18.2 x 23.1 cm (image)

Fig. 147
Giandomenico Tiepolo,
'The Holy Family
Arriving at
the Egyptian Town',
folio 27 of
The Flight into Egypt,
1750–3.
Etching,
18.4x24.4 cm
(image)

The Tiepolos:
A Chronology

Compiled by Rainer Schuster

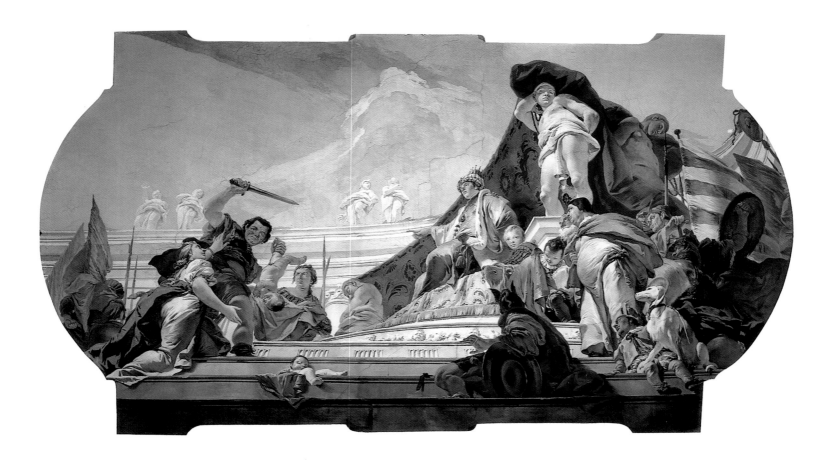

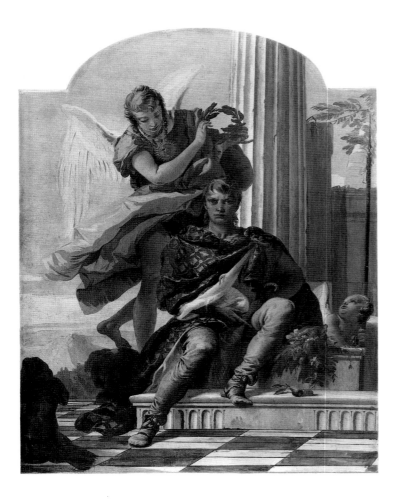

Early Works in Venice and Udine

1696 5 March: Giovanni Battista (Giambattista) Tiepolo is born in Venice. His father, Domenico, is a merchant.

1715–16 Serves apprenticeship with the painter Gregorio Lazzarini. Tiepolo's earliest extant work is *The Sacrifice of Isaac* in S. Maria dei Derelitti (the Ospedaletto), Venice.

1717 First appearance of Tiepolo's name in the lists of the Fraglia, the Venetian painters' guild.

c. 1718 Paints a fresco of the Assumption of the Virgin in the parish church of Biadene, Treviso. It shows stylistic similarities with works by Federico Bencovich and Sebastiano Ricci.

1719 21 November: Marries Cecilia Guardi, sister of the painters Giovanni Antonio and Francesco Guardi.

1722 Produces *The Martyrdom of St Bartholomew* for S. Stae, Venice (fig. 3). The painting's expressive force and use of chiaroscuro recall the work of Giovanni Battista Piazzetta.

1724–5 Paints *Allegory of the Power of Eloquence* in the Palazzo Sandi, his first secular ceiling fresco in Venice (fig. 150). Creates his first religious fresco in Venice, *The Apotheosis of St Theresa* in S. Maria di Nazareth.

above

Fig. 148 *The Judgement of Solomon, c.* 1727; detail.
Udine, Palazzo Arcivescovado

Fig. 149 *Courage Crowned by Glory,* 1734.
Biron, Villa Zileri dal Verme

1726 4 June: Confirmation of commission to fresco the Chapel of the Sacrament in the cathedral at Udine. Subsequently, Tiepolo also decorates the Archbishop's palace at Udine (fig. 148). His mature style, seen here for the first time, is characterized by a strong emphasis on emotion and animation, the calculated abbreviation of detail for dramatic purposes and the use of vivid colour.

1727 30 August: Birth of son Giovanni Domenico (Giandomenico) in Venice.

Travels in Lombardy and the Veneto Region,
1731–1737

1732 Tiepolo works in the Capella Colleoni, Bergamo. The resulting frescos, criticized by some contemporaries as excessively

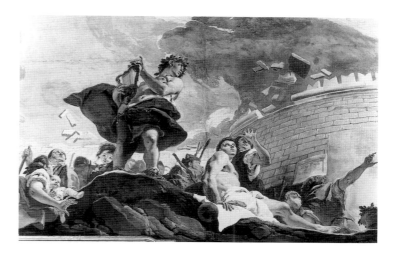

Fig. 150 *Allegory of the Power of Eloquence,* 1724–5; detail. Venice, Palazzo Sandi

Fig. 151 *The Martyrdom of St Vittore,* 1737–8; sketch for a fresco in the chapel of St Vittore in S. Ambrogio, Milan. Oil on canvas, 33.3 × 41.7 cm. Private collection

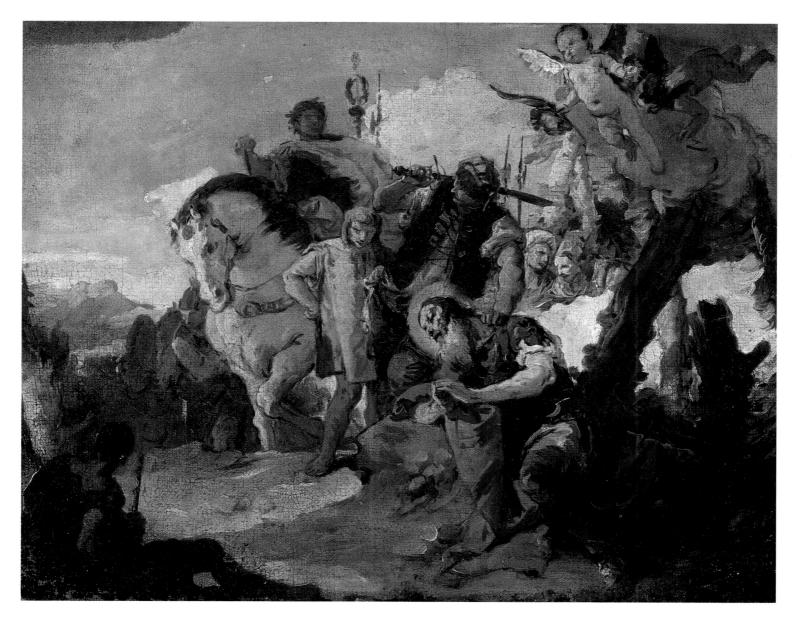

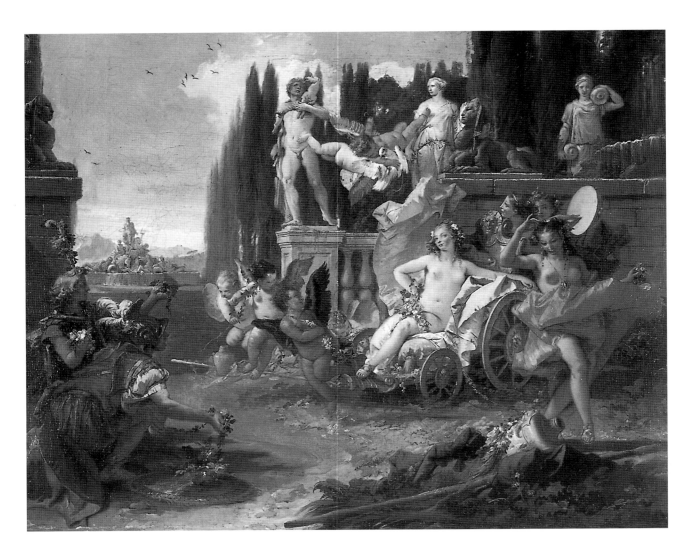

Fig. 152
*The Triumph
of Flora,*
1744–5.
Oil on canvas,
72 x 89 cm.
San Francisco,
M. H. de Young
Memorial Museum

dramatic, display parallels with sixteenth-century Venetian art (Titian, Tintoretto). Creates his first altarpiece for a Venetian church, *The Education of the Virgin* in S. Maria della Fava. Executes peparatory drawings for prints of Roman busts and statues to be published in Scipio Maffei's *Verona illustrata*.

1734 The painter Giovanni Raggi enters Tiepolo's studio.
Tiepolo and his family move to a house in the parish of San Silvestro.
Works day and night without rest on the frescos in the Villa Loschi, now known as Zileri dal Verme, at Biron, near Vicenza (fig. 149) – the first of approximately a dozen such projects in the Veneto region, following his 1719 ceiling frescos in the Villa Baglioni at Massanzago in the province of Padua.
Produces *The Virgin with Apostles and Saints* for the church of Ognissanti, Rovetta, a painting with vibrant, varied colours that reveals far less emphasis on dramatic play of light and shade.

1736 8 August: Birth of son Lorenzo in Venice.
Probably for financial reasons, Tiepolo refuses the invitation of the King of Sweden to decorate the royal palace in Stockholm.

The Major Frescos, 1737–1750

1737–8 Decorates the ceiling of S. Maria del Rosario ai Gesuati, Venice. The main, large-format fresco, *The Institution of the Rosary*, uses compositional devices, such as zigzag lines, derived from the work of Piazzetta, together with motifs from paintings by Veronese, Palma Giovane and Tintoretto in the Doge's Palace.
Commissioned by Clemens August, Elector of Cologne and a member of the Wittelsbach dynasty, to paint *The Adoration of the Trinity by Pope Clement* for the convent church in Nymphenburg, near Munich – the first of Tiepolo's monumental altarpieces, characterized by an almost palpable realism (fig. 16).
Paints three frescos in S. Ambrogio, Milan (see fig. 151).
Produces *The Carrying of the Cross* (S. Alvise, Venice), probably his most touching and emotionally charged work from this period.

1739 2 December: Signs contract to paint the ceiling fresco in the Scuola dei Carmini, Venice.

1740 Paints ceiling fresco in Palazzo Clerici, Milan. The work, highly praised by contemporary commentators, serves as a model for the composition of Tiepolo's later frescos.

1742–5 Creates eight paintings with scenes from Torquato Tasso's *La Gerusalemme liberata*, including the story of the lovers Rinaldo and Armida, which becomes a central theme in Tiepolo's art.

1743 Works at the Villa Cordellina, near Vicenza. The frescos include stylistic and thematic borrowings from Poussin and Raphael, no doubt under the influence of the Venetian connoisseur and aesthetic theorist Francesco Algarotti.

13 September: Signs contract to decorate the vault of the church of the Scalzi, Venice, with a fresco depicting the miracle of the Holy House of Loreto.

Paints *The Martyrdom of St John, Bishop of Bergamo* for Bergamo Cathedral (fig. 154). Tiepolo's style begins to combine heroic and dramatic accents, integrating architectural elements into the action of the picture.

Giandomenico receives a fee from Algarotti for two drawings.

1744 Giambattista's *The Banquet of Cleopatra* (fig. 153) is delivered to the court of Saxony at Dresden. The purchase is negotiated by Algarotti, who emphasizes the sumptuousness of the scene and the 'learned' character of the painting, which he describes as comparable with the art of Poussin. In the summer Tiepolo begins to decorate the Palazzo Labia with a cycle of frescos – his largest secular paintings in Venice – which are greatly admired and much copied by his contemporaries.

1747 Completion of *The Meeting of Anthony and Cleopatra* (now in Arkhangelskoye).

1747–9 Giandomenico paints the Stations of the Cross for the church of S. Polo, Venice.

1749 Publication of Giambattista's *Capricci* and Giandomenico's *Stations of the Cross*.

Giambattista and his family move to a larger and more imposing house near San Fosca.

Fig. 153 *The Banquet of Cleopatra*, 1743–4.
Oil on canvas, 249 x 346 cm. Melbourne, National Gallery of Victoria

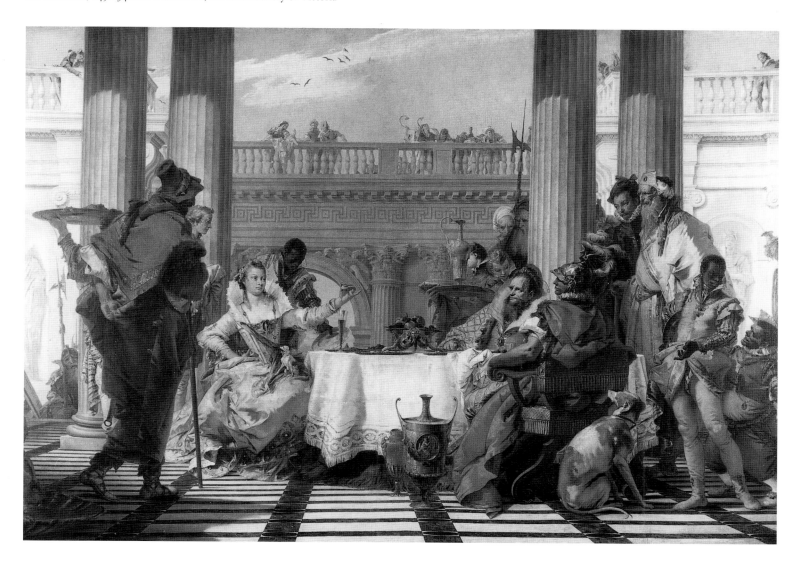

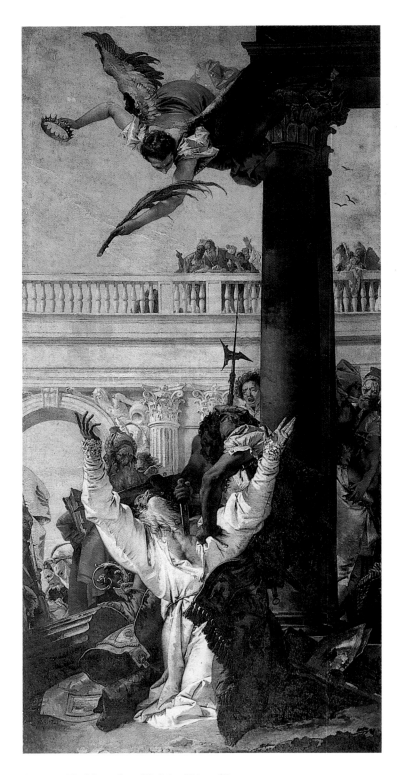

Fig. 154 *The Martyrdom of St John, Bishop of Bergamo*, 1743.
Oil on canvas, 600 x 250 cm. Bergamo, Cathedral

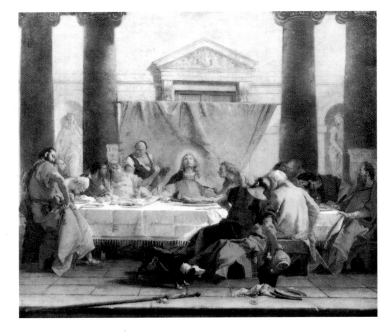

Fig. 155 *The Last Supper*, *c.* 1745 – 50.
Oil on canvas, 78 x 88 cm. Paris, Louvre

1750 Giandomenico paints *St Oswald Begging for a Miracle* for the parish church of Merlengo, near Treviso. This is one of his first major pictures, in which the influence of his father is clearly apparent.

The Würzburg Years, 1750–1753

1750 10 October: Giambattista signs contract to paint the Kaisersaal in the Würzburg Residenz.
12 December: Giambattista, Giandomenico and Lorenzo arrive in Würzburg.
1751 17 April: Prince-Bishop Carl Philipp von Greiffenclau visits Giambattista's studio and inspects the designs for the frescos in the Kaisersaal.

Fig. 156 Balthasar Neumann, detail of *Europe*
from the staircase fresco in the Würzburg Residenz (cf. fig. 38)

27 April: Begins work on the Kaisersaal.

Giandomenico creates the overdoor paintings.

4 July: Completion of the three frescos in the Kaisersaal: *The Investiture of Bishop Herold as Duke of Franconia, The Marriage of Frederick Barbarossa and Beatrice of Burgundy* and *Apollo Conducting Beatrice of Burgundy to the 'Genius imperii'*.

Paints *Coriolanus Before the Walls of Rome* and *Mucius Scaevola Before Porsena* (figs. 127, 128).

1752 20 April: Greiffenclau inspects Giambattista's plans for the staircase fresco.

29 July: Signing of contract for the staircase fresco.

1753 Giambattista completes *The Adoration of the Magi* (now in the Alte Pinakothek, Munich) for the Benedictine abbey at Schwarzach (now Münsterschwarzach), Bavaria (fig. 114).

The Death of Hyacinth painted by Giambattista for the Count of Bückeburg (fig. 134).

Completion of the staircase fresco in Würzburg.

Publication of Giandomenico's *The Flight Into Egypt*, a suite of etchings made for Prince-Bishop von Greiffenclau (see figs. 146, 147).

8 November: The Tiepolos leave Würzburg.

Activities in Venice and the Veneto, 1754–1761

1754 8 May: Giambattista's altarpiece *The Apparition of the Virgin to St John Nepomuk* is unveiled in the church of S. Polo, Venice (fig. 160). The painting, which may have been commissioned by August III, the Elector of Saxony, bears a number of resemblances to Raphael's *Sistine Madonna*, which had been brought to Dresden in the same year. As in most of the pictures painted after his stay in Würzburg, he dispenses with architectural

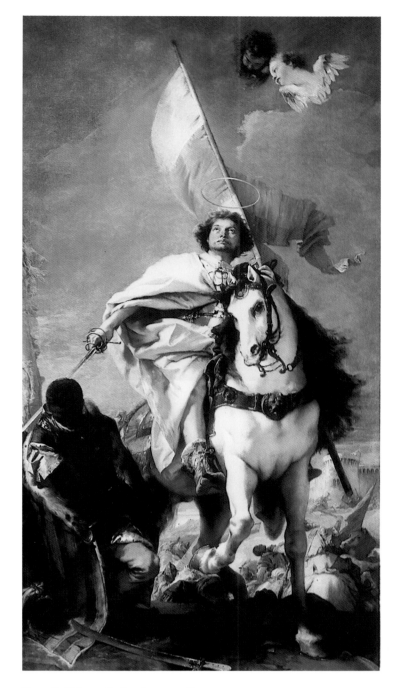

Fig. 158 *St James the Great, c.* 1757–8.
Oil on canvas, 317 x 162 cm. Budapest, Szépmüveszeti Múzeum

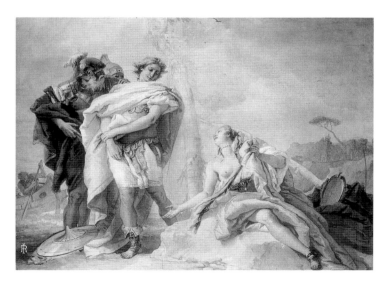

Fig. 157 *Rinaldo Leaving Armida*, 1757. Vicenza, Villa Valmarana

decor. The painting may be a tribute to Giovanni Battista Piazzetta, one of Giambattista's former mentors, who had died on the saint's feast day.

13 June: Begins work on the ceiling of S. Maria della Pietà in Venice, completed on 2 August 1755.

Giandomenico paints *The Adoration of the Shepherds* and frescoes the presbytery and choir of Santi Faustino e Giovita in Brescia with *The Apotheosis of St Faustinus and St Jovita*.

1755 Giambattista and a group of fellow artists draw up a statute for the Academy of Arts at Padua. From 1756 to 1758 he serves as the first president of the new institution.

Fig. 159 *St Tecla Delivering the Town of Este from the Plague*, 1758; sketch for the altarpiece in Este Cathedral. Oil on canvas, 80 x 45 cm. New York, The Metropolitan Museum of Art

below
Fig. 160 *The Apparition of the Virgin to St John Nepomuk*, 1754. Oil on canvas, 346 x 145 cm. Venice, S. Polo

1757 Giambattista and Giandomenico decorate the Villa Valmarana in Vicenza. The themes of the father's frescos in the ground-floor rooms are taken from classical and more recent sources, including Homer's *Iliad* and Tasso's *La Gerusalemme liberata* (see fig. 157). Lorenzo paints a portrait of his mother and a Tiepolo family group; the latter work, often ascribed to Giandomenico, remains unfinished.

1758 Giambattista becomes an honorary member of the Academy of Arts in Parma.
Produces his final large-format altarpiece before departing for Spain: *St Tecla Delivering the Town of Este from the Plague* in the cathedral at Este (see fig. 159).
Giandomenico decorates the ceiling of the choir in S. Giovanni, Meolo.

1759 Giambattista works on frescos in the Cappella della Purità at Udine.

1761 Giambattista and Giandomenico work on decorations for the Villa Pisani at Strà.
Unveiling of Giandomenico's ceiling fresco at the Scuola di San Giovanni Evangelista, Venice.
Lorenzo accepted as a member of the Venetian painters' guild.

Madrid, 1762–1770

1762 4 June: Giambattista, Giandomenico and Lorenzo Tiepolo arrive in Madrid.

1764 Giambattista completes of *The Apotheosis of Spain*, a large ceiling fresco for the throne-room in the new royal palace. This is followed by frescos in the Queen's antechamber and the guardroom: *The Apotheosis of the Spanish Monarchy* and *The Apotheosis of Aeneas* (fig. 162). Working in Madrid at the same time is Anton Raphael Mengs, one of the leading promoters of a return to classicism in painting.

1768 Lorenzo makes a series of paintings for the royal palace in Madrid.

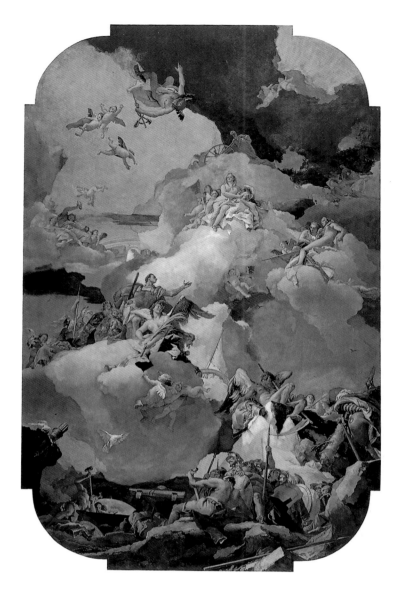

Fig. 161 *Abraham and the Angels*, c. 1767–70.
Oil on canvas, 57×42 cm. Madrid, Luna-Villahermosa Collection

right
Fig. 162 *The Apotheosis of Aeneas*, 1765–6.
Madrid, Palacio Real, Guardroom

1769 Giambattista completes seven paintings for the royal chapel at Aranjuez.

1770 27 March: Giambattista Tiepolo dies in Madrid.
Giandomenico returns to Venice on 12 November.

After Giambattista's Death

1773 Giandomenico paints *Abraham and the Angels* for the Scuola della Carità in Venice.

1775 Publication of a collection of etchings by Giambattista, Giandomenico and Lorenzo.

1776 Lorenzo Tiepolo dies in Madrid.
Giandomenico marries Margherita Moscheni.

1777 Paints an altarpiece for Sant' Agnese in Padua.

1783 Elected president of the Venice Academy, an office he holds for three years.

1784 Paints *The Apotheosis of Jacopo Giustiniani* for the Chamber of the Privy Council in the Palazzo Ducale at Genoa.

1793 Works in the Villa Tiepolo at Zianigo and in Catura.

1793 Paints the *Pulcinella* frescos in the Ca' Rezzonica, Venice.

1804 3 March: Giandomenico Tiepolo dies.

Selected Bibliography

Alpers, Svetlana, and Michael Baxandall. *Tiepolo and the Pictorial Intelligence*. New Haven and London, 1994.

Ashton, Mark. 'Allegory, Fact, and Meaning in Giambattista Tiepolo's Four Continents in Würzburg.' *Art Bulletin* 60 (1978), pp. 109–25.

Bachmann, Erich, and Burkard von Roda. *The Würzburg Residence and Court Gardens*. 9th edn. Munich, 1992.

Barcham, William L. *The Religious Paintings of Giambattista Tiepolo: Piety and Tradition in Eighteenth-Century Venice*. Oxford, 1989.

Barcham, William L. *Giambattista Tiepolo*. London, 1992.

Bott, Gerhard. *Das Fresko im Treppenhaus der Würzburger Residenz*. Werkmonographien zur bildenden Kunst in Reklams Universalbibliothek 92. Stuttgart, 1963.

Büttner, Frank. *Giovanni Battista Tiepolo: Die Fresken in der Residenz zu Würzburg*. Würzburg, 1980.

Byam Shaw, James. *The Drawings of Domenico Tiepolo*. London, 1962.

Byam Shaw, James, and George Knox. *The Robert Lehman Collection, VI: Italian Eighteenth-Century Drawings*. New York, 1987.

Christiansen, Keith. 'Würzburg: Tiepolo' [review of the 1996 exhibition in the Residenz, Würzburg]. *The Burlington Magazine* 142 (1996), pp. 476–9.

Dischinger, Gabriele. *Die Würzburger Residenz im ausgehenden 18. Jahrhundert*. Veröffentlichungen des Zentralinstituts für Kunstgeschichte in München. Wiesbaden, 1978.

Freeden, Max H. von. *Tiepolo in Würzburg*. Exh. cat. Würzburg, Mainfränkisches Museum. Würzburg, 1951.

Freeden, Max H. von, and Carl Lamb. *Das Meisterwerk des Giovanni Battista Tiepolo: Die Fresken in der Würzburger Residenz*. Munich, 1956.

Gemin, Massimo, and Filippo Pedrocco. *Giambattista Tiepolo: I dipinti – Opera completa*. Venice, 1993.

Hetzer, Theodor. *Die Fresken Tiepolos in der Würzburger Residenz*. Frankfurt am Main, 1943.

Hubala, Erich, and Otto Mayer. *Die Residenz zu Würzburg*. Würzburg, 1984.

Knox, George. *Catalogue of the Tiepolo Drawings in the Victoria and Albert Museum*. London, 1960; 2nd edn, London, 1975.

Knox, George. *Tiepolo: Tecnica e immaginazione*. Exh. cat. Venice, Palazzo Ducale. Venice, 1979.

Knox, George. *Giambattista and Domenico Tiepolo: A Study and Catalogue Raisonné of the Chalk Drawings*. Oxford, 1980.

Knox, George, and Christel Thiem. *Tiepolo: Drawings by Giambattista, Domenico and Lorenzo Tiepolo from the Graphische Sammlung, Staatsgalerie Stuttgart, from Private Collections in Wuerttemberg and from the Martin von Wagner Museum of the University of Würzburg*. Exh. cat. Ed. Stuttgarter Galerieverein and Graphische Sammlung, Staatsgalerie Stuttgart. Stuttgart, 1970.

Krückmann, Peter O., ed. *Der Himmel auf Erden: Tiepolo in Würzburg*. 2 vols. Exh. cat. Würzburg, Residenz. Munich and New York, 1996.

Levey, Michael. *Giambattista Tiepolo: His Life and Art*. New Haven and London, 1986.

Lorenzetti, Giulio. *Il Quaderno del Tiepolo al Museo Correr di Venezia*. Venice, 1946.

Lorenzetti, Giulio, ed. *Tiepolo*. Exh. cat. Venice, Palazzo Ducale. Venice, 1951.

Mariuz, Adriano. *G. D. Tiepolo*. Venice, 1971.

Martineau, Jane, and Andrew Robison, eds. *The Glory of Venice: Art in the Eighteenth Century*. Exh. cat. London, Royal Academy of Arts, and Washington, D.C., National Gallery of Art, 1994–5. London and Washington, D.C., 1994.

Molmenti, Pompeo. *G. B. Tiepolo: La sua vita e le sue opere*. Milan, 1909.

Morassi, Antonio. *Tiepolo*. Bergamo, Milan and Rome, 1943. Trans. as *G. B. Tiepolo: His Life and Work*, London, 1955.

Morassi, Antonio. *A Complete Catalogue of the Paintings of G. B. Tiepolo*. London, 1962.

Pallucchini, Anna, and Guido Piovene. *L'opera completa di Giambattista Tiepolo*. Classici dell'Arte 25. Milan, 1968.

Pallucchini, Rodolfo. *La Pittura veneziana del Settecento*. Venice and Rome, 1960.

Precerutti Garberi, Mercedes. 'Asterischi sull' attività di Domenico Tiepolo a Würzburg.' *Commentari* 11 (1960), pp. 267–83.

Precerutti Garberi, Mercedes. 'Segnalazioni tiepolesche.' *Commentari* 15 (1964), pp. 246–61.

Rizzi, Aldo. *L'opera grafica dei Tiepolo: Le acqueforti*. Milan, 1971.

Rizzi, Aldo, ed. *Mostra del Tiepolo*. 2 vols. Exh. cat. Udine, Villa Manin di Passariano. Milan, 1971.

Russell, H. Diane. *Rare Etchings by Giovanni Battista and Giovanni Domenico Tiepolo*. Washington, D.C., 1972.

Sack, Eduard. *Giambattista und Giandomenico Tiepolo: Ihr Leben und ihre Werke*. Hamburg, 1910.

Sedlmair, Richard, and Rudolf Pfister. *Die fürstbischöfliche Residenz zu Würzburg*. Munich, 1923.

Simon, Erika. 'Sol, Virtus und Veritas im Würzburger Treppenhausfresko des Giovanni Battista Tiepolo.' *Pantheon* 29 (1971), pp. 483–96.

Stepan, Peter. 'Im "Glanz der Majestät des Reichs": Tiepolos Deckenfresken in der Würzburger Residenz.' *Belvedere*, no. 1 (1996), pp. 58–79.

Succi, Dario, ed. *I Tiepolo: Virtuosismo e ironica*. Exh. cat. Mirano, Commune. Turin, 1988.

The Tiepolos: Painters to Princes and Prelates. Exh. cat. Birmingham, Alabama, Birmingham Museum of Arts, and Springfield, Mass., Museum of Fine Arts. Birmingham, 1978.

Vigni, Giorgio, 'Note sull'attività del Tiepolo a Madrid ed a Würzburg e sul Quaderno Correr.' In *Atti del congresso di storia dell'arte*, pp. 363–5. Venice, 1955.

Vigni, Giorgio. *Disegni del Tiepolo*. 2nd edn. Trieste, 1972.

Index of
Illustrations

Photographic Acknowledgements

Photographs were provided by the owners named
in the captions to the illustrations and by the
author. Additional credits as follows:

Marilyn Aitken, Montreal p. 30
Jörg P. Anders, Berlin pp. 95 (fig. 90), 99 (fig. 96),
 109, 111, 118 (fig. 131), 119
Osvaldo Böhm, Venice pp. 28, 132 (fig. 149), 133
 (fig. 150), 137 (fig. 157)
Achim Bunz, Munich pp. 39, 40, 50, 51, 54, 56, 92
 (fig. 86), 114, 115, 126
Cambridge, Mass., President and Fellows of Har-
 vard College p. 81 (fig. 72)
Trevor Chriss, London p. 41
P. De Baye, London p. 121 (fig. 135)
Richard F.J. Mayer, Munich p. 103
Munich, Bayerische Staatsgemäldesammlungen
 p. 106
Munich, Bayerische Verwaltung der staatlichen
 Schlösser, Gärten und Seen pp. 33, 34, 38, 47–9,
 67, 79, 80 (fig. 70), 81 (fig. 73), 90, 92 (fig. 85),
 108 (fig. 117), 110 (fig. 122), 116, 117, 128
 (fig. 143), 129 (figs. 146, 147)
Nuremberg, Germanisches Nationalmuseum p. 29
Paris, Service photographique de la RNM p. 136
 (fig. 155)
Edith Schmidmaier-Kathke, Munich p. 70
Matthias Staschull, Munich p. 65
Vienna, Graphische Sammlung Albertina p. 101
 (fig. 109)
Wolf-Christian von der Mülbe, Dachau cover
 images; frontispiece; pp. 1, 7–26, 32, 35, 38
 (fig. 14), 44 (fig. 20), 46, 52, 55–9, 61, 63, 66, 69,
 71–7, 95 (fig. 89), 101 (fig. 108), 102, 104, 105
Würzburg, Kunsthistorisches Institut der Univer-
 sität pp. 48–9